UNBELONGING

POSTMILLENNIAL POP
General Editors: Karen Tongson and Henry Jenkins

Unbelonging

Inauthentic Sounds in Mexican and Latinx Aesthetics

Iván A. Ramos

NEW YORK UNIVERSITY PRESS

New York

NEW YORK UNIVERSITY PRESS
New York
www.nyupress.org

© 2023 by New York University
All rights reserved

Please contact the Library of Congress for Cataloging-in-Publication data.
ISBN: 9781479808458 (hardback)
ISBN: 9781479808465 (paperback)
ISBN: 9781479808472 (library ebook)
ISBN: 9781479808441 (consumer ebook)

This book is printed on acid-free paper, and its binding materials are chosen for strength and durability. We strive to use environmentally responsible suppliers and materials to the greatest extent possible in publishing our books.

Manufactured in the United States of America

10 9 8 7 6 5 4 3 2 1

Also available as an ebook

I like art that comes from under the bridge. Everything is going on on top of the bridge: the clashes, the declarations, the manifestos, the splits, the alliances, the betrayals—and a couple of guys are lying under the bridge trying to recover from a hangover. They look up from time to time. They can hear it. But I like that view—right under the bridge.
—Leonard Cohen

CONTENTS

Figure 1.1. The streets of El Tianguis Cultural del Chopo. ©ProtoplasmaKid/Wikimedia Commons.

Introduction

Unbelonging Subjects and Inauthentic Objects in the Time of Neoliberalism

El Tianguis Cultural del Chopo, one of Mexico City's many street markets, is a veritable paradise for fans of rock and its many subgenres. Begun in the 1980s in response to Mexico City's widespread ban on the distribution and live performance of rock music during the 1970s, this "punk rock" flea market currently occupies a side street next to the José Vasconcelos library every Saturday.[1] Across its two narrow corridors, visitors can find innumerable stalls selling bootleg CDs and DVDs of rock, punk, and metal bands,[2] as well as cult films and pirated merchandise from band T-shirts to bongs and lighters. One can also find stands dedicated to the promotion of anarchist politics, veganism, and even unauthorized recordings of talks by leftist icons like Michel Foucault and Noam Chomsky. On one end of the market—the side that leads from the main cross street to the stands—dealers loudly whisper offers of marijuana, cocaine, and ecstasy to passersby. At the other end of the market, past the majority of the stalls, a parking lot becomes the site of a stage where ragtag bands comprised of people ranging from teenagers to scene veterans perform aggressive sounds—especially punk and metal—as ambling crowds pay varying levels of attention. This market, one of the geographic protagonists of this book, is emblematic of the alternative sonic subcultures of Mexican and Latina/o listeners—often disaffected young people who have found their traditional national and ethnic cultures insufficiently equipped to respond to their sense of alienation. Getting to this market, however, sometimes proves a needlessly complicated journey. On more than one occasion, cab drivers have refused to drop me off at the entrance to the market, sure that I must be confusing it with the Museo Universitario del Chopo, an art museum a few blocks away (and the original home of the market)—a

"friendlier" destination. And, indeed, multiple acquaintances who live in the city have expressed concern when I tell them that I plan to spend a Saturday traversing the market, alarmed by its almost mythological (if misplaced) notoriety as a dangerous gathering place for derelicts and rejects of Mexico City's middle class, despite my assurances that I have never felt unsafe there. In fact, ever since my first visit to El Mercado del Chopo in the early 2000s, I have felt a sense of mutual recognition. Sure, my lighter skin and Americanized comportment make me stand out, but the space is welcoming, and there is always someone ready to talk with me about some obscure punk band or the benefits of a vegan diet. There is a shared feeling of being outside the space of legibility of the rest of the city.

This feeling of being outside of the legible bounds of belonging is hardly unique to this space. I have felt it across other moments in punk rock bars in Tijuana, Morrissey tribute nights in Los Angeles, and '80s British rock nights in Chicago—to name a few. In all these cases, a significant number, and often the majority, of the attendees can be identified by the demographic moniker of "Mexican" or "Latina/o," and there is a recognition of the kinds of reactions that our listening to these sounds tends to create—a lingering sense that our presence there makes us illegible, incommensurable with typical white listeners. In other words, the racial break produced by the imagined difference between certain kinds of (brown) bodies and certain kinds of (white) sounds has made us outsiders. *Unbelonging* takes these moments of shared illegibility as opportunities to examine the intersections of sound, culture, and politics in relation to a sonic history that, while focused on the late '80s and moves across the '90s and into the 2000s, stretches back to graze the '60s and '70s and forward to the present. Thus this book aims to reformulate prototypical understandings of national and ethnic belonging and longstanding lineages of what Mexicanidad and Latinidad *sound like*, in turn arguing that these modes of illegibility enable what I see as crucial modes of refusal. I identify this sense of outsiderdom as "unbelonging"—the embrace of a shared sense of illegibility, a collectivity of outsiders that is the result of their being perceived as "inauthentic" Mexicans or Latina/os, primarily due to these subjects' adherence to what I call "dissonant sounds." These dissonant sounds are sonic forms that stand at a remove from the demands and expectations of national

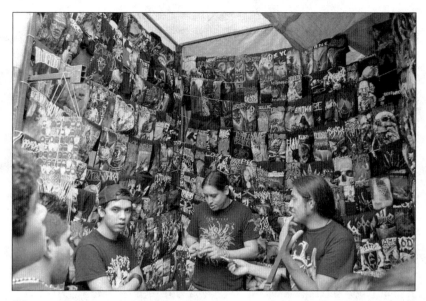

Figure 1.2. T-shirt stall. ©ProtoplasmaKid/Wikimedia Commons.

and ethnic mainstream cultures that seek to dictate what an authentic and proper Mexican or Latina/o subject should listen to. I am particularly interested in the subcultural spaces and unofficial forms of circulation that these listeners move across and within, and especially in the essential—if often unacknowledged—influence these movements have had on the realm of contemporary Mexican and Latina/o art practice, a site which I argue has been central to articulating the political and aesthetic promises of these subcultures and their sounds.

Historically, rock music—alongside other sonic forms identified if not completely as "white" then certainly not as "Mexican" or "Latina/o"—has been received with great suspicion in Mexican and Latina/o contexts, a common occurrence that ties together the transnational slippages in the following chapters. If these racially marked listeners are often culturally incongruent to white audiences, a similar and often more punishing sonic dissonance has been at the center of mainstream discussions of the potentially harmful effects of "foreign sounds," as they have been taken up by Mexican and Latina/o listeners.[3] As rock and roll and, later, punk, metal, and other subgenres have been introduced into these contexts, so too have accusations of national and ethnic betrayal.[4] Indeed, as Mexi-

can and Latina/o youths have adopted these sounds at different points, and even as Mexican and Latina/o artists have been essential creators and performers of these "white genres," they have time and again been accused of becoming seduced by the whiteness—and more specifically, Americanness—of these sounds. Thus, the shared sense of recognition I have witnessed at so many of these spaces and moments sparks this book's attempt to grasp the aesthetic and political moves made possible by the imagined dissonance between national and ethnic belonging and sonic forms and genres that throw that sense of belonging into doubt.

Unbelonging examines the relationship between unbelonging, inauthenticity, and sonic dissonance to investigate how a number of Mexican and Latina/o artists who mostly began working in the late 1980s and early 1990s deployed a dissonant relationship to incongruous sonic forms as a mode of turning away from a number of historical, political, economic, and cultural orthodoxies in Mexico and the United States that have affixed "belonging" to one's national and ethnic identification. The following chapters linger on the incongruity—or dissonance—between transnational Latinidad and certain kinds of sounds, attending to the gestures of refusal they enable. I place these moments of refusal in the context of larger questions of citizenship and belonging in the space defined by the political, economic, and cultural relationship between Mexico and the United States, particularly in the time of neoliberalism—i.e., between the early 1980s and 2015. I anchor this book with an analysis of a set of tendencies in contemporary Mexican and Latina/o art that make use of sonic dissonance to develop gestures of refusal against changing notions of citizenship, challenging what it means to feel a sense of belonging in, to, and between the two countries.

Unbelonging thus examines a collection of aesthetic gestures of refusal in Mexican and Latina/o contemporary art, gestures expressed primarily through an incongruence between sound and identity in performance, video, installation, and visual art, among others. I am interested here in gestures that vary in scale and approach. Following Alexander Nemerov, I see these as "aesthetic gestures that would, far more somberly, yet with a gleaming excitement, settle down to the careful delineation of a profound and infinite *locality*, to the creation of an artistic place amid the emptiness. [. . .] [A]esthetic acts [. . .] whose intensity would be so vivid, so clear, that they would leave a mark."[5] These gestures were

produced by Mexican and Latina/o artists that had come of age in the aftermath of decades-long cultural battles that received rock and other genres with great suspicion. In perhaps the most extreme example of the kind of skepticism mainstream culture reserved for these sonic forms, the Mexican government banned the distribution and live performance of rock music following the Avándaro rock festival—commonly known as the "Mexican Woodstock"—on the outskirts of Mexico City in 1971, a ban that persisted throughout the 1970s and '80s. Rather than turning audiences against these sounds, such prohibitions led to underground subcultures that recognized the critical potential of these sounds and which fostered alternative networks of distribution and performance, as exemplified by the fact that listeners defied the ban by establishing El Tianguis Cultural del Chopo and finding unsanctioned venues for live performance. Indeed, rock and roll and, later, punk and metal were adopted and favored by young people who had already been alienated from the possibility of normative national or ethnic belonging due to growing economic disparities brought by the dawning neoliberal order and the inequalities it created. In places like Los Angeles and Mexico City—two recurring geographic sites in this book—punk and metal flourished at the edges of Mexican and Latina/o mainstream cultures, driven by young audiences who were drawn to these dissonant sounds and their ability to provide a soundtrack to a sense of economic and cultural alienation. I use the term "unbelonging" to mark the ways in which these listeners—and the artists I highlight here—welcomed their alienation and created new scenes where these feelings of existing outside the space of mainstream belonging could be embraced.

However, although *Unbelonging* is deeply engaged with these subcultural scenes and the musical contexts and histories from which they emerged, this book is not about those subcultures or music. Instead, following Alexandra Vazquez, I listen in detail for the ways in which these gestures of sonic refusal fueled a generation of younger contemporary artists who were attempting to turn away from historical and aesthetic legacies that tied national and ethnic identities to specific political aims and aesthetic forms. Each of my case studies highlights an example of how dissonant sound was deployed to turn away from the mainstream of Mexican and Latina/o culture and politics, whether through history, middle-class femininity, motherhood, or other ethnic

and national markers of belonging. The fraught relationship between dissonant sounds and dominant national and ethnic cultural legacies gives each of the artists in this project an opening to reject the demand to belong at a moment when belonging was being redefined at the intersection of the economy and culture via larger events such as the signing of the North American Free Trade Agreement (NAFTA) and the Latino Boom of the 1990s, both of which I explore more fully later in this introduction. I show that these aesthetic gestures of refusal were often made possible by the fact that most of the artists I chronicle in this book came out of—or made work in close proximity to—these sonic subcultures. To that end, this book is as much about the artists and their work as it is about the informal, underground, and unofficial forms of circulation through which sonic negations found their forms.

But allow me to hit pause for a moment and expand on one of the central concepts that animate this book. I identify dissonant sounds as sonic forms that produce an imagined disjuncture between their geographic origins and the racial makeup of their listeners. Throughout the many years I have researched and presented work from this project, I have often heard the protestation that in reality there is no such thing as culturally dissonant sound, since no sound belongs to any one culture; but as my examples show, moments of sonic incongruity between musical genres and racialized listeners abound, bringing about quizzical curiosity at best and hostility and accusations of ethnic betrayal at worst. This is what Jennifer Stoever identifies as the "sonic color line": "the process of racializing sound—how and why certain bodies are expected to produce, desire, and live amongst particular sounds."[6] Indeed, while we may wish to claim sound as a property free from racial associations, music and other sonic forms are inevitably bound by a set of social relations where particular kinds of sounds are understood as belonging to particular bodies.

To further define the sense of illegibility produced between certain sonic forms and particular subjects, I borrow the notion of dissonance from Deborah R. Vargas, who uses this term to mark the interruptive presence of Chicana singers in misogynistic canonical histories of Tejano music. She writes, "dissonance—as chaos, cacophony, disharmony, commotion, static—is deployed [. . .] to symbolize an interruption or disruption of the heteronormative and cultural nationalist limits of *la*

onda by Chicana/Tejana singers."[7] Therefore, the dissonant emerges from the ways in which the listening practices of those who have been excluded from official sonic histories interrupt the inherent power relations that undergird these canons. I take up Vargas's notion of dissonance in concert with my own investment in challenging discourses that discipline and enlist sound in service of nationalist and ethnic belonging, thus limiting the narratives and subjects allowed entry into the annals of Latinidad. Dissonance, according to Vargas, invites listeners to become attuned to sounds that may at first seem to be in excess of the record—in both meanings of the term. "Incidental" sounds—fuzz, background noise, needle scratches, etc.—thus become central to this project. Additionally, dissonance beckons us to be especially attentive to sounds that take place *outside* of a recording that are nonetheless essential to it—like gossip, chatter, interruptions, and social relations that quietly influence our relation to the sonic. I extend this notion of dissonance to help in understanding the politics and aesthetics of the imagined break between bodies and the sounds that have been assigned to them according to their demographic. As I will show, overdetermined understandings of the relation between certain sounds and their cultural heritage are steeped in power relations that may seem silent, but which reveal sometimes pernicious ends when listened to closely. Heeding Vargas's approach, I use the dissonant as a methodological and analytic tool to explore the aesthetic works and subjects that make up the following chapters to consider what new social relations become possible when dissonant sounds interrupt some of the silently injurious demands of national and ethnic belonging.

Intervening in the Record

While not *about* music, this book is nonetheless greatly influenced by scholars of popular music in Latin America and the Latina/o US. Their work has been responsible for mapping the trajectories of sonic forms across the hemisphere as well as illuminating the influence and stakes of culture, economy, and politics in these sounds' varied journeys. Although *Unbelonging* draws from and is heavily indebted to these studies and conversations, my aim is decidedly different. My focus on contemporary art makes this the first study to center exclusively on the

influence that these historical changes have had beyond their immediate cultural and economic context. In other words, I do not prioritize the complex and varied histories of how these sounds came about or the cultural transformations they experienced once adopted by their publics. That said, I do want to take a moment to clarify some of the terms and central concerns this scholarship has articulated, and which influence my own work.

Many of these studies focus on the notion of "transculturation" to explain the constant and unpredictable trajectory that local sounds journey through as they enter new cultural contexts and listeners. I am especially interested in these scholars' reflections on the influence of globalized markets on transnational sonic production and their articulation of how more traditional musicological understandings of circulation have been altered in an increasingly globalized world. For example, as Ignacio Corona and Alejandro L. Madrid write in the preface to their edited anthology *Postnational Musical Identities*, "'Postnationalism,' 'transnationalism,' 'globalization,' 'hybridity,' 'diaspora,' and similar buzzwords have not only informed scholarly discourse and analysis of music, but also shaped the way musical productions have been marketed worldwide in recent times."[8] Like those scholars, I am interested in "the importance of examining how the web of power and ideological relations in which music is produced and performed is inextricably linked to its sociological relevance and cultural impact."[9] They assert that "in a postnationalist world, where composer, artist, and listener are no longer part of the same cultural context, social meaning, performative aspects, and aesthetic values are no longer to be implicitly understood or presumed."[10] I am attentive to these issues throughout this book while also maintaining the importance of remembering the ways in which local contexts tend to reassert themselves.

This body of scholarship has also illuminated the complex histories of rock music and transnational Latina/o audiences. For Frances Aparicio and Cándida F. Jáquez, rock exemplifies a resultant "hybridity" of sounds and cultures, "an index of the new semantics produced by the transnational circulation of music in (post)colonial contexts."[11] Indeed, although *Unbelonging* identifies the historical relation between rock sounds and their racialized audiences as "dissonant," this relationship has hardly been clear or immediately legible. Aparicio and Jáquez rec-

ognize the dominant tendency that I return to in this book: "Historically rejected by many Latin Americans as imperialist and foreign despite its oppositional value in the North, rock has become 'rock en español,' a phrase that clearly denotes its Latin transculturation and musical appropriation."[12] Further, as scholars including Deborah Pacini Hernandez, Alejandro L. Madrid, Eric Zolov, Michelle Habell-Pallán, and others have pointed out in their studies of Mexican and Latina/o rock cultures and musicians, rock is not as foreign to these contexts as it may at first appear. This is part and parcel of the history of rock music globally, as Eric Zolov explains:

> Since its initial mass distribution, in the late 1950s, rock 'n' roll culture has been disseminated via capitalist and underground channels throughout the world, embedding itself in local cultures in ways that came to have profound results. In one sense, the spread of rock 'n' roll culture had an effect elsewhere which was similar to that in the United States: intergenerational conflict, repudiation of authoritarian values, liberation of the body, accelerated consumerism. But where rock music entered nationalist, developing nations (including the Eastern bloc countries), it was adopted by youth (as well as some parents) as an agent of modernity, even while it was frequently condemned by government officials and the intelligentsia as an agent of imperialism.[13]

These anxieties are most immediately apparent in Mexico, where the government as well as cultural commentators continually charged rock with being uniquely representative of the encroachment of American cultural imperialism at a moment in which the United States continued to solidify and expand its political and cultural dominance over the globe. In the United States however, where the government had its own antipathies regarding Latina/o subjects, these anxieties exchanged fear of imperialism with concerns in the community about young listeners becoming assimilated and thus losing their ethnic heritage.

Ultimately, while in hindsight we know that rock has never really been that foreign to Mexican and Latina/o audiences, this imagined break persists. As my opening example shows, there are still sounds that are understood as inevitably irreconcilable with Mexicans and Latina/os, something that I explore in depth most fully in the fourth chapter,

where I describe a variety of discourses that have attempted to provide an exact cultural explanation as to why Latina/o listeners are so inexorably drawn to Morrissey's music. I must also emphasize that although I take rock music as the overarching umbrella under which the subgenres I look at in this book fall, certain sounds have been more popular with mainstream publics, and thus less derided, than others. For example, part of the reason why the first waves of rock music fostered a certain level of cultural panic was because of their immediate popularity with young audiences, including young women who would become part of a burgeoning feminist movement, and yet these more mainstream rock sounds could eventually be shaped into the much more accepted genre of *rock en español*. Punk and metal, however, have failed to encounter such widespread popularity, partly because of their more aggressive tone, and partly because these sounds have for the most part continued to attract working-class audiences who don't have the economic and cultural status to dictate what sounds will come to dominate the mainstream. Even if the manifold encounters between these cultures, listeners, and sounds have not been as exceptional as they are often made to appear, they continue to carry an air of suspicion among certain sectors; and although the threat of cultural betrayal has been partly muted, its legacies persist.

With this in mind, *Unbelonging* abandons the framework of hybridity favored by these earlier studies. I do this in part because, even in its messiest configurations, hybridity still tends to denote a clearly discernable point of encounter (and its effects) between different cultures, specifically in its belief that "traditional culture" tends to become increasingly cosmopolitan through this contact.[14] Yet for the artists and audiences in my case studies, culture is always already hybrid, or perhaps more to the point, they possess a cultural vocabulary that exceeds these traditional notions of hybridity. In other words, the more discernable points of contact that make hybridity legible tend to be absent in my case studies, circulating through unsanctioned modes of distribution, such as the bootleg. Moving across genres, languages, and cultural contexts is as common as moving within "their own." Hybridity also fails to account for the many possible layers and dynamics in a space as complicated as the Americas—as in the case of Iván Abreu, the protagonist of my first chapter, who, as an artist born and bred in Cuba before moving

to Mexico to pursue an engineering degree and who is now a Mexican citizen, positions his work beyond the constraints of overdetermined national conflicts. In my own approach to these objects, hybridity simply fails to provide a sufficiently nuanced account of the ways that these artists and listeners experience and move across cultures. This might also be due to the fact that whereas work on musicians tends to treat musical talent as innate, or handed down through informal means by fellow musicians, the artists I explore in the following chapters were all trained as artists in various university settings where they had to engage and envision their own relationship to a global art history rather than more carefully guarded musical traditions. But as I also argue throughout, hybridity's less messy conceptualization of the ways cultures meet also made it an ideal concept for the dominant culture to harness something like rock into the market genre known as *rock en español*, which I argue is the perfect hybrid form and could only be the result of a culture already entrenched in logics produced by neoliberal markets. Nonetheless, the cultural and economic pathways of rock and its subgenres inform how these artists understood and engaged with these sounds.

Additionally, I place this project firmly within the field of Latina/o studies, and Latina/o sound studies most specifically. In some ways, *Unbelonging* applies pressure to Latina/o studies' more hopeful genealogies, which seek to affirm Latina/o identity and its right to belong, either in concert with or in opposition to the nation. However, Latina/o studies has also fundamentally questioned notions of nation, citizenship, and, ultimately, subjecthood. Works by José Esteban Muñoz, Juana María Rodríguez, Laura G. Gutiérrez, Leticia Alvarado, Ramón Rivera-Servera, and many others have lingered on the productive tensions of Latinidad and queerness, revealing the political possibilities of putting these concepts together.[15] This book is especially influenced by the intersection of queer and feminist scholarship and Latina/o sound studies, which has been essential in offering new methodological and analytical vocabularies to understand the relationship between Latinidad and sound. In addition to Deborah Vargas's aforementioned notion of dissonance, I embrace Alexandra T. Vazquez's invitation to "listen in detail" as a method to grasp how sound and the sonic resist official narratives through moments as seemingly insignificant as "interruptions that catch your ear, musical tics that stubbornly refuse to go away."[16] She delves into the impasses

that have held Cuban music captive to the political tug-of-war between Cuba and the United States throughout the twentieth and twenty-first centuries, ignoring that in reality Cubanidad has been the site of multiple relational attachments in political discourses indebted to Blackness, cosmopolitanism, and aesthetics, among others. Vazquez investigates how music has often been an avenue through which Cuban identity has circulated beyond its politically visible understandings. She deftly sets up a temporal gamble by providing the reader with a concise yet comprehensive journey, showing how Cuban music has been presented as an object of musical and historical analysis, from a 1939 book commissioned by Cuba's department of agriculture through contemporary guides that claim to be the definitive word on this music. I follow such a cross-temporal and geographic gamble here. But as Vazquez makes clear, "listening in detail" requires thinking beyond the conventions of genre. For Vazquez, "details" are how the unwieldiness of Cuban music reveals itself against attempts to locate it as a nostalgic object. I in turn "listen in detail" to read against the grain of official histories of sound and music that have been ascribed to Mexican and Latina/o subjects throughout the century and as a methodology to hear the sounds of unbelonging. I also listen for "the thinking voice," borrowing this term from Licia Fiol-Matta's theorization of the work that the voice does in performance and which exceeds the entrenched histories of female musicians in Puerto Rican music. As with Vargas and Vazquez, Fiol-Matta argues that, in listening for the "thinking voice," the aim is not simply to correct the archive, but also to find the ways in which the archive's insufficiency can be seen as essential to the formation of musical discourse—something that cannot be simply fixed through inclusion.[17] I draw from these works not only theory but also methodology. Indeed, what I take from these and other scholars working within this field is an ongoing commitment to the promiscuous interdisciplinarity required to engage with the needs of a project that embraces the unwieldiness of multiple geographies and temporalities. Thus, listening to and beyond the archive will take the following chapters to a surprising number of times and places, including the ports of nineteenth-century Havana, the trash heaps of 1990s Mexico City, and the streets of 1980s Manchester.

Unbelonging also intervenes into dominant histories of contemporary Mexican and Latina/o art by illuminating the overlooked influence

of these sonic subcultures on specific aesthetic genealogies. Thus far, scholarly work on this period of contemporary Mexican and Latina/o art has focused on how art and performance have responded directly to larger political changes.[18] I draw from these studies and their investment in understanding these artists' clearer alignment with a sense of political opposition. For example, a good amount of art in Mexico during this period openly criticized NAFTA and its effects. As Rubén Gallo explains in *New Tendencies in Mexican Art*, "Most art produced during [the late 1980s and early 1990s] was entirely apolitical. The first year of [Mexican president Salinas de Gortari's] term saw the rise of a young generation of painters who became known as 'neo-Mexicanists' and include figures like Julio Galán, Nahúm Zenil, and Dulce María Nuñez. They painted huge canvasses filled with every conceivable symbol of Mexicanness: exotic fruits, flags, *charros, sarapes*, Guadalupes, and bleeding hearts."[19] But, as Gallo points out, a new generation of artists began producing work that departed from the neo-Mexicanist legacy in at least three ways: "First, they rejected painting in favor of alternative media like installation, video, ready-mades, and performance. Second, they dispensed with the use of nationalist symbols and adopted a visual vocabulary taken from the globalized mass media (including references to television, film, comic books, and other products of American popular culture). Third, they renounced the commercialism that characterized neo-Mexicanist paintings by producing works—many of them ephemeral—that were virtually unsellable in Mexico at the time."[20] I build upon Gallo's crucial observations by expanding my scope to include the context in which these artists emerged from the underground sonic subcultures that preceded this moment in Mexican contemporary art. Indeed, as I discuss more fully in the first two chapters, these emergent aesthetic forms cannot be separated from the punks and *metaleras* who paved the way for new exhibition and performance spaces across Mexico City.

Similarly, many Latina/o artists during this period created work invested in articulating an oppositional politics to the ongoing racism and xenophobia experienced by this population in the United States. As Jennifer A. González explains, "from about 1965 to the late 1970s an efflorescence of activist posters, murals, theatrical productions, and literature rejected mainstream distinctions between folk and fine arts, and

emphasized instead a set of familiar and popularly accessible themes designed to inspire cultural pride and recruit members to *la causa*."[21] This cause supported an emergent Chicana/o movement that defined itself explicitly in opposition to both the United States and an otherwise depoliticized Mexican American identity. But as Chon Noriega writes, this relationship between aesthetics and an explicit political culture has resulted in a number of questions that have defined several issues when thinking about these artists: "Who is a Chicano artist? What are his or her responsibilities as an artist? What *is* Chicano art? Does this art entail a distinct aesthetic, mode, or practice? What is its relationship to other artistic traditions, but also to mainstream museums and the art market?"[22] Indeed, any number of Chicano/a artists have consistently produced work in relation to a pressure to produce art perceived to be in service of larger political goals. While I do not seek to discount the numerous artists who have created work that responds to these calls for political utility, I take these tensions as indicative of the kinds of expectations that the artists I consider in this book attempt to eschew by embracing ethnic illegibility in their turn to dissonant sound.

Although they are inseparable from larger political events, they do not make "political art." This is not to say that these artists are not astutely aware of the high stakes of the political contexts in which their work was made; but this work just does not respond directly to these events. As a result of this, while artists like Nao Bustamante, Sarah Minter, or Shizu Saldamando certainly have a "politics" in their work, they are rarely considered "political artists." As I argue in chapter 1, one of the major factors in the rapid emergence and ongoing popularity of sound art in Mexico was the fact that this form allowed artists to move away from the constant expectation to create work that explicitly engaged with national/ethnic histories and politics.

On Method and Convergences

My approach to these potentially disparate yet intersecting case studies and approaches demands a methodological and theoretical move away from the comparative and toward what I see as the convergent. I borrow the idea of "convergences" from the cultural critic and journalist Lawrence Weschler, who makes use of the term to describe aesthetic

encounters that cannot be subsumed by the more linear logic of comparison. In *Everything That Rises: A Book of Convergences*, Weschler writes that "I [. . .] have increasingly found myself being visited by similarly uncanny moments of convergence, bizarre associations, eerie rhymes, whispered recollections—sometimes in the weirdest places."[23] I bring the objects and modes of analysis in this book together by emphasizing moments of convergence rather than set points of comparison. Weschler continues: "The range in tone of these convergences was considerable: some were fanciful, others polemical; some merely silly, others almost transcendental. Some tended to burrow toward some deep-hidden, long submerged causal relation; others veritably reveled in their manifest unlikelihood."[24] The works I survey here bear closer relation than those Weschler discusses, since I focus specifically on artists working within closely related contexts and art markets. Yet their points of relation and their expression of unbelonging cannot be subsumed by comparative logics, partly because, in spite of their cultural/national proximity, their works are often seen as belonging to different discourses and aesthetic genealogies. But as María Josefina Saldaña-Portillo, Lisa Lowe, Ania Loomba, and others have recently shown, we cannot ignore the origins of the comparative as a research methodology, as it was developed in tandem with Cold War politics that aimed to provide stable and easily understandable accounts of national difference (via literature, culture, politics, etc.) in the service of the US government's attempts to quell a tide of global communism.[25] As Loomba writes, it is the "potential of comparative thought that has fed into the development of 'global' or 'universal' paradigms that posits a hierarchical relation between the entities being compared or simply exclude large chunks of reality from its domain. In other words, the perspective remains narrow while claims are enlarged."[26] Similarly, I follow María Josefina Saldaña-Portillo's approach in *Indian Given*, where she states, "I am less interested in even value-neutral comparison than in demonstrating the ways in which the racial geographies of Mexico and the United States were mutually constituted and imbricated."[27] I am similarly invested here in analyzing points of convergence in aesthetic work created during a particular historical moment in the United States and Mexico through alternative networks of distribution. These points of convergence also perhaps resemble the "obscured connections" that Lisa Lowe argues might best

be captured by the notion of "intimacies," which "involves considering scenes of close connection in relation to global geography that one more often conceives in terms of vast spatial distances."[28] I find this methodological turn especially productive, as the close relation between Mexico and the United States—and between Mexicans and US-based Latina/os—often obscures the more hidden or unexpected moments of convergence I favor here. My interest in experimental aesthetics demands a move away from explanatory narratives and toward speculative points of connection that, although absent from official archives, are nonetheless audible across the following case studies. The convergent therefore allows me to delve into the properties of the sonic while moving away from the scholarly drive to create or trace linear narratives that would reward a teleological thirst for plot and resolution. The narrative I propose is fragmentary and made up of encounters that travel through unexpected moments of convergence—from the nineteenth-century ice trade between the United States and the Caribbean and contemporary Mexican politics to the shared soundtracks of bedrooms and clubs from Mexico City to the Bay Area and the affects they've enabled.

Unbelonging Subjects

The dissonant sounds this book identifies as an aesthetic mode interrupt the linear discourses of neoliberal progress that become tied to citizenship and national and ethnic belonging. This interruption can be defined by its emphasis on a mode of refusal that I call "unbelonging." I place unbelonging in relation to theoretical interventions at the intersections of queer theory and affect studies that insist on the political potentiality of refusal through an emphasis on "negative affects" that open up (rather than foreclose) alternative ways of understanding pessimistic emotional states experienced by minoritarian subjects. Scholars of feeling, affect, and sensation have approached the question of bad, ugly, negative, or otherwise contrarian affective states by relating these emotional vocabularies and their development as a potential resistance to fantasies of progress, capital, race, sexuality, class, and other structuring forces of social difference. Sianne Ngai, in *Ugly Feelings*, calls for us to "dwell on affective gaps and illegibilities, dysphoric feelings, and other sites of emotional negativity [. . .] to explore similarly ambivalent

situations of suspended agency."[29] The affects and objects she identifies "are explicitly *a*moral and *non*cathartic, offering no satisfactions of virtue, however oblique, nor any therapeutic or purifying release."[30] Useful to my argument is Ngai's formulation that "noncathartic feelings [. . .] could be said to give rise to a noncathartic aesthetic: art that produces and foregrounds a failure of emotional release (another form of suspended 'action') and does so as a kind of politics."[31] The subjects in this book are constantly rendered illegible to the fantasy of national and ethnic belonging because of their embrace of sonic forms that are heard as an affective removal from Mexicanidad or Latinidad. And although noise, punk, metal, and '80s British rock might be cathartic genres and might lead to cathartic moments, I focus instead on the ways in which these sounds allow their listeners to hit pause on the demands to be productive subjects and instead open up moments of hanging out and wasting time.

In a similar register, the artists in this book forego what I understand as the cruel optimism of national and ethnic belonging. In *Cruel Optimism*, Lauren Berlant describes the titular concept as that which "exists when something you desire is actually an obstacle to your flourishing."[32] Berlant especially identifies this condition in relation to neoliberalism's hallmark promise of "the good life." This notion of cruel optimism provides an apt description of the relation I see between the nation and belonging as they have been continuously defined since the 1980s. I follow in the path of these studies by examining how moments of refusal hold the capacity to reveal the inconsistencies of power and its exclusions. Unbelonging—the term I use to name these moments of negation—is an attempt to go beyond the states of injury *produced* by forms of inequality and instead linger on what it means to embrace a sense of illegibility that in turn makes the promises of belonging undesirable.

I use unbelonging to denote a mode of rejection that responds to the very impossibility of attaining the desires produced by the promise of belonging. I expand on discourses of negative affects here in significant ways. Indeed, much of the scholarship on "ugly feelings" finds them to be the result of structural dispossessions, where these affects reveal the faults in a pervasive structuring mechanism (e.g., capital, sexuality, race). For example, Ann Cvetkovich has shown how depression is the result of and a response to larger shifts in global capital that produces

this melancholic state in subjects.[33] Unbelonging, as I develop it here, hinges on the perception that, for the subjects and their listening practices, dissonant sounds have a priori rendered them as antithetical to the political project of belonging. For example, the reason Latina/o punks and/or Morrissey listeners resist the siren call of neoliberal citizenship is that they have *already* been figured as traitors to the political aims and cultural specificity of Mexicanidad and Latinidad. Unbelonging is also a particularly effective analytic considering the timing of my project. Indeed, as I place the following case studies in the period following the increasing implementation of neoliberal policies, I am mindful of how these policies coincide with a growing interest in narratives of hybridity and multiculturalism. Thus, as rock music became increasingly mainstream—accepted in Mexico through the hybrid sounds of something like *rock en español* or the large cultural fascination around Latina/o Morrissey fans—the artists I examine rejected the potential promises of multicultural inclusion as it arose in close relation to the aims of neoliberalism. With this in mind, my project adheres closely to Leticia Alvarado's work in *Abject Performances* and her notion that "Latino abject performances reveal abjection not as a resource for empowerment fueled by a desire for normative inclusion but as a resource geared toward an ungraspable alternative social organization, a not-yet-here illuminated by the aesthetic."[34] In particular, Alvarado suggests that the abject—or what I identify here as refusal or negation—provides an alternative to Latina/o political movements that hinge on respectability. The works I survey in this book follow what Alvarado describes as performances in which "residual aftershocks of feeling returns the spectator to the performance into the indefinite future. [. . .] They provoke the sublime and its attendant ambivalence and ambiguity."[35] *Unbelonging* welcomes the power of such errant aesthetic encounters to illuminate the potential for a politics that refuses the political mainstream.

I thus see unbelonging as a practice that allows subjects to access alternate social relations that emerge against traditional modes of belonging such as citizenship, community, family, and even identity itself. The complex articulations of the political goals of identity remain at the center of this project. However, I expose the imagined correlation between the affirmation of belonging and identity as a relation that has been consistently deployed as a disciplining mechanism. I turn to Franco "Bifo"

Berardi's critique of identity and belonging as illustrative of the pitfalls of identity and its promises. In *Heroes: Mass Murder and Suicide*, Berardi maintains that "[i]dentity is not naturally ascribed; it is a cultural product: it is the effect of the hypostatization (fixation and naturalization) of the cultural difference, of the psychological, social, and linguistic particularity."[36] The danger of adhering to identity for him is that "in order to be understood, one must play one's role in the game, and this role is surreptitiously identified as a mark of belonging."[37] Berardi maintains that the perils of seeking identitarian belonging are prescribed by an erasure of culture in which the injured subject mistakes the dominant culture's erasures as affirmation: "The community, which is a place of communication (a place of exchange of signs conventionally charged of meaning), is mistaken as a natural place of belonging, and transformed into the primeval source of meaning."[38] He continues, arguing that "[i]dentity is the perceptual and conceptual device that gives us the possibility of knowledge, but sometimes we mistake this knowledge for a re-cognition. So we are led to believe that which we already know, that we possess a map thanks to our belonging."[39] Berardi identifies a re-entrenched and highly dubious return of identity as a primary marker of belonging as the manifestation of "the deterritorialization that globalization entails" in a way that "hugely intensifies the need for an identitarian shelter, the need for the confirmation of belonging. Here lies the identitarian trap which is leading the world towards the proliferation of points of identitarian aggressiveness: the return of concepts such as the homeland, religion and family as aggressive forms of reassurance and self-confirmation."[40] Berardi's point is especially well-taken given the ways in which neoliberal policies were inevitably articulated around the promise of multicultural exchanges that essentially served to re-entrench the fictions of identity. As my case studies show, subjects who had turned to dissonant sounds to articulate a larger sense of dissatisfaction toward their national and ethnic mainstream were figured as traitors to the homeland, ethnic heritage, and even their families. But these accusations of betrayal were in turn the expression of other economic and social anxieties around the totalizing effect of the United States and its economic and political influence before NAFTA's multicultural turn. Berardi writes, "capitalism ultimately provokes a need for reterritorialization, and a continual return of the past in the shape of national iden-

tities, ethnic identities, sexual identities, and so on."[41] In the following section and across the book's chapters I identify how the shift toward neoliberal capital attached itself to the notion that Mexican and Latina/o subjects could finally participate in a future to which they would belong.

Berardi places this history of identity and belonging into a larger historical context, using the example of the expulsion of Jews from Spain to prove his point. According to Berardi, at the starting point of modernity, alongside the colonial expansion of power (illustrated by Spain's colonization of the Americas), Jewish populations attempted to recuperate the cultural lineages that had been "lost" in the process of expulsion. Berardi explains,

> But much of [the Spanish Jews'] memory had been lost in the decades of persecution and dissimulation, and often, the interdiction of the persecutors appeared to be the only evidence of its previous existence. Paradoxically, what the persecutors had forbidden, increasingly came to be perceived as the "true" identity which had been lost, and consequently, enacting exactly that which had been forbidden appeared to be the safest way to retrace and reappropriate the original identity, to rebuild the collective memory.[42]

But as he reminds us, "This is the essence of the trap of identity: only the gaze of the other acts as a mirror, as the source of self-identification."[43] I view Berardi's argument from a Foucauldian standpoint, in which the formation of a population serves to discipline it at the same time as it conceptualizes it. Or rather, as subjects become tethered to identity as the key to collective remembering, they become embedded in power's ability to appropriate and adjudicate what this definition *is* to begin with. Or in other words, as neoliberal capital expanded its reach, the work of retaining cultural, ethnic, and national legacies was abdicated by the state and passed on to the individual subject who could show their allegiance to being a "good" Mexican or Latina/o by embracing sonic legibility.

The notion of unbelonging that anchors this book is also indebted to Christine Bacareza Balance's theorization of "disobedient listening" and its relationship to fraught legacies of authenticity. According to Balance, "with a method of disobedient listening, we are able to move through

and beyond preoccupations of authenticity by listening against and beyond the dominant discourses that continuously constrain and narrow our understanding of the sonic and musical."[44] For Balance, disobedient listening becomes a necessary approach for subjects whose geographic, cultural, and temporal locations make them illegible to prevailing narratives claimed by the state. She writes, "disobedient listening—or listening against—defies the smooth yet violent framings of colonialism and imperialism's visual regime. Disobedient listening refuses to play the roles of an authentic other, native informant, or indebted giver. Disobedient listening disavows a belief in the promises of assimilation by keeping one's ears open to hidden and distant places often not of this world. Practices of disobedient listening rehearse other types of politics and affiliations than those merely based on the promises and demands of visibility."[45] I define unbelonging in close approximation to disobedient listening, and especially Balance's assertion that disobedient listening is a deeply ethical act that can unveil social relations obscured by nationhood and limited racial paradigms.

Unbelonging does not deny the importance and need for identity *tout court*. Rather, following José Esteban Muñoz's groundbreaking work in *Disidentifications*, identity should be understood as a complex process that destabilizes any notion of it as the basis for a unified subject. As Muñoz's theory of disidentification shows, identity itself might be constructed by a relation to bad objects—a point of particular importance to this project. In acceding to the ways identities in difference are made up by injury as much as they are by felicitous accounts, the subject is able to enter her relationship to identity from a position that is always already fragmented and fragmentary.[46] Thus, I see unbelonging as the deployment and the very ability to remain in the complexities of identity as a move that critiques the powers that attempt to define it and give it meaning. One could alternatively imagine unbelonging as a practice of disidentification or vice versa, disidentification as a practice of unbelonging.

Unbelonging, then, is a strategy of rejection used by those who have *already* been rejected, a tactic expressed by *rejects*. Irving Goh's exploration of the reject is particularly useful for my notion of unbelonging. Goh proposes the reject as a figure that arises in the wake of critiques of the subject, and is perhaps even hidden within these critiques. By call-

ing attention to the ways in which rejects have increasingly come to take center stage in contemporary culture, he considers this (non)subject to help us reconsider the future of politics, community, religion and other relational forms. He offers three versions of the reject: The first, most recognizable to us, is "a passive figure targeted to be denied, denigrated, negated, disregarded, disposed of, abandoned, banished, or even exiled."[47] The second form of the reject "rejects things and people around it with a force so overwhelming that it is only *subsequently* rendered a *reject* by those around it."[48] But a third iteration—the most useful to this project—is the *auto-reject*, which he identifies as "the *reject's* turning of the force of rejection around on itself [. . .]. [T]he *auto-reject* puts in place an auto-rejection in order not to hypostasize itself on a particular thought or disposition. [. . .] Auto-rejection involves creative regeneration, therefore, and not, I repeat, self-annihilation."[49]

Goh understands that these categories are far from discrete and may very well be in constant relation, but for him, auto-rejection emerges as a potential ethical stance that refuses the force of subjectivation that results from becoming rejected. He writes that auto-rejection "is instrumental in countering any return of the *subject*, in freeing the *reject* from an *abject* condition, and in opening the *reject* to another ethics, 'another possibility' of being 'responsible without autonomy,' which still affirms and respects the other and its differences."[50] In other words, auto-rejection is the process of releasing the self from the conditions that rendered one a reject to begin with. This does not necessarily entail forgetting the conditions that create subjection itself, but realizing one's position as the reject allows the subject to "walk away" from allowing abjection to define the self, which Goh sees ultimately as an extension of power exerted upon the subject.

Throughout my case studies, unbelonging is enacted by those who have already been rejected by the norms of belonging—be they citizenship, community, or identity. Indeed, neoliberal citizenship's allure works best on those who want to closely adhere to the imaginary of national belonging. The lure of becoming a productive Latina/o or Mexican citizen who earns their place in the multicultural nation because of their economic productivity will be most quickly adopted by the Latina/o or Mexican invested in being taken seriously as a citizen. But as will become clear, the assurances of citizenship are far less allur-

ing to those who have been told they don't belong in this future, as in the case of the Latina/o Morrissey fan who wallows in depressive states rather than in the joyful stasis of Latina/o identity. But in listening to the British "pope of mope," the Latina/o Morrissey fan can recognize and engage in this process of auto-rejection; for them, the nation and the family have already failed to offer them the possibility of belonging. The aesthetic works I analyze throughout this book all practice unbelonging as a result of their negation to the promise of inclusion. Unbelonging, however, is not a nihilistic act; it offers instead alternative forms of collective engagement, not only affectively, but also materially, as the recurring notion of the bootleg throughout this book will show.

The project of assigning who belongs necessarily defines or adjudicates those who do not. Thus citizenship—and its expression in culture, family, and nation—always rests on constructing a wall against those who will never be included, lest they reveal the very violence behind the promise of belonging.

Inauthentic Objects

The notion of authenticity—or more precisely, inauthenticity— reappears in sometimes minor ways throughout this book. During presentations of this project, the question of distribution has frequently come up, with the assumption that when discussing the global dissemination of rock and its genres, Mexican and Latina/o listeners might be the unwitting pawns of record companies. As I explore, however, in the aftermath of rock's prohibition in Mexico, and given the general antipathy toward this music in mainstream Mexican and Latina/o culture, dissonant sounds thrived through unsanctioned forms of distribution, such as bootlegs. But the dividing line between the authentic and the inauthentic is accompanied in this book by the background hiss of two major cultural and political developments in Mexico and the United States: the North American Free Trade Agreement (NAFTA) and the so-called Latino Boom. I place these events in close proximity to provide a larger economic context, which, I argue, the artists in the following chapters were inevitably affected by.

NAFTA is perhaps the single most important development that defined the economic and political discourse in Mexico during this period.

As Ann E. Kingsolver shows in her invaluable *NAFTA Stories*, the treaty produced a multiplicity of narratives, often at odds with each other, as government officials, media establishments, and citizens tried to make sense of it. This was due in part to the fact that, as the treaty was negotiated and came together, its contents were largely inaccessible to the general public. NAFTA—or, as it's referred to in Mexico, el Tratado de Libre Comercio (or simply, "el TLC")—circulated through competing discourses, led by a suspect promise that its implementation would result in a new era of economic progress designed to rival an ever strengthening global marketplace that found countries coalescing as trading blocks. Perhaps because of this, the majority of the discussions around NAFTA focused on the potential effects of the treaty between Mexico and the United States.[51] Indeed, the United States' investment in NAFTA was to neutralize the possibility of Mexico's other potential alliances, including the rest of Latin America as well as Japan. But, as Kingsolver argues, "in the absence of the document itself, NAFTA/el TLC became a symbolic entity invested with hopes, fears, and agency—the power to change lives and nations."[52]

Kingsolver also points to one of the major misunderstandings regarding the public perception of NAFTA. She writes, "I was motivated to write this book, in part, because of stereotypes of Mexican people and perspectives that I heard in public discourse in my own country. In these stereotypes, Mexican perspectives seemed to be represented as more accepting of NAFTA and less sophisticated than those of U.S. commentators."[53] In the United States, the reigning perception regarding the treaty was that it would overwhelmingly benefit Mexico as the country had moved from decades of economic progress to increasing economic stagnation. And indeed, this was the narrative that the Mexican government promoted among its citizenry as it attempted to portray the treaty as the necessary remedy to integrate the country's economy into an increasingly globalized world. "El TLC," however, was widely contested in Mexico. For the majority of the country, it presaged the end of Mexican autonomy by surrendering its economic futures to Uncle Sam—the figure often used to represent American imperial might in Mexican media.

One of the major elements of the campaign that the Mexican government undertook to mobilize support for NAFTA focused on imports and exports, tying citizenship to consumer legitimacy. Mexico would

finally be able to export locally made crafts, at the same time importing licit goods and commodities from the United States at cheaper prices. In the previous decades, street markets stocked in large part with pirated and bootlegged goods were pervasive throughout Mexico, and when it came time to promote NAFTA, advertisements stressed the idea that cheap goods would soon be a thing of the past since the trade deal would now allow real, officially sanctioned products to circulate—finally giving Mexicans the same access to official products as American consumers. With this in mind, one of NAFTA's goals was to target these inauthentic objects to curb the bootleg industry that dominated Mexican street markets. Part Six of the treaty directly addressed the issue of intellectual property and copyright.[54] Its primary goal was to extend the protection of intellectual property between nations by allowing greater legal means to restrict the circulation of copyrighted products. The provisions were already laid out: under Part Six, Mexico would adhere to the rules of the Berne Convention, the major transnational copyright agreement signed in Switzerland in 1886. Perhaps ironically, the need for the Berne Convention had come as a result of book piracy in the United States (and major battles around the meaning of the republic in relationship to the British empire), although the United States would not actually sign the Berne agreement until 1988—over a century after its original implementation. Throughout the nineteenth century, American intellectuals and manufacturers understood copyright as a trick of empire to diminish national autonomy by enforcing intellectual property laws and thus restricting access to knowledge and information.[55] The implementation of these laws in Mexico is defined in the treaty by using two of the strongest adherents to intellectual property laws: literature and sound recordings. Extending the reach of copyright protections gave transnational corporations the ability to pursue legal action across territories, something that hadn't previously been possible in Mexico. Throughout this book, I look at the significance and effects of the bootleg both as a concept and object, pointing to the ways in which, despite NAFTA's provisions, street markets and bootlegs remained essential for the subcultures and artists that make up my case studies.

As NAFTA targeted bootleg markets in which music circulated between Mexico and the United States, the Latino Boom exploded in the United States. The popularity of this "boom" hinged on the notion that

"Latino sounds" had finally entered the mainstream, with record companies seemingly invested in supporting a newly empowered Latino market. Unlike previous historical moments, which stressed assimilation as the goal of Latina/o immigrants, here the focus was on the Latina/o subject's ability to be legible consumers of an emergent market targeted at them. Music played an essential part in this shift, most notably in the aftermath of the murder of popular Tejano singer Selena Quintanilla-Pérez (known simply as Selena) in March 1995. *People* magazine subsequently devoted a cover story to the singer, targeting her grieving audience across the Southwest. That issue quickly became one of the best-selling in the magazine's history, and as a result, the publishers recognized the existence of a large, previously untapped Latina/o market. Soon after, *People en Español* began its run, which I see as emblematic of the rise of a new Latina/o media landscape that included new corporate investments in cable networks, music labels, literary imprints, and other cultural commodities geared toward this freshly desirable Latina/o market. Deborah Paredez has pointed to the importance of this moment, which she refers as "Selenidad," as it "provided a pivotal arena for the growing number of U.S. Latina/os to define and assert themselves, for corporate enterprises to develop a Latino marketing demographic, and for mainstream communities to police America's borders during a time of increased nativist sentiments and legislation that marked the 1990s."[56] As Selena's posthumous rise to prominence shows, this emergent Latina/o market was especially attentive to the question of musical distribution.[57]

The Latino Boom was defined by a thirst for "authentic" sounds, and artists like Ricky Martin, Shakira, and others entered the American mainstream, accompanied by the notion that such popular embrace was proof that Latina/os were finally being accepted as part of America's sonic tapestry and, more importantly, as a population whose willingness to contribute their sonic heritage had earned them the right to belong, at least in neoliberal terms. But the acceptance of these sounds, and Latinidad alongside them, hinged on a perception of their authenticity and was thus a prime example of America's rich capacity to welcome new traditions, or as it is often expressed in terms of Latina/os, "flavors."[58]

However, even as this sonic Boom and its attendant marketing strategies seemed to offer Latina/o subjects a new pathway to belonging, there

were various dynamics and contradictions inherent to the construction of this market. As Arlene Dávila notes, "the production of Latinos as easily digestible and marketable within the larger structures of corporate America is therefore revealing of the global bases of contemporary processes of identity formation and of how notions of place, nation, and race that are at play in the United States and in Latin America come to bear on these representations."[59] She explains how this process of defining identity through consumer categories "responds more to mainstream society's management of ethnic others than to any intrinsic cultural attribute of the Latino consumer."[60] Dávila is particularly attentive to the complex negotiations of the Latina/o market, arguing that "two variables seem to be constant in these processes: culture, involving the existence of particular and lingering hierarchies of race/ethnicity/language/nationality that mediate people's positions within any given society; and consumption, insofar as—whether as exiles, citizens, permanent residents, or immigrants—individuals are consumers first and foremost."[61] Particularly important to this book's argument, she reveals that the study of "the production of commercial mass-mediated culture can therefore help us uncover some of the ways in which notions of belonging and citizenship as well as the hierarchies of culture, race, and the nation in which they are based, are produced and negotiated in the demanding new context of nationalism and displacement."[62] I expand upon Dávila's claims in chapters 3 and 4 by showing how this economic relation is embedded within claims of authenticity that make Latina/os legible to the rest of the mainstream.

Unbelonging challenges the channels of capital that NAFTA and the Latino Boom make visible by listening to the sonic edges that Mexican and Latina/o listeners who had been left out of the promises of economic progress favored against the demand to be legible, authentic, and officially sanctioned. And notwithstanding the fact that we can trace the relation between dissonant sounds and national/ethnic illegibility back to at least the 1940s, NAFTA and the Latino Boom, and their quest for authenticity, defined the most significant cultural and economic shifts in the time period that I cover here. Throughout the case studies that follow, cultural and consumer goods show up in unsanctioned forms, as they often do in the Global South. Dissonant sound had to navigate underground, against the mainstream flows of capital. There was no

marketing apparatus that dictated what bands or sounds subjects at the margins listened to. For example, the practitioners of metal and punk in Mexico City I explore in chapter 2 did so underground, and documentation of these scenes is scant. But the culture of piracy that sustained this underground was found not just in recordings, but also on T-shirts, lighters, and other unofficial objects that are hardly exceptional to any marketplace outside of the West. Indeed, although the political and cultural discourse of the West continuously demands authenticity from the Global South, those who inhabit the latter have often had to rely on inauthentic and bootleg objects in their quest to be included in a "global" culture. I want to suggest that the alternative consumption practices of the Global South reveal the bourgeois values hidden in critiques that non-Western sonic subcultures are simply being tricked by the marketing apparatuses of transnational record companies. Street markets that cater to local audiences instead of tourists searching for "authentic" cultural products are still filled with pirated and bootleg reproductions of consumer objects—from DVDs and CDs to designer brands and children's toys. And yet even as Western critics and consumers demand authenticity from their experience of the Global South, inauthenticity is a permanent condition that enables the survival of the economically dispossessed.

As Ana María Ochoa Gautier demonstrates in her study of the global place of local music cultures in Latin America, piracy accounts for one of the largest markets in global circulation. This dynamic, according to Ochoa Gautier, should not be viewed simply as the battle of *bad* multinational recording companies vs. *good* pirates, since, as she points out, independent and local record companies are usually the victims of this struggle. Instead, the fight between official products and their pirated doubles should be understood as a complex dynamic that also functions to extend the reach of multinational capital's claim of legality. And yet the pervasiveness of piracy continues to expand, especially with the rise of "illegal" file-sharing networks on the internet. Ochoa Gautier refers to numbers provided by the International Federation of the Phonographic Industry (IFPI) in 2001—a period close to the objects in this book— which reveal that at the time, piracy accounted for 40 percent of the total CDs and cassettes that circulated worldwide.[63] Piracy thus is not only an element of the global recording industry, but its veritable

B-side, a form of circulation that is as essential to the dissemination of sound that is adapted and appropriated by subjects who turn to piracy against the legal dictums that seek to control it. The sonic landscapes throughout this book rejected official forms of exchange for a variety of reasons, but the primary one was the inaccessibility of "official," sanctioned recordings.

Beyond the specter of transnational record companies and the commodified distribution of music, the subjects in the following chapters have often been accused of giving in to racial and cultural inauthenticity. After all, cultural betrayal can be recognized only when the subject is cast as an inauthentic Mexican or Latina/o—as often happened when these subcultures adopted dissonant sounds. Inauthenticity, then, appears in this book as both an accusation and, in the yielding to this accusation, as a rejection of the capitalist logic of authenticity. In the case of Latina/o Morrissey fans, the cultural fascination on the part of American and British media continuously assumes that these fans are not the authentic listeners of Morrissey, and in fact, there is often a sense of relief in the media's description of Mexrrissey—the Mexican supergroup that covers Smiths and Morrissey songs with a "Latin" flair (and in Spanish no less)—as the proper avenue to understand the link between Latina/os and Morrissey. These themes permeate the book's first chapter, in which I read the ice records of Mexican Cuban artist Iván Abreu as self-destructing bootlegs and as part of Mexican sound art's desire to reject what were seen as authentic expressions of Mexican aesthetic genealogies in contemporary art.

Minoritarian subjects are especially expected to perform authenticity, but as *Unbelonging* shows, the repeated demand for the authentic remains tied to the logic of a market and nation-state that dictates its parameters. In an age where cultural appropriation is consistently decried, authenticity often hovers above non-white and non-Western subjects like the sword of Damocles. For example, Latina/o culture in the United States has often been tied to authenticity—from the presumption that Latina/os who don't speak Spanish are less authentic than Spanish-speaking ones to accusations that non–Spanish speakers' claim to Latinidad is always less than those who remain or are "true" Mexicans, Guatemalans, Venezuelans, Dominicans, etc. Even many dishes we would now recognize as "authentic" Mexican food have often been

deemed inauthentic at one point or another. Authenticity, after all, is more often a compliment than it is a threat. To claim something as *inauthentic* is to immediately challenge its cultural legitimacy.

Unbelonging not only risks inauthenticity, it welcomes it. The subjects, artists, and subcultures in each of the chapters below reject any notion of the authentic in their choice of records, in their behavior, and even in their proficiency with instruments or as listeners. I theorize alongside their rejection, understanding instead that authenticity is often a demand that always keeps its resolution at bay. For those of us listening, this does not simply mean turning away from global capital's ability to appropriate customs, sounds, and objects for middle-class consumption, but rather retuning our understanding of the notion as always already deployed by the logics of capital. To reject authenticity is—like rejecting citizenship—to negate the value of a concept used to entrap subjects into the stable identities required to make consumption legible. After all, who gains from the imagined need for "authentic" Mexican goods more than the middle-class American consumers who are in turn able to show off their ability to recognize and show them as such? On the other hand, subjects in the Global South who continuously purchase or make use of unsanctioned, pirated, or bootlegged objects are imagined by the logic of consumerism as fooled by the ever haunting specter of commodity fetishism, unable to turn successfully away from the lures of capital. But the originality or authenticity—the "aura" perhaps—of the commodity that speaks is itself a fiction of a Western project that violently managed to colonize and subject much of the world by appealing to this very logic, to the authenticity of its values and epistemologies, while dismissing the rest of the globe as an inauthentic place that would one day arrive at Enlightenment or Modernity by following Western teleological narratives of progress. Indeed, few concepts throw the Western intellectual into such a panic as the charge of inauthenticity, of being fooled by a fake copy, a pirated brand, a cheaply reproduced idea. *Unbelonging* proposes that this battle for authenticity has been continuously fought in the arena of sound.

Although my case studies are located in Mexico and the United States to argue that the relation between inauthenticity and sound was productively deployed against the state and neoliberal capital at a particular historico-political moment, this sonic battle can be found across the Americas at various points throughout the twentieth century. For exam-

ple, during the 1960s and 1970s, Trova became globally recognized as *the* sonic form of the Latin American revolutionary left precisely because of its use of "Latin American" and "Indigenous" instruments and sounds, such as the jarana and marimba. But as many scholars have pointed out, Trova was ultimately the preferred sound of middle-class youth who were attempting to define their political oppositionality by appealing to their proximity to sonic authenticity, while on the other hand, working-class youth in poorer neighborhoods preferred—and often innovated—the rock sounds of electric guitars. Similarly, rock music and its many genres were decried as foreign—as a turn away from Mexican authenticity—even though these accusations worked to produce cultural objects that staged this generational rift (such as the Mexican *rocanrolero* films of the 1960s) in part because the cultural fascination this music produced ended up inevitably shifting the larger culture. It wasn't until the 1990s, when *rock en español* came into the mainstream, that rock music was finally accepted in Mexico, as a cultural peace accord was reached largely due to the genre's integration of "local" instruments, sounds, language, and themes. In each of these cases, those who refused the logic of hybridity were cast from official histories—inauthentic footnotes in the sonic archive of Latinidad.

Bootlegs, Informal Economies, and the Concept of Illegality

The artists across this book exemplify what, borrowing the term from Lucas Hilderbrand, I call bootleg aesthetics. Before turning in depth to these artists' work, I want to discuss bootlegs, piracy, and the notion of illegality that structures our understanding of them. As mentioned above, one of NAFTA's goals was to stop the distribution of pirated, bootlegged, and other items subject to intellectual property laws by extending the prosecutorial power of multinational corporations. In her analysis of El Hueco (The Hole), Peru's infamous market of pirated goods, Kirstie Dorr suggests that piracy functions as an important counterarchive that preserves some of the most salient but sometimes unrecognized sonic traditions of Latin America (and beyond). For Dorr, the extralegal function of piracy and its markets shows the ways in which Latin American soundscapes exceed the discourses that imagine the Global South as a pawn of corporate capital. As she astutely observes, newer modes of cultural distribution—specifically the internet—reveal

that piracy is a space not only for market transactions or singular goods, but also potentially an aesthetics of reclamation for inhabitants of the so-called Third World.[64] I expand upon Dorr's argument to assert that the bootleg and the pirated copy not only exceed the markets through which they circulate, but also can furnish a framework to understand the extralegal, underground, and unsanctioned modes of life that I have discussed throughout this chapter. In other words, I extend the bootleg as a potential theory to encompass ways of life that continuously risk the punitive force of the law to ensure survival.

I also follow Itty Abraham and Willem van Schendel's argument in *Illicit Flows and Criminal Things* that "there is a qualitative difference of scale and intent between the activities of internationally organized criminal gangs or networks and the scores of micro-practices that, while often illegal in a formal sense, are not driven by a structural logic of organization and unified purpose."[65] They suggest that "adopting analytic perspectives that privilege the participants in international illicit activities leads us to very different accounts and understandings of the causes, meanings, and processes involved in the criminal life of things."[66] I see the bootleg as a micro-practice that subjects in the Global South deploy to access goods that are at a remove from the officially sanctioned modes of distribution of transnational record companies and other industries.

The bootleg, both as an object and as a practice, has been undertheorized in the humanities. Most of the research on bootlegs has belonged to media studies and adjacent fields, where they have been examined in relation to transnational markets, piracy, and copyright laws.[67] However, the fact that a significant number of these studies have centered on markets outside of the West—in places like Asia and Africa—shows that piracy thrives in spaces where bootlegs are framed as colluding in resistance to the legal reach of Western copyright laws. As Shujen Wang explains in *Framing Piracy*, "What ensures the proper functioning of the global information economy [. . .] is copyright protection, which often takes the form of transnational as well as national copyright legislature, agreements, and enforcement. Herein lies the essential role the state plays in global copyright regulation and management, as piracy not only challenges conventional centers of power (e.g., 'legitimate' transnational media rights holders, international intellectual property rights regimes), it also tests a state's internal regulatory and enforcement capacity as well

as external negotiation and trade leverage."[68] In the case of Mexico, the massive number of bootlegs made the country complicit in illicit trade, a major concern that NAFTA attempted to address.

Bootlegs have been largely left out of discussions in the humanities partly because there is an implicit belief that the objects the field engages with are original and, to some extent, officially sanctioned. Even when fakes, bootlegs, and pirated reproduction are approached in fields such as art history, the presumed logic of copyright law remains undisturbed because of the assumption that the distance between the original and its bastardized copies will remain apparent to the authoritative scholar and consumer. This dynamic is especially pronounced in the relation between pirated objects and the archive. After all, the very authority of an archive is upheld by the ability of the archivist and the scholar to recognize authentic artifacts and documents versus objects that attempt to smuggle themselves into history, corrupting the certainty of the past. Even as a tide of scholarship since at least the publication of Derrida's *Archive Fever* has questioned the epistemological grounds of the archive, the certainty of its materials and materiality persists.[69] In other words, we may question the legitimacy of the narratives that the archive might offer, but the originality and integrity of the objects housed within it still upholds the value of authenticity. And yet for many of us who work on the feminist, queer, or otherwise subaltern past, it is through the unfaithful reproduction of a video, a photograph, or even the retelling of an experience where we may first gain access to our objects of study.

My turn toward the bootleg as a queer practice looks precisely to its ability to undermine the logics of normative reconstructions of historical certainty in favor of affective relations as epistemological forms that remain outside the realm of official archival narratives. I draw particularly from Lucas Hilderbrand's essential book *Inherent Vice: Bootleg Histories of Videotape and Copyright*, where he conceives of video bootlegs as "a set of practices and textual relationships that open up alternative conceptions of access, aesthetics, and affect."[70] Hilderbrand also ties the notion of desire to that of access—specifically, a desire to have access to objects and histories, and thus the desire to be a part of objects and histories that might remain otherwise foreclosed. I follow his definition of bootlegging as noncommercial practices that function to "fill in the gaps of market failure (when something has not been commercially dis-

tributed), archival omissions (when something has not been preserved for historical study), and personal collections (when something has not been accumulated or cannot be afforded)."[71] This approach is especially relevant when considering my own objects of study. Anyone who has traveled through Mexico has invariably encountered markets where bootleg copies, from films and music recordings to other goods such as designer clothing and toys, abound.

I follow Hilderbrand's definition of the bootleg and his aim "to reclaim its productively illicit meanings, its intoxicating pleasures, and its amorous relationships between texts and audiences."[72] Indeed, how else could we read the relation between bootlegs and their consumers than as one steeped in queer modes of attachment to subjects and objects? And yet, taking the bootleg as the structuring force of such attachments and relations allows us to expand how we think about access, fidelity, and the truths of archives themselves.

It is also worth reiterating that the bootleg is particularly valuable in spaces within the Global South, where access to technologies and archives may prove challenging. As Laura U. Marks writes, "Images have a life cycle that is material, social, and imaginative. Images' materiality constitutes an everyday problem in poorly infrastructured countries, even if these issues are not exclusive to them."[73] She continues, "Analog demagnetization and lossy digital compression; glitch, error, and artifacts introduced by compression; and layers of formatting draw attention to the trajectories and life cycles of images."[74] Yet, as she points out, these challenges can prove aesthetically useful to artists and audiences working within these contexts. She explains that, "like others in places where official image archives are difficult to access, artists value glitch, error, and loss of resolution not only for their own aesthetic interest but also as indications of the labor of love required to access the past."[75] The bootleg, as Marks argues in her essay, has been essential not only in the circulation of objects, but also in the possibilities opened by turning to the bootleg as a formal element itself. She explains that "it enables more people to participate in image circulation"—in this case not only the artists but also the audiences who find their own entries to histories of contemporary art and punk.[76]

To consider the bootleg, we must also delve into the sites where these pirated copies thrive. Alternative sites of distribution, like El Mercado

del Chopo, have been crucial to the development of informal economies in Latin America. Informal economies are the lifeblood of survival in urban and rural spaces, yet attempts to gain an exact measure of their prevalence tend to fail. In some ways, the circulation of bootlegs across formal and informal borders resembles the concept of the *fayuca*. As Melissa Gauthier explains, "the local expression *fayuca hormiga*, which means 'ant trade' [. . .] nicely captures the complexity of these trans-national networks of 'ant traders,' who respond to the local-market demand for used clothing from the United States, and it conveys the determination and persistence that they must demonstrate on a daily basis to subvert the official rules."[77] According to Gauthier, when attempting to grasp these networks of distribution, "the agency of these economic actors [. . .] arises from the economic culture of the [. . .] region, and how ant traders bypass the multiple activities of governments."[78] In the case of the bootlegs that move across the markets of Mexico City—which include cassettes, CDs, "patches, stickers, fanzines, silk-screened shirts, jackets, and so forth"[79]—we can see that local cultures have a complex grasp of these forms of distribution, which are, in fact, central to the thriving life of these subcultures. Taking the *fayuca* as a common practice of circulation disavowed by the Mexican state allows us to understand how alternative modes of circulation—those outside of the official scope of capital—are a key part of the story of Mexican modernity told from the periphery as opposed to the official narratives of the government and its laws.

As Daniel Goldstein explains in *Owners of the Sidewalk*, "amid mounting poverty and diminishing alternatives, 'informal' commerce proliferates worldwide, in many countries becoming the largest economic sector, employing the majority of the nation's workers."[80] Still, exact statistics that take stock of just how many people survive via alternative economies remain slippery. Goldstein continues: "in an economy in which everything is illegal, disreputable, or simply unfathomable, firm numbers are hard to come by. [. . .] Informality, by definition, eludes measurement."[81] But the prevalence of the informal economy does not mean that street vendors can roam the streets and sell their wares freely. The police and other authorities, such as politicians, of course know that these markets and vendors exist, and they possess the power to arrest, seize, or shut them down at any given moment; but their sheer scale

means that the state must make an uneasy pact with its citizens, know-ing full well that the complete eradication of these markets might plunge the country into social and economic chaos. There are also pacts and socialities that emerge *between* street vendors. For example, it is com-mon to see vendors in the streets of Mexico City communicate with each other to signal when the police are approaching. Someone will whistle or yell a code, at which point other sellers will cover their products with blankets, hiding their objects from the police's gaze.

As Goldstein explicates, informality extends beyond the realm of products. For example, "many neighborhoods dismissed as 'illegal' slums in fact consist of a heterogenous mix of homes, purchased, built, and regularized in a variety of different ways on land that is both legally and illegally occupied,"[82] and someone may move through the day from a formal job to an informal one; "drawing a line around the formal and the informal, the legal and the illegal, as though they constituted distinct and bounded sectors is thus deeply problematic."[83] The case studies ana-lyzed in this book similarly blur the lines between the official and the unofficial, the legal and the illegal, the authentic and the inauthentic. My own investment remains on the side of the other. As Goldstein main-tains, practices of street vending work to reveal the state's exercise of power: "in practice the state itself often operates informally, its enforce-ment of its own rules selective and its functioning organized by unoffi-cial and sometimes illegal relations and procedures. As any comerciante can attest, formality is no guarantee of legality, just as the informal does not necessarily equate with the illegal."[84] This relationship explains why informal economies are allowed to thrive at one moment while being severely disciplined at another.

According to Sandra C. Mendiola García, street vending and other informal economies grew exponentially in Mexico following the decline of the "Mexican Miracle," the period of economic growth the country experienced from the 1940s to the 1970s. Mendiola García's history re-veals important points of connection between street vendors and the student movements across the country. This political alliance resulted in the possibility of vendors forming unions and other organizations that would give them a voice before the state. But, as Mendiola García writes, "The state presented itself as a defender of urban order and capitalist modernization and violently punished those who, like street vendors,

appeared to disrupt it. [. . .] [L]ocal and state authorities regulated what they considered the appropriate use of public space and, with the neoliberal turn, fully privileged the projects of the upper and middle classes over those of the urban poor and the working class."[85] Markets, streets, and other sites in which the informal economy thrive are, of course, not immune to their own power struggles and complex political arrangements, but the state still holds the power to lend them legitimacy, which made the punk and metal scenes stand in constant distinction to such exercise of power.

NAFTA made the street vendor and the bootleg unruly enemies of neoliberal market reforms. As the artists in this book began producing work in the early 1990s, they were drawing from a decade's worth of state repression that had made the circulation of certain music illegal. *Alma Punk* in chapter 2, for example, shows how the counterlogics of the bootleg, piracy, and illegality offered a vocabulary of negation and resistance to those who had been marked by the state as outsiders. One of the most important elements in the work of the artists analyzed across the following chapters is that they refused to participate in any sort of political venture that would amplify the state's power.

A Map to *Unbelonging*

I arrange the unbelonging subjects and inauthentic objects of *Unbelonging* across four chapters, each focused on an act of turning away or refusing a particular political, cultural, or economic development. The first two chapters are set in Mexico during a period ranging from about 1989 to 2015; they investigate the influence dissonant sounds had on the contemporary art scene, focusing specifically on sound art and punk and metal. In the first chapter, I look at the work of the Cuban-Mexican artist Iván Abreu to situate sound art as one of the most important categories of distribution and aesthetic inquiry. I show that sound art in its many forms became prevalent in Mexican contemporary art over the past few decades because it freed artists from having to continuously engage with the historical relationship between artistic practice and the political stakes of Mexicanidad. I delve into one of Abreu's most important and striking works, *M(R.P.M.)*, in which nationalist recordings are reproduced through the medium of ice. I follow the strange

history of ice and transnational commerce in the Americas to suggest that, through the "ice vinyl," Abreu performs a trenchant critique of revolution and its historical proximity to teleology. I insist that sound art's ability to experiment with form and objects provides a refusal of the logics of the market. The second chapter traces the impact of metal and punk subcultures in the economically dispossessed edges of Mexico City and in particular their adoption by female listeners, who took to these sounds to defy conventional expectations. I show that as these sonic subcultures were criminalized, their appropriation of space was essential in the development of a new contemporary art scene where feminist artists thrived. This chapter examines the early work of the artist collective SEMEFO, particularly their use of metal in crafting radical feminist performance. I then look at the video work of Sarah Minter and her 1989 feature-length video *Alma Punk* to argue that, against the lack of archival resources, emergent aesthetic forms were responsible for capturing the legacy of scenes where young women made use of aggression to articulate feminist dissatisfaction. I map how their refusal crafts a new vocabulary that reframes not only prevalent histories of Mexican contemporary art, but also the ways in which they played the minor chords of economic dispossession to reject the political promises of NAFTA.

The final two chapters cross the border into the United States, where I follow the Chicana lesbian punk and the Latina/o Morrissey fan during the years of the Latino Boom. First, I examine the cultural fascination with the figure of the Chicana punk, and in particular the Chicana lesbian punk, across a variety of media to show how this figure provides a sonic alternative that allows Chicanas to experience desire and pleasure against the demands of culturally dictated familial duties. I look at the short life of the "mariachi punk band" Las Cucas, led by performance artist Nao Bustamante, to find how their performance of lesbian desire exemplifies the Chicana punk's ability to turn away from motherhood as the defining feature of Chicana female existence. I propose that the Chicana punk's refusal to be imagined as a caretaker opens new avenues for exploring and experiencing an abject yet pleasurable form of Chicana subjectivity. Finally, I delve into the fervent Latina/o fanbase that has sprouted around the British artist Morrissey since the 1990s. I move away from the sociocultural explanations of this fandom and attempt to make sense of it by finding legible points of proximity be-

tween Morrissey's sound and Latina/o culture. I argue that listening to Morrissey (as well as other British artists like The Cure, Depeche Mode, and Siouxsie and the Banshees, to name a few) gives Latina/o listeners the opportunity to create new social relations rooted in depression and a sense of cultural and economic dispossession. I conclude the chapter with a detailed look at the drawings of the Chicana-Japanese Shizu Saldamando and her rendering of these Latina/o Morrissey listeners through the scene of friendship, an ethics of relationality that refuses to be grounded in the celebratory vocabulary of Latinidad and ethnic belonging. The reject in this chapter thus listens to Morrissey (and other '80s British artists) to negate the demands of ethnic legibility at a time when mainstream politics sought inclusion through the sonic consumption of legible Latina/o sounds.

Unbelonging, unruly Mexicanidad, queer Latinidades, the minor stakes of politics, contemporary art, and their envelopment within practices of sonic negation come together to build a narrative arc that begins as a self-annihilative turn away from history and builds toward a refusal of the politics of identity and toward an ethics of friendship. Indeed, as will hopefully become apparent, turning away, rejecting, and becoming an unbelonging subject are far from being simple nihilistic acts in the service of preserving a self detached from the social. In his final writings, José Esteban Muñoz was attempting to develop a notion of the "brown commons." For Muñoz, this Brown commons could potentially be defined, and perhaps populated, by those with a shared sense of precarities and vulnerabilities. In his essay on the sonic afterlives of punk musician Darby Crash, Muñoz defined his potentially utopic commons as "held together by nothing more than a safety pin."[86] *Unbelonging* proposes that holding this commons together is ultimately a communal act, and each of my case studies dwells within the uneasiness of the commons while landing on the potential of alternative and yet-to-be-explored solidarities. What emerges throughout is an attempt, fragile by nature, to seek alternatives to the siren call of belonging by relying together on an/other who could listen past the fog of history and politics to hear others who felt *like* them, like us. I hope that in the following pages, in the memory of a song, or in the discovery of an artist, you the reader might glean moments of recognition, and share, even if only in the space of a track, the pleasurable rewards of unbelonging.

Figure 1.1. Still from Iván Abreu, *M(R.P.M.) Música y Voz de la Patria, Himno Nacional,* 2007. Screenshot by author.

1

Melting Modernities

Sound, Ice, and the Refusal of History

Iván Abreu's performance *Música y Voz de la Patria, Himno Nacional*—part of his sound series *M(R.P.M.)*—begins as the artist removes a thick, LP-shaped disc from a silicone mold and places it on a turntable. We hear trumpets play "Marcha de Honor," the tune that accompanies the Mexican flag when it enters a ceremonial space. But the sound is harsh and distorted, because the record is actually made not of vinyl, but of ice. Clouding the sounds of the trumpets and drums are violent scratches from the original recording, made rougher still by the instability of the frozen substance that now carries this musical information. The record spins until Abreu intervenes, stopping the record and shaking the table violently until the ice breaks. When only half the record remains, the turntable resumes its rotation, picking up intensely cacophonic scratches. At this point, even the faintest traces of music from the original recording are gone. Again, the artist's hands interfere, fracturing the record further before allowing it to spin once more. The sound is now nothing but the needle violently scratching against ice, past any vestiges of its previous sonic legibility. Abreu's hand stops the turntable once more, bringing the performance to an abrupt halt.

Abreu performed this iteration of *M(R.P.M.)* as part of the 2007 Muestra de Arte Sonoro at the Ex Teresa Arte Actual, one of the most important sites for performance in Mexico City. A former convent, the space has, for the past few decades, hosted artists and festivals devoted to expanding the frame of contemporary art in the city. Although just a few minutes long, Abreu's performance of *Música y Voz de la Patria, Himno Nacional* leads the audience into a sonic field replete with multiple histories—both recent and from long ago—that have helped define Mexico and even the rest of Latin America. There is no "meaning" to Abreu's actions per se—according to the artist his interest lies in the

Figures 1.2 and 1.3. Stills from Iván Abreu, *M(R.P.M.) Música y Voz de la Patria, Himno Nacional*, 2007. Screenshots by author.

process itself rather than its interpretation—instead we experience a series of critical associations brought about by the original record and what I hear as a now-illegal copy in its bootlegged, frozen form. With each revolution, the ice vinyl becomes increasingly unstable, and the effects of these turns extend beyond the production of sound: the turntable itself will bear the damage of an object that was never meant to be on it; the needle will become deformed beyond repair. As ice becomes droplets of water, multiple temporalities echo through the violence of the sounds produced. The title of the series, *M(R.P.M.)* (*Masa en Función de las Revoluciones por Minúto*, or mass as a function of revolutions per minute), resonates with Latin American history over the previous two centuries, alluding as it does to the promise of popular revolution, which has so often dictated the dreams, politics, and fears of the region. But *M(R.P.M.)* also nods toward other, less-remembered histories in the Latin American imaginary, which inform and trouble the project of revolution. Specifically, the piece points to the nineteenth and early twentieth centuries—times when both ice and sound reproduction became technologies of trade across Latin America—and thus evokes the complex and difficult relationship Latin America has shared with modernization itself. These histories, however, are indefinite, wriggling out of the narrative arc of History, refusing it. This is partly because each revolution only hints at multiple points of encounter, refusing to stop at any of them. Abreu's piece most immediately evokes 1968—the year that the original vinyl record was pressed, in anticipation of that year's Summer Olympics in Mexico City, amid a tumultuous political revolution that the government crushed into silence. One is also shaken by sound's relationship to the nation, with remembered childhood songs acting as the soundtrack of citizenship. This chapter asks how we might think through *M(R.P.M.)* beyond the bounds of the present, as a piece that invites its audience to engage with a larger focus on time, duration, and the conditions of history. I analyze the potent ways in which Abreu's piece unites the material properties of sound media and ice to thrust us into a critical journey that, while centered in Mexico, travels into points of encounter around Latin America. This approach marks for me a critical methodology to encounter Latin American history and politics by seeking to dislodge the nation as the privileged site of revolutionary thought.

Figure 1.4. Still from Iván Abreu, *M(R.P.M.) Música y Voz de la Patria, Himno Nacional*, 2007. Screenshot by author.

Iván Abreu is a particularly useful artist to help situate such a critique. Born in Havana, Cuba, in 1967, Abreu moved to Mexico in the 1990s to earn his master's degree in information technology engineering at Anáhuac University. This training has made him one of the most technologically adept artists working in Mexico's thriving contemporary art scene. While not all of his work employs sound, Abreu has been invested in using information technologies as the basis for his aesthetic projects. For example, in *Similitude (National Anthems MX-US)* (2011), Abreu uses music analysis software to process the national anthems of the two nations simultaneously, displaying a stream of horizontal rows of various shades of gray. The resulting image becomes a visual representation of the political and economic dissonances between Mexico and the United States. Like other sound artists of his generation, Abreu has claimed that his art is not intended to be explicitly political, but as I will show in my exploration of *M(R.P.M.)*, by not claiming a direct lineage with protest art, his work allows us to use sound to examine the minor grooves of Mexican and Latin American modernity. Abreu's positioning as a Cuban-born Mexican artist allows us to dislodge the

linkages between citizen, nation, and history. This chapter argues that contemporary Mexican sound art—as exemplified in the work of Abreu—refuses to see the nation as constructed through historical narratives of progress. As such, M(R.P.M.) allows viewers to let go of the historical narratives that are central to a shared national consciousness, which can often hide the more troubling implications of what it means to belong to a nation, obscuring the ways in which this sense of belonging becomes attached to a misremembered past. I also want to suggest that by letting go of these historical narratives we may also let go of the normative imaginings of such teleological demands. I challenge here the notion at the heart of Latin America and its histories: that the revolutionary impulse of liberation will eventually lead to an independent, modernized nation.

By letting go of narratives of history, however, I do not wish to argue for a presentist account of the past; instead, I follow Nancy Raquel Mirabal and her call to be attentive to "the precariousness and ephemerality of a history that doesn't always fit traditional historical narratives."[1] This chapter uses Abreu's ice record as a launching pad to understand how alternative, sensorial ways of knowing—in this case through Mexican sound art's desire to let go of the past—might lead us to paths beyond the demands of traditional historical narratives. I read the destruction of the piece in potential relationship to Amber Musser's analysis of melting in Kara Walker's installation A Subtlety. Writing about its series of statues of young boys made out of molasses, Musser suggests that "they also resist commodification through the act of melting. Melting not only signals these objects' ephemerality—even as many circulate after the installation preserved as museum objects—but also illuminates the power of becoming-molecular."[2] In going through this transformation, "their molecularization means that they permeate the viewer intensely and perhaps more intimately."[3] I argue in this chapter that the sonic reverberations of the piece gives viewers the possibility to intimately touch histories of capital and consumption often left out of memory. But as Musser maintains, "melting also functions as a manifestation of liquidity, which offers an escape from the totalizing grasp of consumption."[4] As such, the chapter engages a multiplicity of narratives that I suggest M(R.P.M.), and Mexican sound art more generally, give us the space to encounter—from the visual discourses of the Mexican

nation to the ice trade in nineteenth-century Latin America. The revolution of the ice record allows me to encircle these histories, embracing the record's spins as a methodological guide.

Sound Art in Mexico

Abreu's work in *M(R.P.M.)* is indicative of the how artists in Mexico have turned to the sonic to find critical vocabularies beyond the aesthetic legacies that tied visual representation to Mexico throughout the twentieth century—what historian John Mraz has called "the ocular strategies for representing Mexico."[5] And where the state was most able to turn in order to craft this narrative were the visual domains of art and design. This was part of a longer history that had, since the beginning of the twentieth century, tied representations of Mexico to the emergence of new visual technologies; echoing this, Mraz has argued that "identity construction in Mexico has been carried through the modern visual cultures of photography, cinema, and picture histories."[6] Drawing on a vast visual archive, Mraz shows how during and after the Mexican Revolution, the primary way that *Mexicanismo* or *lo Mexicano* was expressed was through visual economies that were the result of multifarious networks of exchange, which were centrally situated by the arrival of modern visual culture in Mexico during the US invasion and occupation in 1846. "The Mexican War," writes Mraz, "was the first conflict in the world to be documented in both lithographs and photographs."[7] The scopic regime inaugurated during this time extended well into the early twentieth century, with well-off families becoming immortalized in daguerreotypes, "cartas de visita" offering an early stereotype of Mexican culture, and eventually, the Mexican Revolution, where the contemporary iconography of the nation would begin to be cemented. Mraz writes, "as the struggle developed, photographers and filmmakers poured into Mexico to document the world's first great social conflagration, taking advantage of the relatively free access to the action, especially when compared to the strict censorship exercised during World War I."[8] Particularly fascinating is how the heroes of the Mexican Revolution were constructed, as in the case of Pancho Villa, who "signed a contract with the Mutual Film Corporation in 1914 for $25,000, giving the company exclusive rights to film his battles and executions, which

he was obligated to carry out in daylight or to recreate if they could not be recorded; he was to wear the uniform created by the company (although he was only permitted to use it when filming)."[9] This small detail reminds us of the complex visual negotiations at the core of the creation of a modern political Mexican state in which, from its beginnings, the country's historical narrative was constructed via its images.

After the Mexican Revolution, the visual remained a privileged site of national representation, as a group of muralists and painters that emerged in the postrevolutionary era—including Diego Rivera, Rufino Tamayo, and later icons like Frida Kahlo—gained global prominence through a number of state-sponsored initiatives.[10] By the 1960s, it became clear that Mexico's particular historical condition could be situated and displayed aesthetically, and it was through paintings, murals, and other visual representations where the country's image as a place where different civilizations and cultures meet began to develop. This tendency would be repeated in the years leading up to the transformation of the contemporary art scene, as *Neomexicanismo*—the Mexican painting movement that dominated the 1980s—attempted to narrate images of contemporary Mexico in relation to a precolonial past.

As mentioned, the 1990s witnessed a generation of young artists who turned to new aesthetic forms—including video, performance, installation, and more—to move away from the primacy that painting and design had occupied throughout most of the century. And although these newer genres had been gestating in the Mexican art scene during the previous decades—as evidenced by the careers of individual artists and collectives such as Grupo Proceso Pentágono, No-Grupo, and Polvo de Gallina Negra—until a spate of fairly recent retrospectives, these artists had remained mostly invisible to the official institutions and artists that dominated the local and global circulation of Mexican art. In other words, even if a revisionist glance shows us the vast influence these artists had upon a later scene, it was not until the 1990s that we witnessed a significant rearrangement of institutional support, in addition to recognition in global art markets.[11] Daniel Montero's recent critical reengagement with the art of this period in *El cubo de Rubik, arte mexicano en los años 90*, points explicitly to Eduardo Abaroa's 1991–93 sculptural piece, *Obelisco Roto Portátil para Mercados Ambulantes* (Portable Broken Obelisk for Ambulatory Markets) as the starting point of a new period

of artists and genres that sidestepped the institutional and aesthetic ap-
proaches favored by Neo-Mexicanism, the painting movement which,
as mentioned above, returned artists to the nation as the site of inspira-
tion and perhaps even propaganda.[12] But as exhibitions moved away
from the traditional museum and gallery settings of previous genera-
tions, the new scene began to take over, culminating in a 2002 exhibition
at MoMA PS1, *Mexico City: An Exhibition about the Exchange Rates of
Bodies and Values.*

Among the new aesthetic forms that Mexican artists turned to in this
new landscape, few became as pervasive and powerful as sound, espe-
cially when officially recognized as *arte sonoro*, or sound art. Indeed,
even when considering the variety of genres that have thrived since at
least the 1980s that move away from painting, sound offers an altogether
different genealogy and perhaps even a complete refusal of earlier lega-
cies. Sound, I want to suggest, rejects the weight of history that entwined
mainstream political narratives and aesthetics. Yet the prevalence of
sound as a recurring tendency in production and exhibition of contem-
porary Mexican art has yet to be identified as such in most accounts of
the period. Or to put it more precisely—and to speculate as to reasons
why sound has remained underexamined—we must speak of sound as
a *central* element in a significant number of works. If we examine sound
as a major recurring tendency in contemporary Mexican art from the
1990s to the present, then the scope of what can be included widens
dramatically. Sound and music have become pervasive not only in pro-
duction but also in exhibition, as illustrated by a number of shows across
museums and galleries that have used the sonic as an organizing theme.
In addition, sound has been used as a curatorial impetus beyond gallery
exhibitions, as in, for example, the International Performance Festival's
theme of "El Sonido de la Última Carcajada" (The Sound of the Last
Laughter) at the Ex Teresa Arte Actual in 2013.

As a meeting point across these genealogical strands, the 1990s saw
the category of *arte sonoro* institutionalized among festivals, museum ex-
hibits, and archives across the region. Sound appears in multiple ways—
formally and thematically—often obscuring just how central it has been
to Mexican art after 1996. That year, Radio Educación launched the first
International Radio Biennial featuring artists using radio as a medium;
the following year, the exhibition *La Resurrección de San Martín* wit-

MELTING MODERNITIES | 49

nessed multiple artists exhibiting sound installations; and throughout 1998, the Museo de Arte Carrillo Gil devoted part of its space to feature work by sound artists.[13] Also in 1998, the first official sound festival, the Encuentro de Arte Sonoro in San Miguel de Allende, was organized by Manuel Rocha Iturbide and Michel Bock. By 1999, Ex Teresa Arte Actual hosted the first International Sound Festival (Festival Internacional de Arte Sonoro), "Ruido" (or Noise), for which dozens of artists from all over the world descended on Mexico City.[14] Although the festival only lasted until 2002, it served to foster a community of sound artists and electronic musicians, and helped establish Mexico City as a key location for this kind of work. In a short online piece, Rocha Iturbide, the festival's co-founder and co-curator, points out that the first exhibition featured a variety of artists who worked primarily in more traditional genres, but whose work's main engagement was with sound. In addition to Ex Teresa, other emergent institutionally supported spaces devoted to contemporary art—such as Laboratorio de Arte Alameda and the Centro de Cultura Digital—have also been especially attentive to sound and sound art. And as recently as 2013, El Museo Universitario del Chopo, one of Mexico City's most prominent contemporary art venues, presented the small yet comprehensive retrospective *Sonorama: Arte y Tecnología del Hi-Fi al MP3*, which featured the works of artists like Melquiades Herrera, Álvaro Verduzco, Guillermo Santamarina, and No-Grupo. The ongoing presence of sound art across major galleries and museums has confirmed and expanded sound's role as a central element across aesthetic experimentation in Mexico. In the next chapter I examine how the sonic appears in performance and video art, highlighting its importance. But for the remainder of this chapter, I follow sound's appearance at the interstices of sound art and the multiple genres it touches, with a focus on Iván Abreu's series of ice records.

With all this proliferation of sound art producers, festivals, and gallery exhibitions, a question arises: Why did sound art become so important for Mexican artists and curators? While this chapter is dedicated to a single piece, it seems significant to underline the relationship between art produced after 1990 and its commitment to a politics beyond nationalism. As Rocha Iturbide mentions in his curatorial statement for the third International Sound Festival, sound art, more than any other form or aesthetic development, is centrally tied to the use and dissemination

of new technologies. As curator, Rocha Iturbide insisted on including musicians who were explicitly using computers, samplers, and other technologically advanced tools.

Sound art remains fairly understudied in official discussions of Mexican art due to the fact that the term itself has been fraught within global art history, often producing more questions than answers when a work is labeled "sound art." Indeed, in Europe and the United States, where sound art has been studied and surveyed most often, the category has often been contested. Many internationally recognized artists who have worked with sound, such as Christian Marclay, Pauline Oliveros, and Alan Licht, have expressed ambivalence around being identified as "sound artists" or have rejected the label of "sound art" to classify their work, partly because the exact parameters of sound art remain opaque. Even when sound is a major element, artists and curators tend to refer first to a work as something like installation or sculpture—the two genres that tend to cross over the most with sound art. Moreover, many who could be identified as working in sound art identify themselves primarily as musicians and composers who are experimenting with form rather than as sound artists. Even locating sound across genealogies of twentieth-century art can prove difficult. Some locate early traces of something like sound art in John Cage's experimentations with musical performance in the 1950s, whereas others insist on its specific development during the 1970s.[15] The challenge for art historians, museum curators, artists, and audiences then becomes the shifting distinction between sound art and sound *in* art.

Rather than attempting to provide a definitive definition of sound art, I welcome the slippages inherent in the term to group a variety of works made in post-1990s Mexico in which the sonic appears as a central formal and thematic element. I include Manuel Rocha Iturbide, Manrico Montero, Germán Bringas, María Lipkau, Marcela Armas, and Guillermo Santamarina, among many others. Even with this expanded definition, however, sound art might still seem difficult to locate. For example, a number of works that could be classified as sound art have consistently been grouped under different genres, particularly new media art. But when we use sound art as a specific category to identify works in the canons of Mexican art history, we can grasp a genealogy that extends beyond the 1990s. The origins of sound art in Mexico

can be traced to a number of genres throughout the twentieth century. Sound poetry, radio art, and experimental and electronic music are most often acknowledged as direct precursors to *arte sonoro* in contemporary Mexican art. Rubén Gallo, for example, has uncovered how "nowhere in the world was the literary fascination with radio as deep and as fruitful as in postrevolutionary Mexico."[16] In fact, Gallo writes, "The first radio station in Mexico City was launched by a literary magazine, *El Universal Ilustrado*, a weekly publication [. . .] that routinely published the work of the most experimental writers and artists of the 1920s, from Tina Modotti to Manuel Maples Arce, from Diego Rivera to Salvador Novo."[17] If the high levels of illiteracy throughout Mexico made the visual a prime location through which to showcase the nation, writers and artists could experiment with the sonic to shape forms and ideas outside the auspices of the country's official visual narratives. In a different register, Alejandro L. Madrid has highlighted how questions about authenticity, modernity, and avant-garde cultures in postrevolutionary Mexico were negotiated around experimentation in musical composition. Madrid conveys that throughout the 1920s—ranging from the First National Congress of Music in 1926, to the premiere of the "Indianist" opera *Atzimba* in 1928—musical discourse was as much a site of contestation for national identity as other forms of expression.[18] The most notable figure from this time is the avant-garde composer Julián Carrillo, who in the 1920s constructed his own instruments in some of the earliest attempts to produce microtonal music. Rocha Iturbide, one of the key figures of *arte sonoro* (as noted above), proposes the work of composer Carlos Jiménez Mabarak and the sonic experimentations of the multidisciplinary artist Ulises Carrión as having laid the foundation for the country's contemporary scene.[19]

Another key element that might explain the popularity of *arte sonoro* in Mexico can be found in an introductory conversation dedicated to Rocha Iturbide's work, where Guillermo Santamarina approaches the artist's practice using the figure of a mosquito's buzz as a metaphor for politics—and by extension, the state of mainstream Mexican culture. For Rocha Iturbide, according to Santamarina, a focus on sound became a way to distance experimentation from the mosquito's buzz. It also opened up the genealogical lines of aesthetic work, as Santamarina describes Joseph Beuys and John Cage as the genre's most immediate

and powerful influences.[20] Santamarina's characterization of sound in Rocha Iturbide's work is particularly useful to frame the larger argument in this chapter. First, the conceptualization of politics as a mosquito's buzz highlights how sonic metaphors were useful to define a turn away from traditional or easily identifiable relationships between the aesthetic and the political. Mainstream politics are the annoying buzz that reso-nates at a distance, but they are not a defining or conscious element that can be easily identified as "political" in the works examined in my case studies. And just as importantly, the genealogical influences Santama-rina names—Beuys and Cage—liberated contemporary Mexican artists from having to engage the visual precursors that defined Mexican art in the twentieth century, such as Rivera, Siqueiros, Tamayo, and other (male) painters who became the canonical signifiers of Mexican art.

Like many nascent electronic music scenes, the origins of the sound art scene in Mexico indicate an overwhelming dominance by male art-ists, which has meant that the crossover into sound art has for the most part (although not exclusively) been led by men, traditionally seen as being more engaged with sonic experimentation and the use of new technologies. Nonetheless, several women artists have confidently ap-peared in this genealogy. Whereas the male artists that have been at the forefront of sound art in Mexico have often discussed their work as being invested in a notion of the aesthetic that goes beyond politics, female sound artists have been, perhaps necessarily, more willing to frame their work around the politics of sound and the body. One of the most important female artists working in the contemporary sound art scene in Mexico is Marcela Armas, who has been especially interested in the relationship between sound and urban space. As one of the larg-est and most congested cities in the world, Mexico City's soundscape is dominated by the noise produced by the millions of cars that circulate across its streets on a daily basis. In *Ocupación* (2007), Armas created a "portable kit" made up of seven different car horns, which she then wore on her back as she walked into the city's traffic and used her body to literally occupy the space of an automobile. Controlling the horns with a device on her arm, Armas activated them while walking within traffic "to establish communication with the rest of isolated individuals driving their cars." The piece is especially striking as we witness Armas using the sounds of her ingenious contraption to respond to, and even calm,

drivers who aggressively honk at her to get off the road. (Her walking pace, of course, could not help but slow down traffic behind her.) As her refusal to step out of the road becomes clear to the drivers behind her, a number of cars begin to respond to her sonic output with less aggression, allowing her to claim space. According to Armas's description of the piece, "the result is an unexpected situation: drivers who use the horn of their car to express their bewilderment, while others use it to participate in a dissonant but playful collective concert."[21] Although Armas does not describe this action in relationship to feminism, the self-possession with which she occupies the street cannot help but make viewers aware of the kind of risk that she is putting her body in. Through her sonic intervention, the piece serves "as a reflection about humans as carriers and noise generators, but also, about the loss of sovereignty of the human body in times of consumption society [sic] and exacerbated urban growth."[22] By placing her body against an array of automobiles—dominating space via her deployment of sound—Armas manages to insert her body and add a bodily interruption to the flow of mechanistic progress that has defined Mexico City's streets.

Armas's interest in the effects of the overbearing presence of sound produced by cars in the city has extended to other projects, such as *Circuito Interior* (2008), a piece "formed by a stainless steel track over which [. . .] moves a motor with a pair of car horns. A presence sensor activates the piece when the audience enters the space. The device is moving through the path on the perimeter of [the] space at a speed of about 15 to 20 km/hr. The place that houses the installation becomes a sort of racetrack."[23] Armas does not make use of her own body in this piece; rather, she makes the sonic contraption react to the movement of those present in the gallery. The more bodies in the space, the more aggressively the piece moves, creating a relentless flow of sounds that, although perhaps familiar on the sonically crowded streets of Mexico City, becomes almost overwhelming in the small space of the gallery. Armas explains that this piece "raises the experience of displacement exploring the sonic possibilities related to architecture, mobility, and speed. The work suggests attention to the magnitude of the urban and its relationship to human scale, from a question about the experience derived from a functional and economic logic."[24] Indeed, the piece produces a sense of disorientation that combines sound and movement, highlighting the

materiality of street sounds and their often unacknowledged invasion of human spaces and bodies.

As Amy Sara Carroll explains, "From the early 1960s onward, Mexico City's denizens weathered the frenetic space of infrastructural transformation. Newly erected freeways and overpasses carved up neighborhoods once teeming with walkers. Poorer areas of the city became difficult to access and exit. Drivers and passengers of cars, vans, and buses were caught in a traffic-jammed 'teatro pánico.'"[25] As a result of this, artists in Mexico City have been invested in questioning the increasing devastation of public space and particularly the narrative of progress that the city and nation's governments have promulgated to coerce public support for the many building projects that continue to shrink the space available for human bodies. Although Armas's practice extends beyond sound art, her work has been particularly adept at mining the relationship between bodies and the sonic forces that dominate urban spaces in loud and sometimes unacknowledged ways.

I want to suggest that sound art in Mexico allows contemporary artists to deploy an aesthetic, and thus a politics, that have otherwise been foreclosed by the scopic regime of Mexican politics and art. Artists like Abreu and Armas have successfully made use of sound by focusing on its material properties to move past narratives of modernization, such as the celebratory developmentalism of Mexico City's streets (in the case of Armas), or, as I will explore below, the modernizing discourses that continue to haunt Latin America (in the case of Abreu).

Against the Narrative of History

My interest in *arte sonoro* and Abreu's work is in their capacity to interrogate the modernization narratives that the Mexican state continuously promoted through the latter part of the twentieth century. These narratives were shaped most prominently in the late 1960s, when Mexico, as the site of the '68 Summer Olympics, sought to signal its trajectory into modern statehood as the reconciliation between precolonial, colonial, and revolutionary pasts. In other words, Mexico framed its image to the world by offering a narrative of historical teleology from pre-Hispanic indigeneity to a modern nation. Luis M. Castañeda has identified the Mexican government's investment in "a sequence of official design

projects destined to support the claim that, in the aftermath of its revolutionary wars (c. 1910–20), a socially unified and prosperous Mexico had effectively arrived to the 'developed' world."[26] Castañeda shows how the project of modernization functioned through image economies, in which the visual served to project the depiction of itself Mexico wanted to show the world—an image, as Castañeda points out, that sought to integrate a contemporary Mexico into the nationalist past it had imagined for itself even before the Mexican Revolution.

I do not mean to gloss over the complex ways these visual projects were contested throughout the century. But these images remain central to the stories Mexico tells about itself—both to its citizens and to the world. Even if not all of these artists would have aligned themselves with the official project of the nation, their legacies are still to be found everywhere in Mexico and beyond. Indeed, from the earliest images of the Mexican Revolution, to the paintings of Rivera and Kahlo, to contemporary images that are influenced by this narrative, this is how Mexico has narratively reconciled its many pasts. Ultimately, my argument about the critical openings made possible by the sonic and Abreu's piece hinges on precisely this: that if Mexico had been trying to use the visual to showcase its newfound modernity, the aural chronicles embedded within the saga of modernization I nod to in this chapter reframe sound as a potential site of anti-nationalist political discourse.

In the next chapter, I explore how the Mexican government banned rock music in the aftermath of a series of ongoing student protests, motivated by the belief that this new music threatened nationalist projects. But as I show in these chapters, sound offers an alternative sensorium from which to explore a more complex history of modernity and modernization in Mexico. Although questions of modernization and industrialization are often relegated to the period starting right before the Mexican Revolution and continuing to the present, we must attend to how much further back these histories go.

M(R.P.M.) refuses any single reading. However, its form presents questions regarding both sound and Mexican contemporary art. The piece's ephemerality grounds this chapter's attempt to let go of history, by which I mean the set of narratives—an uninterrupted and easily legible line—that grounds our sense of the past in the present. In other words, Abreu's ice record represents for me sound art's ability to interrupt the

historical accounts proffered by state power to ensure a sense of shared loyalty from its citizens, inviting us to listen instead to what Nancy Mirabal calls "those moments of rupture, chaos, and historiographic silences," which she argues "have [often] gone without study because the assumption is that 'nothing really happened.'"[27] Throughout its many iterations, M(R.P.M.) seems to be commenting on the century before, as the failed promises of twentieth-century revolutionary and Marxist thought in Latin America settled into commemoration and neoliberal geopolitics in the wake of the US-backed dictatorships that claimed much of the continent throughout the 1970s. A temporarily working ice record, of all objects, is surprisingly well suited to (en)counter history. As curator Trevor Schoonmaker points out,

> Whether one is an audiophile or not, the record has a unique capacity to both convey a sense of belonging and to transport us elsewhere. As an object it is evocatively and literally marked with meaning and remembrance, with history. When we lower a needle onto a grooved record, we inscribe the surface again and again with an aftertrace of our presence and spirit. With each listening, with each scratch, we generate a new and very specific (and deeply nostalgic) record that contains within it time and memory, transforming the mass produced object into something highly personalized that is at the same time a document of our larger social and cultural identity.[28]

Indeed, the vinyl record seems to hold particular sway in the history of sound art and contemporary art, partly due to its ability to produce sound, but also its ability to be treated as an art object in a way that many other forms of sound reproduction cannot. This intersection between record and ice leads me to investigate how sound art and performance can help us critically approach the Nation and its relationship to history's longings, which as I have shown above, have often privileged the visual as its site of authority.

I want to suggest that Abreu's ice record performs an intervention and critique of the teleology of progress that Mexico has utilized to affirm its national narratives from the 1960s onward. But the record also allows me to cast a much longer temporal glance that questions the teleological narratives that have sustained Latin America itself. As María Josefina

Saldaña-Portillo has demonstrated, revolutionary ideologies and modernizing developmental logics in Latin America may not be so opposed as they might at first appear. She writes, "it is my contention that the revolutionary movements [. . .] subscribed not only to a developmentalist model of history but—more damning to the everyday practice of radical politics—to a developmentalist model of revolutionary subjectivity, consciousness, and agency."[29] Saldaña-Portillo argues that revolutionary and developmental modes of address are "both animated by a particular theory of subjectivity. Not only do these two discursive terms depend on each other dialectically for their mutual constitution as historical alternatives (i.e., as vying ideological accounts of the first modality of developmentalism), but *both* revolutionary and development discourses also depend on colonial legacies of race and gender in their theoretical elaborations of subjectivity, agency, consciousness, and change."[30]

The spinning of the ice record allegorizes such a relation through its title's allusion to revolution, the choice of a nationalist song recorded in 1968, and, as I will explore, the substance of ice and its historical legacy in Latin America. It is also worth mentioning that these narratives of revolutionary historical progress bear a particularly masculinist stamp. As Saldaña-Portillo writes, "in the age of development, the hero dons the garb of discursive signification specifically associated with its regime of subjection: he is a risk-taking, resolute, frugal, nonornamental, productive, fully masculine, fully national fellow."[31] Or, as Nancy Mirabal asks in her study of Cuban Blackness across the Americas, "How did the discourse on shared masculinities and the subsequent erasure of female bodies from such a narrative influence the way power, geography, and the exile movement were chronicled and remembered?"[32] My challenge to history in this chapter hinges precisely on the ways in which "great men" are made the protagonists of much more complex and unwieldy pasts.

To perform such a critique, we must question the narrative desire hidden in historical discourse itself. Hayden White's foundational critique of history is especially instructive here. In *The Content of the Form*, White interrogates how the very notion of narrative comes to structure how we understand history itself; he invites us to "distinguish between a historical discourse that narrates and a discourse that narrativizes, between a discourse that openly adopts a perspective that looks out on the

world and reports it and a discourse that feigns to make the world speak itself and speak itself as a story."[33] For White, "real events should not speak, should not tell themselves. Real events should simply be; they can perfectly well serve as the referents of a discourse, can be spoken about, but they should not pose as subjects of a narrative."[34] In other words, the impulse to narrativize history, to give the past the shape of a story and, alongside it, resolution, runs the risk of imposing the sometimes hidden ideological investments of its narrators.

Indeed, the narrativization of history is not only beholden to ideological trappings, but also ultimately serves to flatten the attention to waywardness that telling the histories of minoritarian subjects require.[35] I listen here to Black feminist historian Elsa Barkley Brown, who uses sonic metaphors in her call for historians to engage with the complex corridors of history in a way that might unsettle dominant accounts and, in this way, include the women that the record so often hides from view. Brown proposes the notion of *gumbo ya ya* to argue for a polyphonic view of history:

> History is also everybody talking at once, multiple rhythms being played simultaneously. The events and people we write about did not occur in isolation but in dialogue with a myriad of other people and events [. . .]. [T]he trick is then how to put that conversation in a context which makes evident its dialogue with so many others—how to make this one lyric stand alone and at the same time be in conjunction with all the other lyrics being sung.[36]

For Brown, historians should follow the lead of a jazz musician attentive to various modes and moments of improvisation that invite her to consistently change her strategy. "Unfortunately," Barkley Brown writes, "few historians are good jazz musicians; most of us write as if our training were in classical music. We require surrounding silence—of the audience, of all the instruments not singled out as the performers in this section, even often of any alternative visions than the composer's."[37] In her call to historians to listen to the polyphonic variants of the historical record, Barkley Brown notes the importance of recognizing "not only differences but also the relational nature of those differences"[38] when discussing women's history, and also our responsibility to be attentive

to differences of race, class, and gendered bodies as we construct the record. She writes,

> We are likely to acknowledge that white middle-class women have had a different experience from African American, Latina, and Indian women; but the relation, the fact that these histories exist simultaneously, in dialogue with each other, is seldom apparent in the studies we do—these are merely different conversations, different compositions which we can place on the same program but certainly would not play simultaneously.[39]

How then to listen to the polyphonic sounds that would eschew teleological narratives of Mexican and Latin American history? I understand the risks of making such propositions as a nonhistorian myself. However, I borrow the critical approaches of historians like White, Barkley Brown, and Mirabal to explore the hidden histories that a work like *M(R.P.M.)* forces me to reckon with. Thus, as my encounter with history in this chapter takes me across different historical moments, I anchor my critiques of how the nation deploys (or silences) these narratives in the need to develop models that exceed official historical records.

To develop this chapter's stops across different historical moments, I turn to the ways other nonhistorians have reckoned with their archival encounters. Lisa Lowe, for example, has suggested a notion of "intimacies," which might help us grasp "the often obscured connections between the emergence of European liberalism, settler colonialism in the Americas, the transatlantic African slave trade, and the East Indies and China trades in the late eighteenth and early nineteenth centuries."[40] Being attentive to the intimacies of empire might shed light on the multiple linkages between seemingly disparate occurrences that the archive insists on keeping distinct. In concert with Saldaña-Portillo's earlier critique of the desires of revolutionary discourse, Lowe finds that "liberal forms of political economy, culture, government, and history propose a narrative of freedom overcoming enslavement that at once denies colonial slavery, erases the seizure of lands from native peoples, displaces migrations and connections across continents, and internalizes these processes in a national struggle of history and consciousness."[41] What Saldaña-Portillo identifies as the co-constitutive nature of revolutionary and liberal discourses can be placed then alongside a longer narrative of

liberalism, which in Latin America has taken the shape of a teleologi-
cal narrative from postcolonial liberation to revolutionary discourses of
Marxist emancipation to current questions of modernization. Analyzing
C. L. R. James's reading of William Thackeray's *Vanity Fair*, Lowe finds
belief "in a place for reading literature—not literature in the strict sense
of a fixed canon of aesthetic works detached from social history, but
reading literature as that momentary suspension of the desire to fill in
the historical gaps with facts and figures, in favor of the inquiry into the
operations through which such absences are created."[42] In the following
section I attempt to perform this kind of polyphonic reading by tracing
the unexpected pathways of an understudied political history to find
how ice haunts the aesthetic archives of Latin America as I chase the
grooves of Abreu's record and its sonic distortions.

Ice and Its Histories

I wish to take Abreu's ice record as the impetus to dive across a history of
modernization that, although not often told, exists at the margins of the
Latin American imaginary. I can't help but hear the record as a bootleg
object that, through its unstable process of reproduction, unmasks the
fraught national narratives produced by the original record, which was
pressed to provide an official national soundtrack to the 1968 Summer
Olympics. In my earliest analytical approaches to the record, I searched
archives and histories that moved me beyond the piece's immediate con-
texts. Taking the record's material substance seriously, I encountered a
history of trade left out of official narratives of transnational mercan-
tile colonial contact. Indeed, if the effects of colonial exploitation of the
Americas are told by focusing on the exploitation and ongoing extrac-
tion of native goods, ice reveals a history of modernization in which an
often overlooked substance managed to have unexpected effects upon
the region.

While ice has been used to preserve food for thousands of years, the
widespread use of ice as a commodity did not take place until the nine-
teenth century. By most accounts, the international ice trade was the
business venture of the American Frederic Tudor in the early 1800s,
after a friend made a remark about the potentially large market for ice
in the West Indies. As Gavin Weightman puts it in *The Frozen Water*

Trade, "[Tudor] clung to one conviction: people living in tropical cli-
mates would pay a good price for ice if they could get it."[43] While not
much has been actually written on the history of the ice trade at the
international level, most studies of the phenomenon focus on American
ingenuity and entrepreneurial spirit. Even today, Tudor is hailed as an
innovator—the first person to establish the cold chain, which would set
the stage for modern refrigeration technologies. These accounts ignore
that the ice trade was an American colonial venture.

Tudor's attempt to bring ice to the West Indies involved multiple in-
stances of trial and error. No one thought that ice would ever become a
necessity in the United States, but Tudor realized that for ice to become
an appealing commodity, it required a global market where it would
be seen as an indispensable good, rather than a natural occurrence. He
also realized that the very shape of the ice he aimed to export had to be
appealing, which necessitated "cutting, transporting, and selling ice ef-
ficiently to become profitable."[44] Tudor's first shipment to Martinique in
1806 was a disaster: "without an icehouse on the island to slow the rate
of melting, the cargo disappeared quickly when the open hold exposed
the ice to the warm tropical air."[45] In response, Tudor began establishing
ice depots in several locales—from Havana to Rio de Janeiro, and, with
the help of his associate Nathaniel Wyeth, he developed increasingly
complex technologies to cut and store the ice. Even the opacity of the ice
itself was considered, as "the desire for transparent ice actually predated
concerns over the safety of the product."[46] This aesthetic dimension of
ice led to further innovations in its harvesting, until it resulted in "ice
so fine that you can see [and] read a printed paper through a block 42
inches long."[47]

Tudor's American trade set up monopoly deals with the British, Span-
ish, and French governments who ruled over the islands, and by 1928,
he had set up the first major depot in Havana. As the trade expanded
from the Caribbean to the world, the demand for this new luxury item
eventually went as far as Calcutta, where Tudor reaped his biggest prof-
its. The vast effect of the ice trade throughout the Americas and beyond
cannot be minimized. The capacity of ice to conserve food over long
periods of time contributed to the rise of interest in the very notion
of food conservation as a capitalist enterprise, which quickly impacted
other emerging industries in the United States and abroad. Tudor also

figured out that his ice containers, emptied of their product, could bring items *back* from the Caribbean to the United States, leading to the idea that fresh meat, fruits, and vegetables, could travel across long distances while still retaining their "freshness," which in turn led to innovations in railroad travel as food chains became established from California to New York. Even as his business grew, Tudor's feelings about the people he encountered across his travels to the Caribbean were not hidden. During a forced exile in Havana, he found the "grossness of the people extreme."[48] Eventually, the ice trade would die off as ice harvesting became obsolete and new refrigeration technologies became widespread by the 1930s. Tudor is now mostly remembered as an ingenious businessman. Indeed, as I visited the archives of the Tudor Ice Company at the Harvard Business School in search for more details about his dealings in the Caribbean, the colonial implications of his venture remain in the background, and as ice has become commodified across the world, this early history is rarely told.

While the stories and images of the ice trade are mostly devoted to a triumphalist narrative, there is one particular image that has held my attention throughout the years. Most images from this period are devoted to illustrating the process of harvesting ice from frozen lakes in the Northeast—even a short passage in Henry David Thoreau's *Walden* recounts his staring out a window to see Tudor's company cutting out large blocks of ice. But one of the few illustrations that remains of the trade in the Caribbean, a drawing from S. G. Goodrich's *A Pictorial Geography of the World*, published in 1832, shows the reaches of the ice trade in the tropics. The image consists of four slaves carrying a large block of ice off a boat. I am especially haunted by the image of the slaves' hands, one of them raised ever so slightly while the other stops the ice from falling. It took me a few glances before realizing that this gesture came from the fact that their hands were probably being burned by the block of ice. The ingenuity of the process becomes violent in the hands of enslaved laborers. I follow this brief historical detour because it exemplifies the edges of history that deny a single sense of linearity or narrativity, as I argue Abreu's ice record does. Although several authors have pointed out how the exploitation of substances—such as sugar, coffee, and the coca plant—have contributed to the colonial extraction of the Americas, the story of the ice trade can shed new light on the ways

Figure 1.5. Spanish slaves in Cuba unloading ice from Maine.
Samuel Griswold Goodrich, *A Pictorial Geography of the World*,
1832, reproduced in Richard Cummings, *The American Ice Harvests*
(public domain). Screenshot by author.

new technologies were central to the maintenance of this exploitation.[49]
Abreu's ice record has unexpectedly led us to understand how narratives of modernization promoted by Latin American governments in the twentieth century had already begun to take hold in the century before. Tudor's ice company promised colonial rulers the possibility of comfort—a minor detail that highlights the wayward operations of power that remain hidden in historical accounts of progress.

Even though the ice trade is now largely forgotten, its colonial roots have persisted in surprising ways in the Latin American imaginary. During my research, I was reminded of what is perhaps the trade's most well-known appearance in Latin American cultural production: within Gabriel García Márquez's *One Hundred Years of Solitude*. The story of the fictional town of Macondo, which in turn functions as an allegory of Latin American modernity, is set off by an encounter with ice. The novel begins: "Many years later, as he faced the firing squad, Colonel Aureliano Buendía was to remember that distant afternoon when his father took him to discover ice."[50] This opening image corresponds to an interplay between the brutal and the magical that permeates the book. Aureliano faces the firing squad, but in his last moments he recalls the event that will drive the rest of the novel. Ice arrives to the still burgeon-

ing town of Macondo from a group of gypsies that set up camp there every year. It interrupts a place still in the throes of development, in which "[t]he world was so recent that many things lacked names, and in order to indicate them it was necessary to point."[51] "The other world" already weighs heavily upon the mythical construction of the town, and particularly its patriarch, Aureliano Buendía. García Márquez describes the ice extravagantly: "Inside there was only an enormous, transparent block with infinite internal needles in which the light of the sunset was broken up into colored stars."[52] At this sight, José Arcadio Buendía at first thinks this block of ice is actually the world's largest diamond. After touching it he declares, "This is the great invention of our time."[53] García Márquez uses the language of aesthetic awe to illustrate Arcadio's response. Ice does not appear simply as a commodity, but as a sublime object intertwined with the notion of invention—a new world coming into form.

Sometime after the original patriarch passes away, his grandchildren achieve the dream of bringing ice to Macondo. They build an ice factory, and with it the wrath of modernity descends upon the town, this allegorical Latin America. As the frozen water trade expands beyond the boundaries of Macondo, Aureliano Triste, the protagonist of the third part of the novel, reaches a decision: "We have to bring in the railroad."[54] The train brings along domestic electricity, a movie theater, and, eventually, foreign investment in the form of the banana trade. Making a brief but notable appearance after the train's arrival is the gramophone. Unlike ice, this technology is not a hit in Macondo. The old ladies who "dress like villains to witness the miracle up close" find the record to hardly be a replacement for live music, and in fact, even as the new invention quickly makes its way to each household, it does so only as entertainment for children. But as the novel becomes intertwined with history, the foreign owners of the town's banana plantations declare martial law, eventually massacring the workers who try to organize against the everyday terrors the companies bring. The book closes with Macondo a barren sight—the dreams of its greatness eradicated almost completely by capitalist modernity.

Revolutions Frozen in Time

Rather than a wayward detour, the history of the ice trade and its effects in the Americas animate my desire in this chapter to interrupt triumphalist historical narratives. I am particularly struck by how the transnational trade and its promises of progress still resound in recent times—as in the Mexican state's celebratory discourse around NAFTA. I can't help but hear *M(R.P.M.)* and its ice records as providing us with a potential aesthetic invitation to find these forgotten narratives in order to critique the dreams of progress that continue to reign over Mexico and the rest of the region. Abreu's ice records open up the possibility of confronting Mexican (and Latin American) history through minor divagations, as a refusal of the intertwined promises of modernization and revolution that reoccur time and again and which have helped dictate official nationalist narratives for over a century.

By Abreu's own admission, *M(R.P.M.)* is a piece that has gone from embracing ephemerality to one concerned with conservation. In an interview with Mexican contemporary art magazine *Galatea*, Abreu complains that the initial experimentation of the piece resulted in a "bureaucratic process" of repetition, one of the main reasons he considers the work finished, despite it being his most well-known project. In the remainder of this chapter, I examine the *M(R.P.M.)* series, starting with its final iteration, as a gallery installation at the Centro Cultural Tijuana. I begin here because Abreu used this context to conclude the series, providing viewers with a retrospective of its many manifestations. Even though Abreu created one more record for this exhibition, the installation focuses on the most well-known records he transferred onto ice: *Música y Voz de la Patria, Himno Nacional*, in 2007; *John Fitzgerald Kennedy: The Presidential Years* and *Historia Ilustrada de la Musica Popular Mexicana: Los Inmortales de la Canción Ranchera*, both in 2008; and *Deutschlandlied*, in 2011.

This final iteration of *M(R.P.M.)*, housed in the Centro Cultural Tijuana's 2013 exhibit, *Teoría de la Entropía*, brought together "works by 14 makers of contemporary electronic art to offer a multiple reflection on the fugitivity of time and the persistence of memory."[55] Located in a corner of the gallery, the installation consisted of three short wooden stools a few feet apart, which held three projectors that in turn held another

Figure 1.6. Iván Abreu, *M(R.P.M.) 2007–2013*. Installation view for the exhibition *Teoría de la Entropía*, Centro Cultural Tijuana, April 19–June 30, 2013. Screenshot by author.

short stool used to support three of the molds Abreu used to make the records, each covered with a circular glass plate. The projectors showed looping video documentation of each performance of *M(R.P.M.)*. A small freezer sat to the right of the exhibit, containing a mold with a still-intact frozen record—a reproduction of the one Abreu used to perform at the exhibition's opening. Finally, in addition to the projected video, the back wall also displayed photographs arranged in chronological order—from Abreu's first experiments using ice as a medium to the last single performance of the piece, *Deutschlandlied*, in Berlin, in addition to images of the original ice records used for each performance. The molds function both as documentation and as present art objects—their detailed grooves visible through the circular glass that covered them.

The installation also highlights the attention to historical detail that Abreu brought to the series, revealing the intentions that I argue are built into the piece. *M(R.P.M.)*, and its critique of nationalist narratives, rests on the global political tensions of the 1960s. The late 1960s was a period of dramatic social and cultural change in Mexico, as the country (along with many other places across the globe) saw major uprisings

in labor and student activism. However, with Mexico City as the site of the 1968 Summer Olympics, the government violently resisted these peaceful protests, culminating in a massacre of thousands of students and civilians in the Tlatelolco section of the city, just a few days before the start of the Olympics. As the government turned to placating its rebellious populace with calls for national unity and pride, it also managed to invoke an image of the Mexican state that presented itself as the exception to the rise of autocratic regimes in Latin America throughout the 1960s and 1970s. By using recordings made at this time, Abreu infuses the performance with the tensions of a moment that the state tried to repress not only in '68, but also in official histories. The ice records invoke these histories of national violence by shaping the contradiction through its performance.

The records themselves were made by using silicone to create a mold of the original record, which Abreu then filled with water. When the water freezes, the information remains imprinted in the ice. *Música y Voz de la Patria, Himno Nacional* was the first in the series, performed in 2007 at the Fifth Muestra de Arte Sonoro at the Ex Teresa Arte Actual in Mexico City. The original record was pressed in 1967, amid massive social unrest, its title connecting the nation to voice and music. The pieces in the original album include the "Marcha de Honor," typically played in civic ceremonies to welcome the arrival of the national flag. Anyone schooled in Mexico is certainly familiar with this ceremony. Other songs on the original include the Mexican national anthem, the military national college's official anthem, and other official state songs. Each piece was played by a nationally sanctioned group, from an ensemble of soldiers to the national symphony orchestra.

The sound in the ice version is (unsurprisingly) heavily distorted, with multiple details competing for our attention. While frozen water can retain the record's information, the very act of playing it contributes to its erasure with each revolution. The pops and crackles any vinyl record accumulates after years of use dominate much of the soundscape. With each turn the original information becomes further fragmented. What first attracted me to the piece was precisely this steady destruction, knowing that the object would get closer and closer to its own annihilation with each revolution. However, even if the ice record is produced to be destroyed as it plays, it can be reproduced by freezing more

water in the mold. At the same time, even if the process can be repeated, each time the atmospheric conditions will be different; it will melt at a different speed depending on the circumstances. But in this particular performance the record will not melt completely. After a couple of minutes, Abreu interrupts it, increasing the sonic disturbance to the point of overpowering the now barely discernable original sounds. Abreu finally grabs the remaining piece of ice and scratches it with the needle. As the violence of this scratching intensifies, the performance ends. The change brought about by the destruction of the record renders a radical transformation of its materiality, from recognizable sound into loud vibration. Indeed, as the piece mutates into cacophony, our own perceptual engagement with it changes as well. The vibrations at this moment don't just make contact with the ears, but instead disturb the listener/viewer's whole body. The scratching is far from pleasant, as Abreu transforms the sounds of the nation into a sonic assault, but this allows us to consider the violence of a seemingly benevolent state enacted upon our own bodies. I want to suggest that this moment offers viewers an unexpected—if not immediately recognizable—encounter with the histories I have explored throughout this chapter. The violence of the past takes on the material shape of the record, and in turn the sonic excess of its play can perhaps be understood as an allegory, but one that manifests physically on the bodies of its audience.

Another performance, *Historia Ilustrada de la Musica Popular Mexicana: Los Inmortales de la Canción Ranchera*, shows Abreu reworking the piece in a different way. In this version, Abreu creates a dyad between a fully frozen record and the fragmented chunk of the other one. First, he plays the complete record, allowing us to hear the ranchera songs of the original—ranchera being perhaps the most popular postrevolutionary musical form in Mexico. After a few minutes, he pulls a small chunk of ice from another mold and begins scratching it. Here, Abreu will allow the first record, now broken, to keep playing as he turns his attention to the failed mold. By creating this pairing, Abreu offers no alternatives but a literal presentation of the break in sound.

There was one piece in the series in which Abreu deviated from his usual choice of Mexican records. In November 2008 at the Pulse Miami Art Fair, Abreu reached back to 1964, and to the album *John Fitzgerald Kennedy: The Presidential Speeches*. The record begins with Kennedy's

State of the Union address from January 1962, with the promise that his goal "remains the same: a peaceful world community of free and independent states—free to choose their own future and their own system, so long as it does not threaten the freedom of others." The record, however, skips on the promise of how this peacekeeping mission free of coercion will be accomplished—through "the moral and physical strength of the United States." Yet Abreu connects this statement as the record segues into another speech delivered later in 1962, in an address about the Cuban Missile Crisis. The transition highlights the change or perhaps the continuation of Kennedy's earlier rhetoric, promising that the United States will respond aggressively to any threat coming from Cuba. Yet the rhetoric that Kennedy employs in this speech is particularly relevant to our discussion of revolution. Here, Kennedy's promise is to the Cuban people, who have been "betrayed" by their own government. He has "watched and the American people have watched with deep sorrow how your nationalist revolution was betrayed—and how your fatherland fell under foreign domination. Now your leaders are no longer Cuban leaders inspired by Cuban ideals. They are puppets and agents of an international conspiracy which has turned Cuba against your friends and neighbors in the Americas."

Abreu's choice of record as a Cuban expat residing in Mexico further complicates possible readings of this piece. If the tug-of-war of Cubanidad has been played out in the aftermath of Cold War politics, Abreu exists interstitially through another national relationship. That is, he is a subject whose work and living does not necessarily attach itself with any allegiance to Cuba, yet it also rejects decades of US policy as the dominant discourse that has prevailed in Cuba—along with the ongoing subjection of Cuban people on the island as a result of ongoing sanctions. Indeed, Abreu's criticism comes not only through policy, but through Kennedy's very invocation of a revolution derailed—what he calls the betrayal of the Cuban people. By performing this version of *M(R.P.M.)* in Miami, Abreu subtly comments on the anti-Castro and anti-communist politics that dominate the Cuban diaspora in the United States. Further, when we consider the role that Cuba played as the first successful recipient of Tudor's ice trade, the piece cannot help but hark back to a much longer history of colonial trade that in turn also offers a sly commentary on the ongoing US-led embargo of the island. I want to emphasize, how-

ever, that as with Abreu's other pieces in the series, the potency of these critiques remains well below the surface, as the audience focuses on the sound in the grooves and cracks. Yet Abreu's critique remains potent, as the audience is invited to reflect upon the piece and the link between the dissolution of the record and its potential larger meaning. In some ways, by claiming an apolitical agenda, Abreu sneaks in questions of history, empire, politics, and ephemerality into these art spaces. My exploration of his work in this chapter has listened to the materiality of the sounds produced by the record to grasp the histories that official narratives aim to freeze out of collective memory.

The hidden stories of the ice trade and the violence of state suppression burst through works like Abreu's and remain at the margins of a book like *One Hundred Years of Solitude,* as they do in other works. For example, in Francis Alÿs's 1997 piece *Paradox of Praxis 1 (Sometimes Making Something Leads to Nothing)*, the artist pushes a large block of ice through the streets of Mexico City until it melts completely, evoking a fragile sense of temporality as the ice becomes smaller and eventually melts. In the song "El Hielo (ICE)," the members of Mexican American band La Santa Cecilia intone in the chorus, "El hielo anda suelto por esas calles / Nunca se sabe cuando nos va a tocar / Lloran, los niños lloran a la salida / Lloran al ver que no llegará mamá" (ICE is loose on these streets / No one knows when it will be our turn / Children cry after school / They cry when they see mom will not be coming back). The song, of course, references the acronym for Immigration and Custom Enforcement in the United States, along with the waves of fears experienced by Latina/o communities in Los Angeles at the sight of the immigration agents targeting immigrants for deportation. Thus even if ICE's name is purely coincidental, the surprising and at times uncanny convergences that burst through the walls of narrative allow us to grasp the ways in which empire seethes into daily life across time.

I point out these moments of convergence in the spirit of revolution found in Abreu's piece. These convergences aim not to trace a linear history through modernity, but precisely to upend such attempts. As Mexico marches ever toward the hope of another revolution, the full title of Abreu's series, *Masa en Función de las Revoluciones por Minúto,* offers up an important warning: that we cannot tether hope to the images a nation projects of itself. In this case, however, the images of historical reconcili-

ation are interrupted by the cacophonic thrust of an ice record that hints toward moments in time that remain mostly forgotten. As leftist thought in Latin America has been continuously bound to the promise of revolution, we must revise our understanding of these notions to see the many forms that development took, especially the comforts that imperialism seduces us with. Abreu's work invites us to reckon with a present (and future) aggressively structured by its past. Ultimately, sound allows us this space and this encounter, as the aesthetic properties of sound art offer us alternative ways of encountering this past, beyond the tidy narratives of patriotic tales and ever-delayed guarantees of a modern future always tied to the potential of economic progress. As we observe the ice record and its inevitable destruction, we are able to understand how its multiple losses—of fidelity, of the social, of the object, of the nation, of the record, of the sound—structure the very shape of history as a struggle itself.

Figure 2.1. Cristina Ochoa, *Phantom Power*, 2012. Photograph by Oliver Ludwing/Centro de Documentación Ex Teresa Arte Actual. Screenshot by author.

2

Aimless Lives

Punkeras, Metaleras, and the Sounds of Negation

At the XV Muestra Internacional de Performance (entitled "El Sonido de la Última Carcajada" [The sound of the last laugh]), which took place at the Ex Teresa Arte Actual museum in Mexico City in 2012, Colombian artist Cristina Ochoa performed her piece *Phantom Power*. The work opens on a dimly lit stage with a giant glittering vinyl star at its center and a DJ booth toward the back of the space. Three microphones hang suspended by their cords from the ceiling, and on the ground are two megaphones. Three women—described in the artist's statement as "Riot Girl characters"—appear in the background. They are extravagantly dressed, sporting outfits reminiscent of women in punk rock history— from Joan Jett to Pussy Riot. One approaches the mixing booth, playing a series of song snippets, all sung by female voices, all in English, most identifiable as punk. The track plays for a couple of minutes as the DJ dances and, at times, sings along. The two other women, previously masked, then step out and begin jumping and screaming—first onstage, then within the audience. This audience infiltration has the goal of "instigating, teasing, pushing, and provoking" the spectators.[1] The energy shown by the performers is unruly and purposefully obnoxious. The reactions from the spectators are mixed, but some jump along with the women, eventually taking the stage and yelling into the microphones—creating a cacophony of voices and sounds accompanying the shuffling prerecorded tracks. Even if someone knows the lyrics to a particular song, it doesn't play long enough to dominate the soundscape. The conjunction is disorienting, but the audience has been roused into movement. After twenty minutes of interaction, the two performers disappear, leaving the crowd alone with the DJ while the final ten minutes of the track play out.

In her artist's statement, Ochoa credits the history of female-led punk bands with having introduced many a girl in Latin America to femi-

nism and feminist politics.[2] As she demonstrated that night in Mexico City, however, she was referring not only to punk's lyrics but its particular *attitude*—the kind of petulant aggression that the jagged edges of this music allow. It's about the way punk has invited girls to jump and scream, often within the confines of traditionally patriarchal and masculinist contexts throughout Latin America. Indeed, although only US- and European-based singers make appearances in Ochoa's soundtrack, punk, metal, and other genres that share this aggressive proximity have provided an alternative genealogy of feminist music in the Americas. Examples of such bands abound throughout the hemisphere, far too many to enumerate here, as their music circulated among fans in bootlegs and mixes. The aggressive noise and attitude of feminist punk has historically sprouted most prominently in moments of state repression. During the early 1980s, for example, the Brazilian all-female post-punk band As Mercenárias used their angry-yet-catchy songs to decry the country's dictatorship. Comparing the local police to the Stasi, the group laid bare the oppressive power of the regime.

In Mexico City, these feminist punk and metal genealogies are especially important to grasp in the aftermath of the government's prohibition of rock music—both in live performance and over the airwaves. As mentioned earlier, a major reason why rock engendered panic in the cultural mainstream was the fear that its sounds and attitudes would produce a generation of liberated, angry, sexual, and unruly girls. But the people this panic aimed to protect were the middle-class girls who were among the first audiences of this emerging youth subculture. After the crackdown, rock moved to the outskirts of Mexico City—to poor, violent, unincorporated neighborhoods that to this day provoke fear in the hearts of those who populate the central areas of the city. Here, outside of the view of the authorities, rock not only survived but thrived. The rock and roll that the government had prohibited was later succeeded by punk, metal, ska, and other genres, evading the government's prohibition and maintaining their own sense of style and place.[3]

This chapter, however, is not about this history of punk and metal in Mexico City or even about the feminist bands that were formed during this period. Instead, I trace two instances during the early '90s in which metal and punk moved from peripheral neighborhoods to a burgeoning contemporary art scene in the city, where female artists, along

with their attitudes and ethos, brought these sounds into new realms that defied the neoliberal shifts chronicled throughout this book. Punk and metal (as well as offshoots and fusions such as anarcho-punk, death metal, and hardcore), perhaps more than any other genres, provided feminists with a sonic vocabulary of aggression and negation, which exerted its most powerful influence in works of contemporary art. These sonic forms gave young women in Mexico a way to express what I call "unbelonging"—a rejection of the patriarchal and class norms that dictated the terms by which these women became excluded from national discourses of middle-class belonging. What outsiders might see as simply an expression of anger can be understood instead as a way of giving a sound to the feelings of dispossession that dominated the lives of these young women at the margins of mainstream Mexican culture.

The two case studies I focus on here are the artist collective SEMEFO and the multidisciplinary artist Sarah Minter, both of whom emerged in the Mexican art scene of the late 1980s and early 1990s. In the case of SEMEFO, I analyze their earliest performances, in which some members of the collective staged radical psychodramatic pieces accompanied by a metal band made up of other collaborators. I then turn to Sarah Minter's 1991 video piece *Alma Punk*, which chronicles a few days in the life of its titular character, Alma, a wayward punk girl who traverses Mexico City attempting to make sense of her chaotic life. In both cases, metal and punk render an aggressive feminist politics that challenge patriarchal expectations of Mexican womanhood. Their work preceded and paved the way for the sound art scene discussed in the previous chapter. I take the examples here out of chronological order, moving from an institutionally supported contemporary art moment to trace the subcultural undercommons that guide this book.

Even as punk and metal became crucial to the Mexican underground, the material factors in the neighborhoods where these scenes thrived limited the ability to archive many of the bands and participants in these subcultures. The survival (and, indeed, existence) of these scenes required alternative forms of circulation, necessary at a moment in which rock recordings had been officially prohibited by the Mexican government. Given that the young people that made up these scenes lacked resources, they improvised ways to make music circulate, venues in which to play, and, ultimately, the very archives that contain their traces. In-

deed, even as these archives lack official (and often unofficial) recordings or other "high-quality" documentation of these scenes, we can still find how they deployed piracy as an alternative method through which their existence persists. This chapter takes these alternative archival contributions and proposes the bootleg as an unexplored object and conceptual tool that may capture the ethos of the scenes. I use the bootleg to challenge notions of illegality tied to piracy and other informal distribution practices and to examine how marginality was the driving force for these sonic subcultures. This chapter ties feminist anger to piracy, illegality, and marginal geographies to provide an expansive account of how women during this period defied strictures not only of gender but also of class and belonging.

Before Punk

In September 1971, the Avándaro music festival—nicknamed the "Mexican Woodstock"—drew over 250,000 people. They were mostly young listeners of rock music, but as student protests continued across the country, the festival promoter's emphasized that this was a *musical*, not political event. Despite this, "federal, state, and local armed forces made the government's presence ominously apparent: up to 1,000 soldiers with machine guns milled around the perimeter of the concert grounds, though no violent incidents were reported."[4] The festival revealed a significant shift in the class makeup of listeners of and adherents to the Mexican rock movement known as La Onda (The Wave). As Eric Zolov explains, "it was the striking presence of so many lower-class youth, the nacos, as they were derogatorily called by the middle and upper classes, sharing a common space and musical culture with other youth that caught the attention of [the authorities]."[5] The Mexican government became increasing perturbed by the fact that this countercultural movement was becoming attentive to social and economic disparities and was especially effective in speaking to working-class audiences. If upper- and middle-class youths had been the main targets of the earliest sounds of rock and roll music in previous years, they were arguably still invested in maintaining their economic status. In marginal neighborhoods like Ciudad Nezahualcóyotl where working-class youth came from, on the other hand, "rock had worked its way into an integral aspect of everyday life, where live performance

Figure 2.2. Cover of *La Prensa*. "Avandaro: The Madness. Hippies, Drugs, and Turmoil in the Festival." September 12, 1971. Archivo Biblioteca, Hemeroteca y Fototeca Mario Vázquez Raña y La Prensa.

offered the possibility of self-representation in a society which mocked and marginalized them."[6] One of the reasons the authorities might have been especially worried about the solidarity that Avándaro might engender was the fact that the festival took place only a few months after "El Halconazo"—the Corpus Christi Massacre—in Mexico City. Although the '68 Tlatelolco massacre has occupied a central place in the narrative of the conflict between the government and the student left, another massacre a few years later, known as "El Halconazo"—named after the CIA-trained paramilitary group that carried out the massacre—left over one hundred protesters dead and served as a reminder that the Mexican government's persecution was far from over.[7]

Avándaro became an excuse for the Mexican ruling class to suppress this emerging cultural resistance, which had started to regain steam. President Luis Echeverría's government, shocked by the sheer number of people rock could bring together, cracked down on musical distribution and live performance. Authorities prohibited dissemination of any materials related to Avándaro, and, as foreign record companies abandoned distribution of La Onda, magazines, radio stations, and live music venues were shut down. As a consequence, a multiplicity of genres evolving from rock music moved underground, where populations that were already expelled from the political and economic life of the mainstream formed their own independent subcultures.

Although this book is mainly concerned with the aesthetic turn toward dissonant sound, which experienced its most important developments in the 1990s, we must return to the 1980s as the moment that set the scene for artists who chose sound to refuse the demands of national belonging. In particular, I want to argue that to understand these shifts in the realm of contemporary art, it is also essential to understand how they were the result of an encounter between subcultures that grew out of the repression of rock music in the 1970s and became mixed with these emergent art scenes. The 1980s were a time of great turmoil in Mexico, as the economy remained stagnant and the rate of violence in Mexico City skyrocketed. Although rock music had been officially banned, it flourished on the outskirts—in places like Ciudad Nezahualcóyotl, Santa Fe, and Tepito—where the city's authorities clashed with gangs who retained control. Even if places like Ciudad Neza and others became well-known for violence, they also provided alternatives to state

discourses, affording those who had been already dispossessed by the national economy the possibility of forming their own autonomous—if potentially dangerous—zones. But as I will show, danger and violence are poor metrics to grasp the sense of everyday life in these areas, since such danger and violence were often a product of the state's attempts to maintain control over poor areas (which were in turn produced by an increasingly broken economic regime). However, forms of sociality that had been foreclosed in the metropolitan center sprouted here in important ways. For example, the Museo Universitario del Chopo began hosting bands in 1980, held annual competitions, and, as you'll recall, was the first home of what would become El Tianguis del Chopo.

I place the spatio-sonic specificity of these underground scenes in direct contrast to the growth of *rock en español* on the national stage. *Rock en español* (or *rock en tu idioma*) seemed to resolve tensions between dissonant and local sounds by providing instrumentation, lyrics, and references that made major bands like Café Tacvba and Caifanes legible to national sensibilities. These bands gained a following not only throughout Mexico but also in the United States, where they were promoted by transnational record companies that had abandoned Mexico in the preceding decades. This does not discount the fact that many of these bands first emerged from these poor neighborhoods and underground subcultures. Indeed, as Tere Estrada explains in her essential book *Sirenas al Ataque*, these scenes were characterized by the increasing use of Spanish as well as the integration of "Mexican sounds" and lyrics that focused on urban conflict, as we hear in the case of El Tri, Cecilia Toussaint, and Botellita de Jerez, to name a few.[8] I also remain attentive to the fact that although in Mexico these bands enjoyed popularity among middle-class youth that had turned away from rock genres, for many Latina/o listeners in the United States, *rock en español* served as a lifeline—a point of connection between their life as immigrants and their relationship to a Spanish-speaking homeland.[9] But these bands could be supported by transnational recording markets, and especially the Mexican government, because their sonic hybridity fit the mainstream image of Mexico City as sanitized and consumable—the perfect music for the country's contemporary neoliberal policies. Even if many of these bands were invested in maintaining the oppositional politics of the underground, their distribution was utterly suited for the neoliberal

nation that resolved the political tensions of earlier decades by show-
ing that Mexican cultural exports could enjoy market success *because*
they gave foreign consumers a taste of what they perceived as authentic
Mexican culture. The bands of *rock en tu idioma* signed contracts with
major American labels, who could now have access to Mexico's previ-
ously closed-off markets as well as the untapped United States–based
Latina/o market. This was not entirely accidental, as NAFTA specifi-
cally lifted the laws that had made American record companies unable
to market rock music in the country after 1972. Essentially, I want to
argue that *rock en español* became the soundtrack of NAFTA in Mexico
because it appeared to resolve the class tensions embraced by punk and
metal subcultures. Even if these artists were unwitting participants in
the discourse of economic progress under the guise of cultural hybrid-
ity, unlike the harsh sounds of punk and metal rooted in working-class
subcultures, the sounds of *rock en español* could be transmitted by new
multinational channels—literally, in the case of MTV Latino, which was
launched across the region in 1993 to capitalize on this new market.

I don't mean to create a simple binary between *rock en español* and
the underground punk and metal subcultures. For one, the focus of
this chapter remains firmly invested in aesthetic interventions that I
will analyze in relation to the city's performance and contemporary art
scene. The emergence of these aesthetic practices remained potent in
their refusal to become co-opted. Of course, the physical manifestation
of NAFTA was most pronounced in border cities like Tijuana and Ciu-
dad Juárez, where maquiladora factories run by *las multinacionales* en-
trenched new labor economies that relied on the exploitation of women's
bodies. But Mexico City remains the center of national culture, and thus
it is the ideal site to study the contrarian relationship between subaltern
cultures and NAFTA. Here, the sounds of the underground remained
legible in performances that refused the sonic hybridity which gave *rock
en español* its global success.

On the Outskirts

Places like Ciudad Neza, Tepito, and El Tianguis Cultural del Chopo
became the hot spots of alternative rock, punk, and metal during the
1980s because they existed out of reach from Mexico City's investment

in signaling its modern image via its apparent construction of a new middle and upper class. Attempting to locate the histories and cultures of these neighborhoods is a difficult task. Most research into these regions bears the language of social science pathologization, focusing as it does on links between these areas and crime, domestic violence, and poor health. I turn in this section to Annick Prieur's 1998 ethnography, *Mema's House, Mexico City: On Transvestites, Queens, and Machos*, which provides one of the few in-depth accounts of the kinds of alternative queer socialities that could be found in these areas. During the time of Prieur's research, Ciudad Neza was estimated to have over 2.3 million inhabitants, but, as she points out, while "Neza is a big city, [. . .] it does not even figure on most maps of Mexico, and has no postcards to offer visitors."[10] She describes the kinds of attitudes that continue to reign in the rest of the city: "[N]obody except those who live in Neza would go there. Why would they? There are no industrial plants of importance in Neza, nor any recreation areas or even any downtown. Neza has a very bad reputation too: dirty, dangerous, and poor. Middle- and upper-class citizens of Mexico City have told me they would never dream of venturing into Neza."[11]

Prieur was invited by the titular Mema into her house to conduct research into the lives and experiences of homosexual men, trans women, and others who had made Ciudad Neza one of the most surprisingly welcome places for queer life—albeit one outside of Mexico City's official gay and lesbian narratives. As Guillermo Osorno's history of gay Mexico City, *Tengo Que Morir Todas Las Noches* shows, queer life in more central areas had been supported by the bribes of upper-class gay men, who paid off the police to ensure invisibility.[12] On the outskirts, however, alternative modes of life flourished even as life itself appeared unruly, as queer subjects on the margins unwilling to meet the expectations of gay rights' march of progress. This is not to deny the precarity inherent in economically depressed areas. As Prieur explains, "It is true that Neza is dusty. Most of its streets are not asphalted. It is true that there is a lot of garbage in the streets and that the antiquated buses are terrible polluters, making an earsplitting noise and belching out black exhaust. It is also true that the youth gangs may make life outdoors after dark somewhat hazardous. Neza is undoubtedly a poor, lower-class area. [. . .] Neza grew up as a shanty-town."[13] That said, "Neza's poor reputation seems unfair,

because it is also a nice place, with its small houses in lively colors, the rows of pennants flying like semipermanent decorations for some fiesta or other, the tropical music blaring everywhere from a myriad of transistor radios, the neighborhood women chattering in the gates, the crowded markets where traditionally clad older women sell all kinds of exotic fruits, the small shops with the shy young girls attending, and the narrow plots of land where youngsters play soccer, between the heavily trafficked main streets."[14]

Prieur's ethnographic approach might seem outdated and perhaps even offensive by current identitarian standards. We might even wish to challenge her own position as a European woman conducting ethnographic research into the lives of Mexican subjects living at the margins of the economy (and sexual categories). Such protestation seems to me not only insufficient but also reveals our own middle-class discomfort with forms of life that fail to conform to our desire for queer and feminist world-making to bear the visible traces of liberatory politics. Instead, I am drawn to the point of encounter between *Mema's House* (both book and actual location) and the kinds of marginal ways of living that allowed punk and metal to flourish in spite of repressive regimes that sought to extinguish them. In fact, my first time venturing to Ciudad Neza was in search of Spartacus, Mexico City's longest-operating gay club—and one that is still only rarely visited by middle-class gays and lesbians, who prefer the tidier streets of "la Zona Rosa," Mexico's own "gayborhood," modeled after other cosmopolitan gay streets around the world. As Maurice Rafael Magaña proposes in his ethnography *Cartographies of Youth Resistance*, hip-hop and punk youth subcultures "build on existing organizing traditions and experiment with novel political cultures to help sustain social movement energy."[15] He borrows the notion of "counterspace" from the French social critic Henri Lefebvre to define these subcultural movements as "spatial projects produced through the political imagination and practice of social movements, as an alternative to the spaces created by the dominant system."[16] Ciudad Neza was thus capable of engendering multiple counterspaces as an alternative to the increasingly sanitized city center. Entering the punk and metal archives, ephemeral though they may be, means letting go of bourgeois expectations and instead understanding the possibility that "selling sex could be a way to gain independence, taking drugs a way to

get some entertainment, stealing a way to win self-respect, that violence is just the order of things."[17] Yet the violence that Prieur refers to here is vastly different from the forms of violence enacted by the state across these locales. Punk and metal as ways of life emerged as survival strategies that could not be tamed by middle-class desires for liberationist discourses.

As Mexico sank further into economic depression during the 1970s, Mexico City became increasingly imagined as a delinquent locale where the threat of violence and criminality ran rampant. Throughout the 1980s and early 1990s, the state employed new regulatory and disciplinary apparatuses to combat the imagined dangers of living in Mexico City. As Markus-Michael Müller discusses in *The Punitive City*, neoliberalism "transformed neoliberal state formation into [. . .] *penal state* formation."[18] According to Müller, the neoliberalization of economic policies "was accompanied by an increasingly punitive turn in urban governance rationales."[19] These punitive shifts demanded the creation of "imagined urban 'enemies'" that were found in the city itself. These security regimes were the state's way of managing both economic transitions and oppositional populist movements to such reforms. Neoliberal securitized democracies thus guaranteed not only economic prosperity, but an increased sense of security for populations that saw new enemies within. In other words, the state terrorism of the 1970s and 1980s became displaced onto a working class that could be marked as a threat to the goals of neoliberal reforms. As Müller points out, "Latin America's new violent normality, as reflected in [. . .] high homicide numbers [. . .] is inseparable from persistent patterns of socio-economic inequality and exclusion that deepened under neoliberalism."[20] To manage the possibility of popular revolt, governments "continuously produce security discourses that divide the social space into two antagonizing camps, that of 'citizens' on the one hand and that of 'anticitizens of a neoliberal social order' on the other."[21]

In Mexico City, those anticitizens could be found on the outskirts that continue to be imagined as lawless places that threaten to trespass into the social stability of the city's central neighborhoods. Although Müller's analysis centers on Mexico City's rise into a "global city" during the second part of the 1990s, he briefly traces the city's transformation during the earlier part of the decade. As he writes, "Not only did these [neolib-

eralizing] processes contribute to a breakdown of the local manufacturing sector that had been central to the city's economy throughout most of the twentieth century, Mexico City also lost its national importance as the centre of economic decision making. [. . .] This development was accompanied by the broader decline of formal economic activities,"[22] which forced citizens to engage in informal economies—which, according to inexact data, account for up to 50 percent of all jobs in the city.

Following the implementation of NAFTA, one of the sectors that received most attention was the distribution of copyrighted goods, as outlined in section six of the treaty. As Müller explains, "Contemporary legislation defines the profit-oriented illegal reproduction of copyright-protected products, such as movies, music or software, as a federal crime that is punishable by up to ten years in prison or up to 10,000 days' earnings of the minimum wage."[23] Understanding this detail is central to my argument. It sheds light on the relationship between forms of power fostered by neoliberalism and acts of refusal that responded to the need for access to music and other cultural products that had been deemed illegal in the 1970s.

Following rock's prohibition in the wake of the Avándaro festival, punks became emblematic figures in the Mexican war against youth gone awry. As Laura Martínez Hernández writes in her investigation of alternative musical cultures in Mexico, "when finding legal avenues closed to them, musicians and rock publics appropriated spaces destined for other means."[24] Limited resources in these marginal neighborhoods meant that "information about shows would be painted on the walls or in posters[; these subcultures'] production was minimal and was home-made: *demos, fanzines, graffiti*."[25] Although Martínez Hernández recognizes that such makeshift conditions were essential to creating a sense of community, she repeats the idea that punks wanted "total anarchy" and were dangerous, violent, completely opposed to all social rule. An alternative view, however, reveals that punks, metaleros, and others were responding in great part to having been made out to be threats by the police. Like the jipitecas (the name given to the first wave of Mexican hippies) before them, punks became a legible hazard. Punkeras and metaleras were the perfect figures to ensure Mexico City's new punitive forms of law enforcement—what Mexican theorist Sayak Valencia has identified as one of the aftereffects of "gore capitalism."[26] After all,

punks and metalheads came from Mexico City's notoriously criminal-ized neighborhoods; their very styles of cultural expression—e.g., at-titude, dress, hairstyle, gender expression, drug use, and sounds—made them the ideal bogeyman for a country invested in securing the support of its upper and middle classes. These subcultures, however, were far from an actual threat. As Tere Estrada explains, in addition to museums and art spaces, rock, punk, and metal also moved to universities and high schools and were promoted by cultural curators.[27] But regardless of such growth, these genres and the young people associated with them remained scapegoats for the Mexican media throughout the 1980s.

I emphasize these details because they are necessary to understand the social context in which these scenes and the subjects within them came to thrive. Punk and metal were not simply genres that allowed the expression of teenage alienation, but instead were the result of a complex network where the often unmentioned class politics of a changing city came to a head. Rather than a mere curiosity, these subcultures were explicitly targeted by the authorities and a mainstream culture that saw them as a danger to the social and economic fabric of the city. And, as mentioned in the opening example of this book, many denizens of Mexico City continue to believe that spaces like El Tianguis Cultural del Chopo pose a great danger.

As I explore below, punkeras and metaleras found a home and a pos-sibility for survival in the city's burgeoning performance scene, which thrived on illegality. Many of the aesthetic sites I discuss existed outside of the official domains of the contemporary art scene. The sonic aggres-sion of punks and metalheads functioned both as an aesthetic mecha-nism and a formal one, as evidenced in the use of abandoned spaces and the use of a furtive cinema vérité style in the case of Minter's *Alma Punk*.

Feminism in the New Subcultures

Given that this particular history actively obscures sound, punk, and women, research has been a challenge. In my years returning to Mexico City, I often found myself faced with the reality that, due to a lack of resources, few of the bands and artists in these subcultures were offi-cially documented. This chapter is thus also an attempt to articulate the necessary work of bringing together the aesthetic and the social through

various moments of what I name the bootleg encounters that allowed me to piece together these histories.

As Tere Estrada chronicles in her encyclopedic *Sirenas al Ataque*, women always played a major role in the history of rock in Mexico, even if their careers were often limited by record companies, agents, and conservative social mores.[28] But as Licia Fiol-Matta argues in *The Great Woman Singer*, female performers have time and again found ways to escape these restrictions through their very performances and the material specificity of their singing.[29] As metal and punk remained underground, their sounds endured outside the purview of the main-stream. The absence of Mexican and Latina women punks in the archive has been remarked upon by scholars like Michelle Habell-Pallán, who writes, "although these women helped shape the sounds and concerns of the local independent music community, with a few notable exceptions almost no scholarly documentation of their participation exists."[30] Other scholars working in Latina/o sound and music studies, such as Deborah R. Vargas, Alexandra Vazquez, and Licia Fiol-Matta, have additionally suggested that encountering the contributions of female artists in the transnational Latina/o archive demands looking past official records, and instead turning to stories, gossip, and other forms of distribution that exceed official narratives of hemispheric sound.

The ethos of the punk archive at its most transgressive enacts a refusal to be documented, a refusal to be committed to nostalgic memory. And, in places like Santa Fe and Ciudad Neza, middle-class demands for archival memory and official narratives held little meaning anyway. It was in these neighborhoods that one of the most important figures of the Mexican punk movement emerged: La Zappa Punk. Patricia Moreno Rodríguez adopted the moniker partly as a tribute to Frank Zappa, but also because her family had "worked with shoes and leather"—*zapato* being the Spanish word for shoe. She was a core member of bands like Secta Suicida Siglo 20 (Twentieth-Century Suicide Sect) and Virginidad Sacudida (Discarded Virginity). In an interview with Julia Palacios and Tere Estrada, La Zappa Punk describes one of her acts, Susy's Peleoneras Punk (named after the Ramones song "Suzy Is a Headbanger"). According to her recollections, the band was made up of women and girls she had met on the streets—up to thirty-two at a time—and the group functioned more like a women's collective than a traditional band. She de-

scribes them in the following way: "The band was like family; we were very close. Some were single mothers from the street, others came from neighborhood families. The *chavas* [Spanish slang for 'girls'] who ended up pregnant were helped according to whatever they decided. It was a form of resistance against marginalization and repression in a system as rotten as ours."[31]

I was fascinated by this description of the group in Estrada's collection of La Zappa Punk's memories and hoped to find out more, but over several research trips to Mexico City, I found almost nothing about the band other than the story La Zappa Punk had already provided. I had visited El Museo Universitario del Chopo's impressive Mexican punk zine collection and frequented El Tiangüis del Chopo's still-thriving Saturday market in search of any traces of Susy's Peleoneras Punk. I asked vendors and other members of the scene I came across for any memories of the group. But the band simply refused (or had no means) to be written or recorded into Mexico's existing punk canons.

In fact, La Zappa Punk's recollections of the band—and Estrada's own findings—provide the very reasons for their refusal to be integrated into the archive. The group's members were most likely women attempting to escape from dangerous situations: they had no interest in being found. We might also assume that they never had access to a recording studio in which to record an album. The large number of women in the group means that most likely only a handful of them ever played live at any given time, a self-generating rotating lineup anchored by La Zappa Punk.

I encountered a text that had escaped the archives and bibliographies of Mexican punk I was so familiar with: José Manuel Valenzuela Arce's *¡A La Brava Ése!* Originally published in 1988, the book chronicles two major youth subcultures, cholos and punks. It is organized as a Marxist/Gramscian analysis of these groups, supported by a series of fragmentary anonymous ethnographic interviews, which run anywhere from a sentence to a page long. Valenzuela Arce gives little information about the interviewees, using their stories as evidence of his larger argument. One of the primary themes of the book is how young people adopt these styles to protest against systems of inequality, and the text is particularly attentive to the struggles that women face in these subcultures. Although the book primarily chronicles the emergence of these subcultures in the border city of Tijuana, Valenzuela Arce devotes one large section to punk

in Mexico City. The interviewees describe feelings of social dispossession, and several women highlight the fact that, while feeling distanced from society played a part, their adoption of a punk lifestyle came more from feelings of alienation from their families and the patriarchy. Amid these stories I found an anonymous interviewee who says:

> When we started to come out there was a band playing, and they played "Susy Is a Headbanger" (peleonera), and the girls liked it. We are not from the same place, some are from Ixtapalapa, some are from San Felipe. Right now the majority of the Susys are from San Felipe, but we all get together. Then we started getting together, to talk, and everything started. No pues que onda [oh hey, what's up], let's start a band, let's call ourselves Susys Punk—the Susys ended up sticking. When we go to a show we all wear skirts and on our shirts it says Susys Punk.[32]

This disrupts several assumptions that I had been working under when looking for the band. For one, the name is different, omitting the Peleoneras moniker La Zappa Punk had mentioned in the interview with Estrada. Other details emerge as well—for example, the idea that the band members all adopted the Susy moniker, creating a sense of collectivity that in some ways displaced their everyday identities, at least before their audience. It provides an entirely new way of referring to the band and its members as Las Susys, a name by which they were probably referred to during their short heyday. I had also originally assumed the members of the band were mostly in punk attire, but this was the first evidence that the band members maintained an explicitly "girly" aesthetic in their adoption of skirts. It also reveals that even if these women were marginalized, they still managed to thrive in the social world of the larger punk scene.

And yet rather than attempt to authoritatively correct the archival absences of Las Susys—or any other countless Mexican punk bands of the period—I am instead moved to interrogate my own desires to find them. Perhaps this impulse comes from a certain sense of queer Mexican solidarity with a group of women who so fully elided and resisted the potentially oppressive cultures of their surroundings. I cannot help but read both the sense of feminist collectivity and the alternate forms of queer relationality the band practiced. In this sense, Susy's Peleoneras

Punk could be said to embody what theorists Stefano Harney and Fred Moten have called the "undercommons."[33] But this is an undercommons that, in its punk ethos, refuses to be integrated into the tenets of proper political and historical remembering. They remain encapsulated in fragments, recollections that can never be anything more than elusive for a listener that will never get to hear them. Susy's Peleoneras Punk's near absence from the archive does not foreclose the possibilities of knowing the kinds of scenes they emerged from nor those they enabled. In the final part of this chapter I delve into Sarah Minter's *Alma Punk* to explore how, through its vérité style, the video captures a glimpse of these scenes and their feminist contestations.

Another major element that allowed feminist art in the 1990s to flourish was the legacy of female artists of the 1970s and 1980s. As Gabriela Aceves Sepúlveda explains, "the visual and embodied manifestations of feminist activists and media artists [. . .] challenged established structures of power and knowledge and [. . .] opened up avenues of expression to different forms of political subjectivity." She continues, "their works constructed a different range of archives (both in content and form) from which alternative histories could emerge and spoke to changing and emerging regimes of media and visuality in which normative representations of the female body—both aesthetically and in formal politics—were being contested."[34] For example, we can nod toward the work of Polvo de Gallina Negra, the group formed by Maris Bustamante and Mónica Mayer in 1983 as a response to the overwhelming sexism of the public sphere. Bustamante and Mayer had become renowned artists in their own right throughout the late 1970s, the former as a founding member of the collective No-Grupo and the latter through her public interventions. Their work together in the 1980s made essential contributions to the public perception of female artists, crossing museums, public spaces, and, on a few memorable occasions, even television. The group derived their name from a powder used in popular markets to ward off the powers of the evil eye. In retrospect, these early interventions presaged the appearance of the more well-known Guerrilla Girls in the United States, yet Polvo de Gallina Negra's ability to interfere in the public sphere exceeded even the Guerrilla Girls' biggest actions. The punkeras and metaleras of Mexico City's outskirts and an older generation of feminist artists

laid the groundwork for women who got to observe these worlds. These cultures would meet during the dawn of the 1990s in new, alternative spaces, where punk, metal, performance, installation, and other aesthetic forms would thrive.

The feminist music scenes I follow in this chapter are entangled with the story of a changing city. Essential to comprehending the early work of SEMEFO and Minter's *Alma Punk* is tracking their interventions into unsanctioned spaces. I draw from Kirstie Dorr's suggestion to "[theorize] the constellated practices of imagination and performance that transform street corners into sound stages, sidewalks into vending stalls, private patios into public nightclubs, or living rooms into theater venues."[35] Thus, abandoned mental hospitals became performance venues, and illegal street vending sustained otherwise criminalized musical cultures. Dorr's call to think of performance geographies as a methodology that may comprehend the flows of sonic circulation is especially important to apprehend how feminism, sound, and space became inseparable sites for the rise of a Mexican counterculture.

SEMEFO and Metal Feminisms

As punk and metal undergrounds moved from the margins back into the center of the city through the end of the 1980s, they met a burgeoning art scene that was redirecting the course of Mexican contemporary art. Especially significant was the appropriation of abandoned spaces, where the lines between musicians, artists, and publics were blurred. This section focuses on the early works of the art collective SEMEFO, which centrally consisted of Teresa Margolles, Arturo Angulo, and Carlos López. Their performances and installations helped launch Mexican contemporary art onto the global stage. They took their name from the federal agency tasked with retrieving bodies from crime scenes, performing autopsies, and cremating corpses when families are unable to do so. Local SEMEFO branches often run out of space for dead bodies, resorting to so-called *fosas comunes*, or public mass graves. Although the group would become best known for their later installations, SEMEFO's earliest performances brought together performance and music in a way that set the stage for the rise of necroaesthetics in Mexican contemporary art. These performances were influenced by the rich aesthetic

traditions of death in Mexican culture and art, but became known as well because of the group's innovative use of sound.

El Tianguis Cultural del Chopo and other such sites became congregational locations where students from UNAM and the working class came together and traded records, drugs, and styles. An abandoned psychiatric hospital, La Floresta, became one of the main spaces for a new scene that brought SEMEFO to prominence. In this space, the group's members would interact with students, artists, and performers to inform their practice. When SEMEFO first met, as UNAM students in the late 1980s, "the members started working around the visual and musical influences they shared. [. . .] They used visual resources bringing them together with music and theatre as cathartic elements so as to provoke their audience—this included urinating on the public or even getting into fistfights."[36] The musical influences they most shared were death metal and hardcore. The group's earliest incarnations included a metal band that accompanied and structured many of their performances, and who would eventually record an album, *Laervarium*. According to Luis Javier García Roiz, the use of death metal in these performances "dared to show something that is not supposed to be shown, what we are most afraid of: our certain future. For Semefo, music was always a cathartic, inspirational, and provoking element."[37]

SEMEFO's performances explicitly derived from the underground music cultures that had thrived in the city's outskirts in the previous decade. In a short piece from 1996 on the work of the group, Naief Yehya wrote, "There is no such thing as a silent SEMEFO performance. Wherever the group presents its flirtations with atrocity, one hears the deafening rhythms of the band, which has passed through covers of classic tunes, the hardest rock, experimental noise, and Grind Doom Death Metal, a genre whose sound attempts to pay homage to every one of its adjectives."[38] Yehya continues,

> Semefo's music is, for many, an inseparable part of the whole of their show, and is intimately related to the physical violence, excess, secretions, and mutilations of dead flesh that the rest of the group [. . .] partake in. But it is worth the effort to submerge one's self in the hasty violence of its compositions in order to discover a very vital and interesting group which in no way limits itself to making background noise.[39]

The group was especially adept at making use of those abandoned spaces where sonic subcultures and a young generation of artists were meeting. In a review of *Viento Negro* (Black Wind), the group's first public performance in 1990, Estela Leñero describes the scene:

A rock band—with its members dressed in white as nurses—opened the show

> playing thrash metal music. First appeared a man, with his body painted in brown and green, throwing entrails everywhere. Then a woman painted in white with a real hog snout resembling a penis danced. [. . .] They were making love violently, while also making it to "Christ" tied to a tree. The audience would come closer or try to get away from the man who threatened them with throwing the entrails or hit them with a heavy tool.[40]

Near the end of the performance, the woman (Mónica Salcido), cut the strapped-on hog snout until it bled. The performance took place at La Quiñonera, one of the emerging performance and art spaces in Mexico City at the time. *Viento Negro* seems shocking even today with its placing of the female body as a site of action and desecration. The metal band's ghoulish outfits, punctuated by white makeup, set the scene by pairing the sonic assault of the music to their visual presence. By doing so, the actions on the makeshift space—the gallery's patio—are transformed, preparing the audience for the assault to follow. The first figure to emerge, the man, challenges the audience by threatening them with animal entrails. Accounts of the group's performances and installations highlight the smells produced by a number of substances and objects in their pieces—strongly intervening into all of the viewer's sensorial realms. The introduction of the female body throws the audience into further disarray. She jerks with sudden movements, clashing at times with the male figure. Their trysts are both violent and sexual. He drops her and pretends to fuck her while she is on her knees. Yet her body is not victimized. By wearing the visible pig snout on her strap-on and matching the male's actions, she challenges the role of the female body in performance. Most saliently, her final action of sitting as she cuts the snout with a razor blade draws from male anxiety and ultimately functions as a symbolic castration.

Figure 2.3. Still from SEMEFO, *Viento Negro*, 1990. Teresa Margolles Collection.

There is a rich tradition of explicit, transgressive, and dangerous uses of the body in the history of performance. As Amelia Jones writes, feminist body art "activates a mode of artistic production and reception that is dramatically *intersubjective* and opens up the masculinist and racist ideology of individualism shoring up modernist formalism."[41] Jones explains that feminist body artists "*particularize* their bodies/selves in order to expose and challenge the masculinism embedded in the assumption of 'disinterestedness' behind conventional art history and criticism."[42] Jones directs her study to the ways in which body art intervened in the prevailing critical and aesthetic discourse of postmodernist art. Her argument helps us to grasp the disjunctures produced by SEMEFO. Their early performances challenged existing relational forms, pulling the veil back on their audiences' perceptions of the female body, marking it as a site of desecration and unruliness. Performance theorist Laura G. Gutiérrez has explored the ways in which Mexican feminist artists of the 1990s used performance to "unsettle" Mexican national discourses of sexuality as they become attached to normalizing women's bodies. She argues that these artists' work "unsettles heterosexual national culture" by deploying their bodies as publicly transgressive through their use of explicit sexuality.[43] Gutiérrez highlights how "unsettling" is meant "to signal the idea that 'unsettled comfort' or *dis-*comfort may in fact be a way of life [. . .] and that it is, above all, a politicized and queer modus vivendi."[44] Following Gutiérrez, I want to suggest that *Viento Negro* stages a purposefully unsettling set of actions with and against viewers. The accompanying metal band prevents the audience from looking away, instead sealing the space with a sonic assault that entraps the viewer by all senses. In doing so, the performance calls the audience into becoming collaborators rather than antagonists, breaking down the distinction between artist and audience in an attempt to create a potentially unsettled collectivity able to challenge a misogynist and patriarchal national culture.

The group's second major performance in 1990, *Imus Cárcer*, once again employed the metal band to structure the proceedings. Marco Antonio Rueda, writing a review of the piece for the newspaper *El Universal*, sums things up:

> Suddenly, a nun with a torch appeared on stage, where she started to
> walk, repulsively. Heavy and sharp notes from the musicians roared in

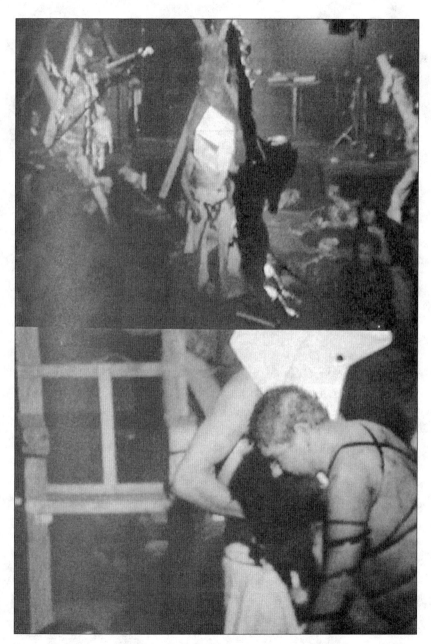

Figure 2.4. Still from SEMEFO, *Imus Cárcer*, 1990. Teresa Margolles Collection.

our ears. The multitude surrounded the nun, who dangerously threatened them with fire. The executioner arrived dragging what we later knew was a convict. He kicked him, whipped him with a belt, dragged him, and trampled him right in front of the blazing eyes of the nun, who took off her habit revealing a chastity belt and a brassiere with pointy ends, ready to destroy anyone who embraced her.[45]

The audience knew very little about the piece—only that the members of the band had previously formed Caramelo Macizo, one of Mexico's most influential metal bands, and that the title of the piece was taken from the name of a medieval prison. The performance, steadily growing in intensity, culminated in a scene again described by Rueda:

The executioner, the nun, and the tortured man began to take out chicken entrails, throwing them everywhere, no matter where they fell. . . . Compared to other audiences, these spectators integrated themselves into the show. One of them even began to beat the floor with a chain, while others accompanied the nun in her nymphomaniac, lesbian dances. Everything happened in fractions. The music continued beating down on us, not only in our ears but in all our other senses, producing a great existential exasperation. The climax came when they placed the tortured victim on the chair and pretended to behead him with the axe. The executioner focused his instincts on the nun; he sullied her, beat her, tortured her, hung her, and she gutted an animal from up above and spilled the blood all over. The act ended with her beheading.[46]

I wish to highlight two major elements from Rueda's summary. First is the sound itself. Action in the piece is not so much accompanied by the music, but rather a reflection of the sonic thrust provided by the musicians. The activities on stage extend to the viewer's body, giving them the option to deny patriarchal complicity and join in with their destructive acts and what Rueda describes as the "existential exasperation" produced by the performance. Jairo Calixto Albarrán gives a further sense of the sonic elements of the performance in his review for the daily newspaper *Excélsior*: "Then begins the thundering of two smashing metal rods, the fierce growl of a guitar accelerating elliptically and racing off towards unknown places, of the strings of the bass that controls, digitally, the

rhythms crashing in psychotropic stampedes, beyond the reach of the force field of the ruling mechanisms of melody."[47] Albarrán closes his review by calling the piece "the longest fifteen minutes in the history of Mexican rock."[48]

In the introduction to their anthology *Metal Rules the Globe: Heavy Metal Music around the World*, Jeremy Wallach, Harris M. Berger, and Paul D. Greene explain that metal "has become a viable mode of resistance, of identity assertion, and of self-empowerment, often in the face of powerful, totalizing, and even life-threatening forces."[49] Framing their discussion through the paradigm of globalization, they argue that "metalheads around the world are responding to [. . .] globalization in ways that reject both conformity to a new global capitalist order *and* narrow fundamentalisms based on ethnicity, religion, or locality."[50] Indeed, metal cultures may be observed in many "turbulent" parts of the world. The editors identify metal's "affective overdrive," produced primarily through sonic specificities: "through heavy guitar distortion, volume, speed, tendencies toward atonality, and distorted vocals, metal explores extremes of human expression, gesturing toward escape, empowerment, or transgression."[51]

Although SEMEFO's work would increasingly find a home in the museum, eventually leaving their performance practice behind in favor of installation, what attracts me to their early performances is their sheer ferocity. Both of the early pieces described above have desecration as their central theme—of the space, of the audience, of the female body, of the phallus, of religion, and of the law. But if the bodies on these makeshift stages seemed to perform against patriarchal norms by using feminist abjection, it was the punishing pulse of metal that allowed it to offer the possibility of catharsis. Indeed, as Carlos López explains in an interview with Luis Javier García Roiz, "the intention was always to supplement the catharsis brought about by the visual experience with a background of aggressive and obscure music [. . .] often the script—if you can call it that way—was determined by the music. All of our performances were conceived with music as part of them."[52] Out of all the genres discussed in this book, metal is most often excluded from people's listings of their favorite types of music. Metal's satanic imagery has also provoked anxiety and even panic, giving SEMEFO's desecration of holy figures its potential for terror: the biggest anxieties around metal brought to life. Step-

ping back, we also see how SEMEFO's work elucidated the kinds of social worlds that become possible through actions such as the repurposing of public spaces and alternative forms of circulation that supported the development of these emerging contemporary art scenes.

Sarah Minter and the DIY Aesthetics of the Bootleg

Despite the relative lack of "official" archival records that might provide us with a full picture of the punk and metal scenes in Mexico City in the 1980s, other aesthetic objects manage to maintain a record of this moment. For example, Paul Leduc's 1986 hybrid documentary-fiction film *¿Cómo Ves?* captures the life of the punk scene on the outskirts of the city. We see rock shows—with El Tri and Cecilia Toussaint performing at various moments in the film—as well as the social and spatial lives of the subcultures.[53] The film also highlights the ways in which these young people are continually harassed by the police. Similarly, Sergio García Michel's 1988 feature film *Un Toke de Roc*, shot in Super 8 film, foregoes dialogue in favor of a soundtrack featuring Cecilia Toussaint, Jaime López, and Chac Mool, among others, and tells the story of four young women who escape their repressive family lives to form a feminist collective. Similarly, Sarah Minter's *Nadie es Inocente* (1986) and *Alma Punk* (1992) both make use of hybrid documentary-fiction narratives focused on young punks who reject social conventions to access forms of life that are able to redress their dissatisfactions. The remainder of this chapter focuses on Minter's *Alma Punk*, but it is worth highlighting that, even today, film has been an essential medium to archive or produce a remembrance of these subcultures, e.g., in films such as Hari Sama's *Esto no es Berlín* (2019) and Julián Hernández's *La Diosa del Asfalto* (2020), which both return to the now mythical scenes of the punk underground in Mexico City to provide an alternative and expansive view of the contributions that these subcultures have made to Mexican culture. Indeed, even as official histories remain silent when it comes to the contributions and important forms of life that these scenes offered young people who had been dispossessed by an increasingly neoliberal Mexican state, we find traces of their everyday life by expanding the reach of the archive to include the ephemeral moments that films like these captured or aimed to recreate. Another important detail is that the majority of these films focus on teenage girls, which

reveals just how central these subcultures were, and continue to be, in shaping a notion of working-class feminism in Mexico.

Sarah Minter's fifty-six-minute video piece *Alma Punk* narrates the story of its protagonist, Alma, a wayward punk who traverses the space of Mexico City. The title is the protagonist's name but also means "punk soul," locating something essential to her very being in this sound and lifestyle. I am especially drawn to this work because it archives (anti)communities that could not be captured otherwise; and in fact, La Zappa Punk is credited among the main artists in the piece's soundtrack, giving us a glimpse of what their scene might have been (and sounded) like. The video is shot cinema vérité style, capturing Alma's daily activities on Mexico City's unruly streets. Minter's camera lingers on small moments, creating a sense of intimacy and even familiarity between the viewer and the main character.

Minter's name is absent from most official chronicles of Mexican contemporary art. In fact, none of the scholarly texts discussed in the previous section mention her work and, until fairly recently, none of her videos appeared in exhibitions of Mexican contemporary art from the 1990s, which usually reserve spots for feminist video artists. This is due in part to the fact that Minter was slightly older, making her first forays into the art world in the 1970s, during the heyday of Alejandro Jodorowsky's early work in Mexico—even appearing as an extra in *The Holy Mountain* (1973). Minter died in 2016, the year after her one major career retrospective was hosted by MUAC (Museo Universitario Arte Contemporáneo), giving audiences the opportunity to consider the scope of her work in one of Mexico City's most important contemporary art museums. As her retrospective made apparent, classifying her feature-length videos among the works of artists with more abstract formal preoccupations involved in performance, installation, and experimental video is challenging. Both of Minter's works dedicated to chronicling the Mexico City punk scene, *Nadie es Inocente* and *Alma Punk*, require viewers to sit in galleries for long periods of time, blurring the lines between narrative film and video art. But Minter saw herself primarily as a video artist, even if her oeuvre might appear at first to be more closely related to narrative and documentary filmmaking. I am particularly interested in the ways Minter's work as a video artist captured the sounds and sense of unbelonging, foreclosed to traditional archives.

Minter was also especially committed to the aesthetic affordances provided by video's rudimentary look. In many ways, what might appear as aesthetic insufficiency instead emerges in Minter's films as the perfect vehicle to give us a sense of otherwise lost punk worlds. Although *Alma Punk* might have the narrative structure of a feature-length film, video allows for specific formal elements. If *Alma Punk* had been shot in 16mm film, it might have been distributed in traditional film markets. Given the social status of punks at the time, it is difficult to imagine any Mexican film company providing funding for a film about a young female punk—especially one that refused to make her an example of social decay. The low-fi video quality gives viewers the feeling that they are watching a bootlegged product, smuggled into the gallery. The camera follows the protagonist, with Mexico City as a backdrop, making unwitting participants of unsuspecting passersby, heightening its sense of immediacy. Video remains an understudied genre in Mexican contemporary art, although certainly a new generation of artists were exploring the possibilities of video in their art practice during the 1980s and 1990s. In a short text tracing the histories of video in Mexico, Minter suggests that formats such as Super 8 and later video gave artists invested in formal and political radicalism a potent tool.[54] For her, these formats were key to resisting television's influence as the country's primary purveyor of information. This is especially important considering that Televisa, the nation's major television network, effectively functioned as a mouthpiece for the Mexican government by holding a monopoly up to the 2000s. Minter also underlines video's ability to capture the city's poverty during the 1980s—a social reality that television and film refused to cover—and especially the lives of punks, whom she identifies as the most demonized subjects of the era. Minter emphasizes that with *Alma Punk* and her previous effort, *Nadie es Inocente*, she explicitly sought to bring together documentary and fiction to capture a punk world that had been otherwise vilified in the mainstream.[55]

Even within a museum/gallery context, *Alma Punk* retains its DIY aesthetic. One of the video's recurrent elements is the camera's following of Alma, unbeknownst to the people around her, creating a sense that fiction and documentary are coming together. If *Alma Punk* had been shot on film it would have certainly lost the sense of immediacy it produces in its interactions with everyday locales, and locals.

Soulful Punk

Alma Punk's narrative is fairly straightforward. Alma, played by Ana Hernández, wears her punk style well. She has short, choppy hair, a pair of black boots, and T-shirts and jackets instantly recognizable to anyone who has ever been in a punk scene. Her attitude alternates between that of a punk and that of a girl looking for something beyond her local world. We follow her interactions with lovers and friends over the course of a few days. The scenes for the most part withhold dramatic tension in favor of conversations between the untrained actors that waywardly move from moment to moment. The feminist punk scene in Mexico City lacked any sort of archival resources to memorialize itself, but Minter's DIY approach provides viewers a glimpse of this subculture in all its ordinariness. Alma is our guide, showing us not only recognizable monuments like the Zócalo plaza and Centro Histórico, but also sites that do not appear in tourist guides—from the original Mercado del Chopo to a landfill. These moments convey the everyday experience of punk survival in the city.

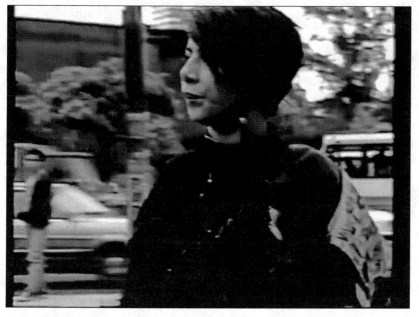

Figure 2.5. Still from Sarah Minter, *Alma Punk*, 1992. Screenshot by author.

Alma Punk captures seemingly minor moments throughout its running time. It is especially adept at showing time passing, as one day bleeds into the next, en route to the climactic eclipse. The most enjoyable scenes are the moments of sociality among Alma and her friends, scenes of hanging out that would have never been caught by mainstream film or any other media. For example, during a hangout to create a zine, we see Alma with her social circle (made up of other punk girls) sharing a beer and a joint. Their stoned interaction is a moment of revelation on various levels. Drinking and drug use are shown as part and parcel of shaping sociality, without ever gesturing to middle-class castigations. This sequence consists of a series of extreme close-ups—eyes and mouths captured upside down as the conversation turns to the boys in their lives. Alma concludes, "I'm really fucked up," referring to both her mental state and her life circumstances.

Such moments of female friendship were rare in visual media, and perhaps most striking is an abortion subplot. Alma welcomes two girls into her apartment and we realize then that one of them has just had an abortion. The latter falls asleep as the other friend shares a book about great women in Mexican history with Alma. The discussion turns to another previously lent book about suicidal poets.[56] The video refuses to make any judgments, instead simply showing care for the girl's wellbeing after an abortion. Although abortion was illegal in Mexico, *Alma Punk* treats the moment matter-of-factly, revealing alternative forms of care that punk women had established for their survival, as La Zappa Punk mentions in her own recollections. Pregnancy and abortion are folded into the narrative because they happen, but Minter refused to let illegality structure any discussion of it. I am also struck by how this moment is punctuated by the girls' take on suicide. Alma asks, "Yeah, Sylvia Plath, how do you like her stuff about suicide?" to which the friend replies, "I don't know if that was her ideal. But it's pretty heavy duty, suicide, isn't it?" Without skipping a beat, Alma replies, "Our destiny." This exchange segues into another conversation indicating an interest in suicide that is not cast as dramatic or as pathologizing the girls. For them, suicide is an option. The moment resists didacticism; it simply exists within the time of the hangout.

Especially effective are the film's depictions of real-life locales, shot in vérité style, which folds the narrative into the everyday. In one sequence,

I don't know if that was her ideal.
But it's pretty heavy duty, suicide, isnt' it?

Figure 2.6. Still from Sarah Minter, *Alma Punk*, 1992. Screenshot by author.

Alma stops at the municipal landfill, where she meets a male friend. Among the heaps of garbage, she finds a few items to sell at the market, including a pair of boots. As they walk away, the friend tells her that he's exhausted from the smell of corpses, indicating that, amid the rubbish, abandoned bodies may often be found as well. The sequence that follows shows El Mercado del Chopo, where banned recordings circulated as bootlegs and where sonic subcultures gathered outside of the official purview of the law. Minter shows a man getting a crude street tattoo in the open air, after which the camera pans to Alma, a blanket splayed before her with some records and the aforementioned boots for sale. A man inquires about the boots, which she's selling for ten pesos, despite their condition. She claims that the spikes in the boots are "imported" and thus worth the extra two pesos—a perverse and portentous commentary on NAFTA's ongoing assurance that Mexicans would have access to better manufactured foreign goods after the signing of the treaty.

Alma Punk also comments on the persecution of punks by the police in a scene where a group of men enter the bar where the punks

Figure 2.7. Still from Sarah Minter, *Alma Punk*, 1992. Screenshot by author.

have been hanging out. The cops smash bottles, beat up the clientele, and even stab Marco, one of Alma's paramours. Yet the scene does not simply decry the illegality of such an attack. While we are made aware of the unjustness of the attack, the scene shifts to Alma's care of Marco, telling him that he needs to stop complaining, that it can't hurt that bad. Its realist style refuses to lecture the audience, instead showing such exchanges as a normal challenge of everyday survival.

A particularly striking moment in *Alma Punk* is its depiction of the intersection between punks and the emerging art scene. After Alma has been kicked out of her apartment, she roams the streets of the Centro Histórico, where she stumbles into what appears to be a performance festival. We see performers and dancers occupying a number of seemingly abandoned spaces, including a striking image of two men surrounding a woman, their bodies covered in silver paint and wearing Greek robes. Alma observes a proscenium where a band is playing, and a man speaks into the microphone, "Ladies, and gentlemen, citizens of Tenochtitlan, Aztec warriors from Europe, let's cheer up the spirit. We present you the work of many people that nobody knows." This scene is intercut with various shots of the performances around the space. Although the camera does not remain for long on any one performance, we get a sense

of the spatial appropriations that brought punks and artists together, joined by their anonymity, their status as "people that nobody knows." Yet even if the moment lasts only the span of Alma's movement through the space, this sequence is one of the very few documents that captures a moment where dispossession increasingly became redefined through aesthetic invention, setting the stage for work that would come to dominate the contemporary art scene in the following years.

Alma Punk also shows a recurring element of the Mexican experience: that of migration to the United States. Although Mexican migration has experienced ebbs and flows, the nation's declining economy forced a younger generation to attempt the difficult act of undocumented crossing. Early in the film, Alma reveals that her mother is already in the United States, and that she plans to attempt the journey herself, not only to see her mother, but also to work and make some money so she can travel. We never hear any references to a paternal presence, only the relationship between Alma and her mother, separated by geographic distance. Shortly after becoming homeless, Alma hops aboard a train to

Figure 2.8. Still from Sarah Minter, *Alma Punk*, 1992. Screenshot by author.

Tijuana, where she is welcomed by another punk she met at El Mercado del Chopo. After spending a couple days in Tijuana among the city's burgeoning industrial/goth scene, she heads to the border fence. A new paramour asks why she wants to cross to the US, since in Tijuana she can find "puro pari pari" (nothing but partying). Alma replies that there are too many cops looking for bribes, to which the man affirms that cops are "the plague of the world." They walk to the border fence near the beach, where he says, "This is where T.J. [Tijuana] ends, where everything ends." She replies, "All of Mexico ends here and all of Latin America as well."

This conversation happens overlooking a beach marking the separation between Tijuana and San Diego, and in the distance we see American skyscrapers. He tells her how difficult it is to cross, to which she says, "Fucking gringo assholes, they can cross but we can't." But Alma has made up her mind to leave. The video's final sequence shows her running alongside the border fence, intercut with a close-up of her observing the visible grounds of the United States, with a tracking shot of endless other immigrants looking to climb over, stuck in the space between the two nations. As the closing credits appear across the screen, we see Alma climb the fence to the other side, along with shots of other immigrants like her. The experience of border crossing is treated with the same sense of the quotidian as other moments in the video.

Most films about immigration made on either side of the US/Mexican border treat the experience with a sense of humanitarian panic, flattening the immigrant's experience into a melodrama of injustice that puts pain on display for liberal viewers. Here, the reality of this injustice is treated without fanfare. Alma knows the cops are pigs, that the US is unjust, that the border fence is just an illusion, where all of Latin America ends. But the realistic dialogue and acting style avoid heavy-handed moralizing and dramatic excess. Reality—even at its most unjust—rarely has the staged ardor we see in other media. Minter encapsulated modes of exchange, sociality, entertainment, survival, and existence of punks who were excluded from a Mexico attempting to show its economic capacity for modernization. It's a form of respect to ways of life that refuse to be folded into disciplinary existence. It's also a deft deployment of the bootleg aesthetics that animate this chapter.

Alma Punk concludes where the following chapter begins: with a girl punk leaving Mexico behind in search of different opportunities by

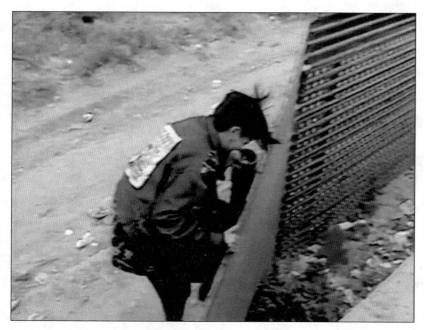

Figure 2.9. Still from Sarah Minter, *Alma Punk*, 1992. Screenshot by author.

crossing into the United States. In some ways, this is another relation-
ship defined by illegality that the video performs. Like the bootleg, the
practice of crossing and immigration have been defined as "illegal," giv-
ing the state the power to define the relationship between bodies and
lands in ways that *seem* logical, stable, legal. And indeed, perhaps the act
of becoming an "illegal" immigrant is haunted by piracy itself: bootleg
citizens. Like Alma, the rest of this book leaves Mexico behind to follow
the sonic pathways of dissent as they cross over to the United States,
where punk and '80s British music gave Latina/os their own tools to
negate the promise of belonging.

3

Dyke Chords

Chicana Punks and Lesbian Dissolution in the
Performance of Las Cucas

If punk has been an important way for women in Mexico and Latin America to sonically articulate a sense of angry dissatisfaction with the state and their general cultural context, it has also thrived in the United States among Chicana feminists. This chapter embraces a longing for the destruction of the self in the pangs of love, a sensibility that emerges through sounds that thread the line of self-annihilation. I argue here that these forms of negativity work as an ethics anchored in queer feminist desire. Considering how Latina/o music is often registered as being in a major key—as a source of positivity and pride—I turn to punk's sonic negations to suggest that, for Chicanas and other Latina women, such minor sound has been essential to critique and counter the demands placed on them by the mainstream of Chicana/o politics. In particular, I argue that punk has afforded Chicana feminism a powerful vocabulary with which to articulate forms of desire that exceed normative Latina/o politics and culture. This chapter gives an account of what Latinidad contributes to a queer ethics (and vice versa), and how lesbian desire and sex, so often ignored in the ethical vocabularies of queer theory and Latina/o studies, enables us to engage with questions of negativity and identity itself. Anchoring this discussion is the Chicana lesbian punk who—like the Morrissey fan in the next chapter—has become an important, if surprising, recurring figure in Chicana/o cultural production. The Chicana lesbian punk becomes my guide in thinking through questions of negation, desire, and ethics. As I argue throughout this book, to embrace the position of the reject is a deeply ethical act that reframes the parameters and limits of belonging. I show here that for Latina/os, culturally harmonious sounds and belonging have been central elements in defining

Figure 3.1. Las Cucas. From left to right, Renee Mercado, Al Lujan, Cheryl Tesh, Gigi Otálvaro-Hormillosa, Nao Bustamante, and Marcia Ochoa. Nao Bustamante Archive. Courtesy of the artist.

the cultural contributions of this group within the United States. How might Chicana lesbian desire be a potential avenue to express negation and unbelonging? And what does the intersection between queerness and punk offer the Chicana? How might the embrace of aggression and desire—blurred by the sonic energy of punk—be the beginning of an ethical practice that allows a productive encounter between Chicana and queer feminisms?

I read the Chicana lesbian scream through the language of pain articulated by a meeting between punk and the bolero. I engage the recordings of the short-lived "mariachi punk band" Las Cucas, comprised of Nao Bustamante, Marcia Ochoa, Gigi Otálvaro-Hormillosa, and Al Lujan. Las Cucas provided listeners with an alternative archive of lesbian longing, desire, and sexuality that allows us to reframe the possibilities of a Chicana queer feminism. Although their recorded output consists of only five songs, they remain in the ephemera of memories, photographs, and even an abandoned website whose residues are maintained by the Internet Archive. Through these shards of cultural memory, I stage an

encounter between Latinidad and queerness, listening for what they can offer each other in terms of an ethical engagement with the world.

Although this chapter is grounded by the real Chicanas that have made punk a thriving subculture since the 1970s, my approach here is motivated by the ways in which Chicana punks have jumped off the stage and into multiple facets of Chicana/o cultural production. In other words, I want to suggest that the Chicana punk—and, perhaps more specifically, the queer or lesbian Chicana punk—has become a recurring figure in the realms of literature, film, graphic novels, and other media that both extends from and affects the "real" presence of Chicana punks. Indeed, although we find Chicanas at the very beginnings of punk in Los Angeles (in the late 1970s), they have shifted away from that originary music scene to occupy a productive (if curious) space in Chicana/o cultural production. I draw my notion of the Chicana punk as a "figure" from French theorist Roland Barthes. In his notes for a series of seminars leading up to the writing of *A Lover's Discourse*, Barthes gives his reasons for approaching the lover in such terms: "I have opted for analyzing not a genre, not even a novel, but a discursivity, a mode of speaking; discursivity which, through the method of fragmented figures, has a much larger projective density." For Barthes, "through figures I am narrating *my language, not my life*."[1] The figure thus gives us the possibility of understanding how a discourse works, how it comes to be, and its defining elements. He writes, "the figure is not the element of a structure, it is *fugitivity* from structure: figures don't have a natural phrase, or a natural statuary. They are *isolated elements*, which can be supported by a thousand kinds of phrases, form an indeterminate number of cycles."[2] I deploy Barthes's idea of the figure to articulate how the Chicana punk is in many ways the product of multiple discursive modes of comprehending the boundaries of Chicana women. In doing so, I move away from the need to provide biographical details of specific Chicana punks or even specific geographically located subcultural scenes to instead analyze how and why the Chicana punk has become a discursive figure that reoccurs across different forms of media and genres. Even though I focus on the work of Las Cucas, I want to argue that their songs *exceed* the band and may show us what kinds of alternative discursive constructions are possible when Chicana feminism becomes infused with the convergence of punk and queer desire.

In some ways, this chapter is invested in answering the question of what punk allows queer Chicanas to express that might otherwise be impossible within normative Chicana/o culture and politics. Why, we might ask, have Chicana/o writers, filmmakers, artists, and others sought the Chicana punk—often queer—in their work, when, to the larger American mainstream as well as mainstream Latina/o culture, Chicana punks remain mostly unknown or unrecognizable? Indeed, within the canons of Chicana/o and Latina/o subcultures, few other scenes have been translated from the real world into the aesthetic realm with such force. While, for example, the Latina/o Morrissey fan is widely seen as evidence of a recognizable genre of Latina/o identity, Chicana punks remain somewhat illegible to the mainstream media machine; nonetheless, they reappear again and again in works made by Chicana/o writers, filmmakers, and artists. Thus, although this chapter will focus on the work of an actual Chicana punk band (Las Cucas) and specific artist (Nao Bustamante), I want to suggest that they occupy a space in the Chicana/o cultural imaginary already imbued with meaning. Or, to put it differently, there is something about the image or figure of the Chicana queer punk that becomes realized through the practice of punk in the present.

As Jimmy Alvarado has pointed out, "when mentioned at all, East LA punk is often dismissed as an anomalous ethnic curio [. . .]. The focus is almost always limited to the discussion of three or four bands, one club, and a time period of March–November 1980."[3] Over the last decade or so, scholars, cultural journalists, and those who were part of the original scene have attempted to correct this historical oversight. For example, the exhibit *Vexing: Female Voices from East LA Punk* curated by Pilar Tompkins and Colin Gunckel at the Claremont Museum of Art in 2008 reframes this history. According to the exhibit's description, "music played a pivotal role in defining new images of self" and specifically the ways in which women were central to "the multiple scenes and identities they negotiated."[4] As this description suggests, Chicana punks were invested in more than just the music they created, looking to punk as a fertile site to experiment with modes of self-fashioning that exceeded the demands of the Chicana/o mainstream. With this in mind, we can understand punk as both a musical and cultural scene and an ethos that provided Chicanas with a vocabulary of unbelonging. This mode

of negative attachment follows previous decades of mobilization and consolidation of Chicana/o nationalism, which, as I explore later in this chapter, was perhaps inevitably tied to heteronormative idealizations, restricting women and queers. Reflecting on the exhibition, Gunckel has suggested "several frameworks through which the East LA music scene of the late 1970s and early 1980s might be historicized and understood: the broader LA music scene, the transformation of Chicano art, and the related structural and aesthetic changes in the Los Angles art world."[5] By considering these intersecting frameworks, we gain a wider view of the reasons why that East LA scene (which may at first have appeared to be a transitory subculture) produced the Chicana queer punk as an enduring figure, one that, as the *Vexing* exhibition posits, has "served as a model for subsequent generations interested in alternative social movements as a platform of expression, as well as the post-identity conceptual practices of today."[6]

Punk has historically been one of the most contested genres in terms of its origins. Although the UK and New York are widely accepted as the original sites where punk was born, other expansive notions of what exactly makes punk complicate these origin stories. For example, Marci McMahon identifies Patssi Valdez's style and attitude as exhibiting some of punk's ethos as far back as her tenure as a member of the artist collective ASCO in the mid-1970s, a few years before the explosion of punk proper in Los Angeles. McMahon writes, "Valdez [. . .] demonstrates Chicana punk's investment in disrupting accepted notions of femininity."[7] And indeed, we may find traces of what would later come to be known as punk in an earlier moment of rebellion. In particular, LA punk was influenced by the glam movement, exemplified by artists like David Bowie in the 1970s. Yet even as these accounts have extended the temporal and geographic reach of punk—and while I agree that earlier figures such as Valdez (and Bowie) might offer a "protopunk" style and attitude—I claim that the Chicana punk can be identified specifically as sonically aggressive punk rock was adopted as its own genre in Los Angeles at the end of the 1970s.

Michelle Habell-Pallán has traced the roots of Chicana punk feminism to the late 1970s and 1980s, where "this phenomenon circulated at the same time as other burgeoning Chicana activist and scholarly endeavors, as well as the East Los Angeles/Hollywood punk scenes, all of

which still have not been examined in-depth."[8] Habell-Pallán reminds us that the significant contributions of Chicanas to punk, and of punk to Chicana/o culture, remain mostly undocumented. She writes,

> Perhaps these women do not register in nonacademic accounts because of the way they disrupt fixed, one-dimensional notions of identity. In other words, Chicanas are not punk; women are not true musicians. Hence, fixed notions of Chicana identity framed by the dominant culture do not allow for recognition of these women in discussions of subcultural musical practices or in discussions focused on countering the shrinking of the public sphere.[9]

Habell-Pallán, however, gives other reasons as to why it is so significant that we study the crossroads between Chicana feminism and punk, asserting that "theirs is a story of transnationalism told from the bottom up, in the years leading up to accords like NAFTA, from the point of view of working-class women. Though each woman's experience was different, each was attracted to the punk subculture because it was a place where she could see herself as an empowered subject."[10] And while I agree that it is imperative to locate the work of Chicana punks in sonic archives, as I argued in the previous chapter, doing so necessarily entails expanding our definition of the archive, looking for sounds and legacies in places where they might resist becoming heard, visible to audiences that perhaps were never meant to find them.

To contend with the limits surrounding the construction of the archive, I turn to perhaps one of the most essential and influential members of the Los Angeles punk scene: Alicia Armendariz—better known as Alice Bag. Originally from East LA, Bag grew up witnessing the rise of the Chicano movement in Los Angeles. In her 2011 memoir, *Violence Girl: East L.A. Rage to Hollywood Stage, a Chicana Punk Story*, Bag recounts the influence of the movement on her younger self and how she came to terms with the realities of racial difference during her upbringing. Bag fled an abusive household during her teenage years and became involved with a burgeoning LA punk subculture, where she would become a founding member of the Bags, one of the most influential bands of the scene. The Bags would subsequently be immortalized in Penelope Spheeris's essential 1981 documentary, *The Decline of Western Civiliza-*

tion, which remains one of the few documents to capture Alice Bag's furious and beguiling performance style in her prime. Bag eventually abandoned the scene, which had become decimated in part because of rampant drug use and in part because of Nazi sympathizers who were drawn to the punk aesthetic. Bag stayed active with bands like Cholita, a collaboration with the artist Vaginal "Creme" Davis, but she remained a mostly underground figure, relocating to Arizona with her family to work as a schoolteacher. It is worth mentioning that, in the tradition of many Latina/o artists—from Ritchie Valens to Rudy Martinez of ? and the Mysterians—Bag's Chicana identity was mostly unremarked upon. Which is to say that this isn't solely a question about who is included in the archive, but how the archive is structured. Indeed, *The Decline of Western Civilization* makes no specific mention of the racial makeup of the two Latina/o lead singers who appear in the documentary, Bag and Ron Reyes (the lead singer of the band Black Flag at the time). Yet the influence of punk (and Bag in particular) continued to resonate in Chicana/o undergrounds. Bands such as The Brat, Stains, and Thee Undertakers have carried punk's flag as the genre's popularity ebbed and flowed over the past several decades. And although Bag has remained somewhat of a cult figure, the publication of her memoir (the title of which refers to her as a "Chicana Punk") saw Bag reclaiming her Chicana background, and by doing so also reclaiming the influence of punk on Chicanas in Los Angeles more broadly.[11]

Before Bag's triumphant return to the music scene, the figure of the queer Chicana punk appeared in unexpected places within Chicana/o cultural production, perhaps most prominently in the pages of *Love & Rockets*, one of the first major comic book series to lead the alternative comic scene during the 1980s, co-authored by Gilbert and Jamie Hernandez. The brothers independently produced two narratives across their stories. Jamie's series, *Locas*, focused on the Los Angeles punk scene that they had come of age in, and featured a complicated and sometimes turbulent romance between Margarita "Maggie" Chascarrillo and Esperanza "Hopey" Glass. Although Maggie is ostensibly bisexual and dates several men across the series, her romance with Hopey is one of the major sources of narrative tension over the years. *Love & Rockets* has remained one of the most popular and notable (by cult standards) Chicana/o works of the past few decades.

In the world of film, Jim Mendiola's 1996 short *Pretty Vacant* tells the story of Molly "La Molly" Vasquez, a teenage Chicana in Texas obsessed with punk and the Sex Pistols. She makes zines and plays drums in Aztlan-a-Go-Go, an all-Chicana punk band. We see Molly's zine, *Ex-Voto*, adorned with the subtitle "soy punk y que?" which the protagonist has created to address her need to defiantly bring her punk and Chicana identities together. Although *Pretty Vacant* takes place in a different decade and geographic locale from the original punk scene that Bag fostered, the film shows the ways in which the sounds of punk afforded young Chicana women a space and vocabulary to express their dissatisfaction with the patriarchal demands of Chicana/o mainstream culture across the Southwest.

Contemporary literary works, too, such as Myriam Gurba's *Dahlia Season* and Dia Felix's *Nochita*, tell the stories of wandering Chicana punks who find solace and empowerment by embracing their anger. And over the last two decades Chicana feminist punk bands such as Fea and Las Sangronas y el Cabrón have claimed the sonic imaginary of alternative queer Latina communities across the United States. This chapter does not aim to trace these histories nor to provide a comprehensive accounting of Chicana punks in the United States, as others are currently doing.[12] I note this growing archive to illustrate how this *figure* comes to animate so much cultural production; this chapter shows how this expansive archive warrants an understanding of the aesthetics and ethics of the Chicana punk.

I join the women in these punk archives through the force of the scream, which harks back to the origins of rock and roll and the perhaps unexpected Chicana influence upon them. As Deborah Vargas explains in her analysis of the San Antonio–based Chicana punk band Girl in a Coma, their "musical sound represents a sonic circuit that moves through the place of San Antonio, the bodies of *mexicanas* in rock, and across borders of nation and gender. There has been a rocking reverb in Tex-Mex music; it echoes between the presence of Gloria Ríos's 'primer grito del rock-and-roll en México' and the pasts in Girl in a Coma's music."[13] The reference to Gloria Ríos is especially important when we consider the ways in which Chicanas appear, even if often obscured, in the history of rock music across the border. The San Antonio native is widely considered to be the first woman to record a rock and roll song

in Spanish, which appeared in the film *Juventud Desenfrenada* in 1956. As the star of other Mexican films of the period focused on the detrimental effects of rock music on young people, including *Las Locuras del Rock and Roll* (1956), *Concurso de Belleza* (1958), and *Melodías Inolvidables* (1959), Ríos's originary scream reverberates across time—what Licia Fiol-Matta, drawing on Giorgio Agamben, calls a "voice operating in the realm of the future perfect."[14] Although this chapter focuses on the scream of Las Cucas—of Nao Bustamante, specifically—I take up Fiol-Matta's appropriation of Agamben's concept of the *arkhé* to think of Bustamante's scream as a material presence that carries these other Chicana screams, all operating in the time that has been and which has yet to come.

The Chicana Lesbian Punk vs. Chicano Nationalism

As I have made clear, rather than attempt a recuperative history of Chicana punk, I am interested here in approaching the Chicana lesbian punk as a *figure*, a subject in the Chicana/o imaginary that becomes a repository for larger questions concerning gender and sexuality and their collusion with Chicana/o narratives of social and political triumph. I see the Chicana lesbian punk as revealing and informing new encounters at the intersection of Latinidad and queerness. Thus, this chapter is not concerned with bringing to light those whom the archive has made absent, but rather with the potentialities of a figure that is found recurring in the archives of Chicana/o cultural production despite what would appear to be ongoing cultural antipathy toward lesbians and punks in Chicana/o life. That said, this chapter is not simply about placing Chicana punks in the archives of mainstream Chicana/o history, even if my focus on Las Cucas cannot but bear a certain recuperative longing. Instead, I turn to Chicana punk and its driving desire to reject the demands of belonging in the hopes of creating a mode of engagement with Chicana feminism that forgoes historiographic demands to correct the archives that have left them unspoken.

I argue that punk provides Chicana feminism with an alternative vocabulary of unbelonging based upon a form of aggression that disengages its adherents from the historical demands placed upon women in the dominant Chicano political, social, and cultural imaginary. In

other words, I want to suggest that while the Brown Power movement of the 1970s cast Chicana women in the role of the caretaking mother, punk offered an alternative version of queer feminism rooted in feelings of anger and negation, opening up affective avenues otherwise foreclosed by traditional politics. Furthermore, during the years of the Latino Boom, advertisers identified "the family" as one of its central tropes. Arlene Dávila has previously shown that even as the roles that configure the family have changed in advertising aimed at Latina/os, it is a constant narrative in which "Hispanic women, in contrast to their analogues in the general market [. . .], are more emotionally expressive, family-oriented, and feminine."[15] For advertisers, and their creation of a Latina/o consumer public, this population is perceived as "the most family-oriented, most brand-loyal, and most rapidly growing minority group."[16] Advertisers, of course, are not the only ones seduced by images of the family. As Richard T. Rodriguez has argued, the Chicano Brown Power movement of the 1970s was fueled by a normative investment in "la familia," a move that relegated women and queers to the sidelines. He writes, "If there is a single issue almost always at stake in Chicano/a cultural politics since the Chicano movement of the 1960s and 1970s, it is the family in some shape, form, or fashion."[17] As a result of this, "the archetypal Chicana would necessarily provide a feminine spirit of maternal consolation (in spite of her suffering) while ensuring the procreation, hence survival, of Chicano culture."[18] In a similar vein, Sandra K. Soto has identified the way in which "contemporary Chicana subjectivity continues to be circumscribed by the heteronormative *virgin/chingada* (virgin/whore) sexual framework set in motion by the hegemonic deployment of miscegenation and religious conversion during the conquest of Mexico in the sixteenth century."[19]

To Soto's formulation I add the "mother" as an additional signifier that is often employed in critical readings of Chicana and Latina feminist cultural production. And although the work of Chicana feminism arose in response to these images as part of El Movimiento, the centrality of the mother remains. By projecting the responsibilities of motherhood onto the Chicana, her labor and cultural work must always already be in service of someone other than herself. It is not my attempt here to critique the material realities of the Chicana mother. Poor mothers, single mothers, racialized mothers find themselves under attack far too

often. But I challenge the discursive construction of woman-Chicana-mother and, by extension, of woman as caretaker and guardian of vulnerable gay Latino men, as a trope that often demands Latina figures to take on the affective labor of nurture and care to the detriment of their own sexual autonomy and self-assertion. While lesbian mothers can also of course be sexual, kinky, imaginative, and horny, Latino gay boys often look toward the lesbian as a substitute mother and caretaker who fills the void of affective absence in the heterosexual mother, who must always uphold the law of a punitive father. This chapter places the Chicana lesbian punk at the center, then, to investigate and wade into the ethics of desire. I can't help but nod to Carla Trujillo's edited anthology *Chicana Lesbians: The Girls Our Mothers Warned Us About* and its use of Ester Hernández's "La Ofrenda" (The Offering) as its cover image in one of its editions. The painting shows a Chicana woman, legible to us as a punk because of her spiked hair shaved sides of her head, her back turned to display a tattoo of the Virgen de Guadalupe. This choice of cover shows that the Chicana lesbian is always already a source of anxiety to the family, anticipated by the mother as a figure who may turn her daughters away from the inevitable future of motherhood while also offering an alternative image of defiance against these expectations.

Negativity against Belonging: Latina/os and the Musical Mainstream

Listening to the Chicana lesbian punk is productive for both queer theory and Latina/o studies. However, the story that emerges is not one of self-possession or simple representational reparation. On the contrary, it is one that risks embracing the rhythms of negation in the self: sadness, self-abnegation, self-annihilation, and oblivion.

Much like how Chicano nationalism limits women's political contributions to the home, a major reason why Chicana and Latina punks have remained mostly unrecognized in canonical accounts of Latina/os and their musical contributions is that their culturally dissonant sounds fail to fit into an ongoing narrative tying Latina/o belonging to culturally recognizable musical forms. For example, in January 2018, *Billboard* magazine published an article with the title "How Latin Went Mainstream, and Why It Will Continue to Happen in 2018." The article points

out that, during 2017, "19 predominantly Spanish-language tracks made it onto the Billboard Hot 100. They include, of course, Luis Fonsi and Daddy Yankee's 'Despacito,' which is now tied for the longest-running No. 1 ever, in any language, on the Hot 100."[20] Although the news was met with enthusiasm in Latina/o markets, those familiar with the crossover narrative of Latina/o music in the United States sensed a familiar pattern. After all, the idea that artists who could be identified as Latina/o once they cross into the United States had finally "arrived" in the popular music vernacular of American culture has been repeated in some form or another since the 1950s, as mass-market forms of distribution and national radio networks rapidly expanded during the years after World War II. Indeed, ever since Desi Arnaz and the mambo/conga craze of the 1950s, every subsequent decade seems to have experienced a "crossover" moment in which Latina/o artists took over the popular culture landscape—with the claim each time that they had "finally" found acceptance in the American mainstream.

It might at first seem surprising that this new declaration of Latina/o supremacy on the music charts happened at the same time that Donald Trump's immigration policies ignited almost unprecedented panic in Latina/o immigrant communities in the United States—with feelings enflamed still further by the government's neglectful response to a devastated Puerto Rico in the wake of Hurricane Maria. The *Billboard* article, and its assurance that Latin sounds would continue to dominate the charts that year, might also seem surprising given that, just a few weeks prior, outlets dedicated to covering film and television declared a crisis in the lack of Latina/o representation across these media. And yet this discrepancy should be anything but surprising: throughout the past few decades there has been a recurring disjuncture between the political and demographic presence of Latina/os in the United States and the presumed significance of their musical contributions with each new "Latin craze." Indeed, if the material realities of Latina/os have consistently cast them as eternal outsiders who must be kicked out of the nation, their music has time and again shown the promise of multicultural integration into the national body. As I argue in this chapter, punk has given Chicana and Latina artists the possibility to reject these promises of integration in favor of a sonic refusal deeply invested in challenging the status quo of belonging.

As Jennifer Stoever has pointed out, sound has been a crucial if at times buried component of the very construction of the color line in the United States.[21] After all, even as African American artists have been responsible for perhaps the great majority of new musical genres and innovation in the United States, Black communities have yet to benefit in any sort of structural way. Nonetheless, the sonic in the United States has been continuously imagined as a site of multicultural integration, decidedly more so than any other form of media. Each time that a new Latin music "explosion" has generated a renewed wave of enthusiasm about the potential for an inclusive America, the terms by which Latina/o artists come to be acknowledged within larger musical genealogies have been determined by a number of factors in which race, sound, and bodies become equated.

Unlike in Mexico, where rock-listening youth were subjected to state repression, suspicions around the adoption and dissemination of rock genres have taken a different shape in the United States. For Latina/os in this country, the perceived sounds and music that accompany their migration have been essential to imagining their place in the nation. In other words, Latina/os in the United States have historically been closely associated with sound, which is taken to be a central element in imagining their multicultural contributions and eventual integration. The sonic allegiances of Latina/o Americans have often shaped and followed the narrative of Latina/o citizenship to which we have become accustomed. For example, the 2015 HBO documentary *The Latin Explosion: A New America* takes music as a barometer by which to gauge Latina/o acceptance into mainstream US culture.[22] Most scholarship on music and Latina/os in the United States stresses the importance of harmonious sounds to the development and strengthening of communities. Cumbia, salsa, mambo, as well as pop (including artists such as Ricky Martin and Shakira) import with their music the possibility of expanding the definition of what it means to be "American."

Latina/os of course have been important figures in the development of rock and roll, punk, metal, and other forms since their very inception. For many of these musicians, however, Latinidad is not a defining feature, with many going so far as changing their names to disguise their roots. At the very beginnings of rock we find Ritchie

Valens (born Richard Steven Valenzuela). A precocious Mexican American teenager from Pacoima, California, Valens is one of the key figures in the history of rock and roll. His legend is partly a product of his untimely death, at the age of seventeen, in a plane crash with two other rock pioneers, Buddy Holly and the Big Bopper. But in Latina/o music history, Valens is a figure that shows how Chicanos were central to rock and roll from the start, and able to integrate into the sound of the United States in ways rarely seen since. Although he was certainly not the first Latina/o crossover superstar, Valens is perhaps the first performer who, although racially veiled (in spite of the Spanish in his biggest hit "La Bamba"), entered the mainstream of US culture. And yet, perhaps because of this, Valens also often remains a footnote in retellings of the history of Latina/os and music in the United States. While he does appear in larger historical narratives—partly due to a Hollywood biopic and the recuperation of his biggest hit, a rock and roll adaptation of "La Bamba," by later artists such as Los Lobos—he is presented as an exception to the beginnings of rock and roll. Valens, like many other Latina/o artists in rock and roll that would come after him, changed his name (washing away a clear marker of his Latino roots) to become a legible crossover artist in the American rock scene. In this narrative, Latina/o artists must lose at least some aspects of their racial legibility to be accepted as capable of producing rock or any of its subgenres.[23]

This has meant that contributions by Latina/o artists to the genealogies of rock and other genres have remained largely obscured. The issue with the archive, then, is how it is constructed to limit what forms of expression are recognizable to mainstream cultural narratives. For example, although the early punk scene in Los Angeles crossed multiple class and ethnic boundaries, many of its major Latina/o figures— Alice Bag of the Bags, Anthony Martinez and Ron Reyes of Black Flag, Kid Congo Powers of The Gun Club, The Cramps, and Nick Cave and the Bad Seeds—are rarely if ever included in the triumphal stories of Latina/o contributions to music. Chicana/o and Latina/o punk musicians have most often been considered central figures when reconstructing (and challenging) otherwise mostly white narratives of the punk scene, yet I contend that the notion that punk itself could be a Latina/o genre has seldom been discussed in these stories.

Chicana Feminism between the Queer and the Punk

In the remainder of this chapter I bring together Latina/o studies and queer theory to turn up the volume on the productive intersections of these fields through the Chicana punk. I follow important work at the intersections of queer and Latina/o studies that has similarly searched for the political possibilities of the abject. In *Dead Subjects*, Antonio Viego insists that ethnic and critical race studies in the United States have adopted much of their vocabulary and aims, directly or indirectly, from ego psychology. The result of this influence is that "we fail to see how the repeated themes of wholeness, completeness, and transparency with respect to ethnic-racialized subjectivity are what provide racist discourse with precisely the notion of subjectivity that it needs in order to function most effectively."[24] Viego turns to Lacanian psychoanalysis as a theoretical framework that might provide us with an ethical project that "rejects ideals of happiness and health."[25] For Viego, a future that will bring the racialized subject wholeness (which ethnic studies insists upon) can never be achieved because wholeness is always already dictated by that which makes us less than whole. He writes,

> [a] practice on the self that risks ruination in order to precipitate the subject is in the service of an emancipatory politics for the ethnic-racialized subject who must take up her rightful place in the chain of the signifier in order to luxuriate in and suffer the full range of losses that a human subject stands to endure in the world. From here, one can then engage in the full range of meanings that can be made of those losses as well as engage in the full range of strategies that can be crafted in response to those losses.[26]

I propose that the punk sounds of Las Cucas, and especially Nao Bustamante's scream, allow us to luxuriate in such ruination. And as I explain later in the chapter, this has much to do with love and ethics as well.

The other major field that comes into focus in this chapter is queer theory. Since its beginnings, queer theory has often been defined by an ongoing rift between gay male and lesbian desires. Numerous texts have attempted to give an account of lesbian sexuality articulated in distinc-

tion to the male sexual cultures that have driven much of this scholarship. This is in part because gay men and lesbians do not always share the same sexual cultures or erotic vocabularies, yet the prescriptive tone of our fields has often meant that the political, ideological, and sexual ethics of queer theory have been drawn from the sexual experiences of gay men. Teresa de Lauretis's *The Practice of Love*, for example, provides a theory of the lesbian's perverse desire. In her psychoanalytically inflected account, De Lauretis points in particular to the incommensurability of the lesbian with the figure of the mother. She writes,

> I would even suggest that the maternal imaginary is dangerous for women, in this troubled end of a century which could again mark the end of feminism—dangerous, first of all, because reducing female sexuality to maternity, and feminine identity to the mother, whether imaginary or symbolic, erases a history of women's political and personal struggles for the affirmation of a difference of and between women vis-à-vis hegemonic institutions and cultural formations in many countries; and dangerous, as well, because reclaiming maternity and maternal power on the ground of an ambiguous theoretical premise [. . .] in turn erases the history of individual and social struggles for the affirmation of lesbianism as a particular relation between women that is not only sexual but also sociosymbolic.[27]

De Lauretis offers an intriguing reading of Radclyffe Hall's lesbian classic *The Well of Loneliness* alongside Cherríe Moraga's play *Giving Up the Ghost* (as well as her hybrid text *Loving in the War Years*) to propose her theory of perverse desire.

In *Are the Lips a Grave?* Lynne Huffer turns to the work of French feminist Luce Irigaray and Michel Foucault to explain how they "articulate an ethical dissolution of the subject: this dissolution is also, oddly, that which binds us, each to the other, through the ethical force of relation."[28] Huffer uses Irigaray to reread Leo Bersani's "Is the Rectum a Grave?" She writes that while, for Bersani, the rectum and the specter of gay male sexuality, feminized into oblivion by the phallus, represent the dissolution of the self as an end of politics, taking the *lips* as the grave offers queer theory an ethical proposition. Huffer turns to the lips, both facial and vaginal, to "articulate an ethics of relation that differentiates

them from the pure negativity of queer antisociality. For it is in their catachrestic, heterotopian attempt to speak otherwise that the lips are simultaneously here and elsewhere, now and not now."[29] Although my own approach in this chapter moves away from the psychoanalytic genealogies favored by these thinkers, I am indebted to their articulation of the specificities of lesbian desire as a space where queer and feminist politics not only meet, but are seen as inseparable from each other. Dissolution, as articulated by Huffer, opens up a queer feminist account that rests on lesbian desire instead of disavowing it. I also want to acknowledge the essential work of queer feminists of color, such as Juana María Rodríguez, Amber Jamilla Musser, Karen Tongson, L. H. Stallings, and others, which has been increasingly invested in finding the kinds of possibilities and politics that lesbian desire and sexuality might create.

However, what unites many of these different strands of queer theory is attention to negativity. As Mari Ruti writes, "the degree to which different queer critics adopt the stance of negativity varies, as does the type of negativity they emphasize, but it seems safe to say that, for many, this stance represents an antidote to the valorization of success, achievement, performance, and self-actualization that characterizes today's neoliberal society."[30] Ruti reminds us that, in queer theory, "much of the historical archive of queer lives relies on ephemera: passing impressions that have produced no enduring record or that have merely produced scraps of a record that cannot easily be reconstructed into a coherent whole."[31] She sees the works of José Esteban Muñoz and Heather Love, among others, as creating an account of negativity that nonetheless remains hopeful in its aims "by emphasizing that both utopia and melancholia are modalities of opting out of an unsatisfying present, utopia by looking forward, and melancholia by looking backward."[32] This chapter suspends subjectivity and agency for a moment, in favor of a forward glance of what utopia—even if in the short span of a song—might look like. By exploring the sonic crevices of punk, I am called by its annihilative force, which ultimately may not look so different than the possibility of the utopic.

Punk performance provides the setting for my theorization of lesbian ethics. As Tavia Nyong'o wonders in his rereading of Cathy Cohen's foundational essay "Punks, Bulldaggers, and Welfare Queens," "Might we theorize the intersection of punk and queer as an encounter between

concepts both lacking in fixed identitarian referent, but which are none-theless periodically caught up and frozen, as it were, within endemic modern crises of racialization?"[33] In other words, the punk in its many vernacular forms welcomes a rejection of politics by choosing modes of anger manifested through a corporeal scream, which I argue has been particularly useful in the queer Chicano imaginary. I also follow José Esteban Muñoz's theorization of punk's annihilative force: "a way to, in a sense, 'pause' a temporal moment, allowing people hailed by a mode of negation associated with the outsider's trajectory, the space to find an otherwise elusive mode of being-with."[34] Muñoz is particularly atten-tive to the fan as capable of an affective mode of not only the listener who "was there" but also the one who listens from a distance and is thus able to access the temporal registers found in the music. As a fan of Las Cucas, one who arrived to the Bay Area nearly a decade after the band's dissolution, I enter the temporal and geographic specificities encoded in their recordings through my own desires, enabled by the practice of what Alexandra Vazquez calls "listening in detail."

Las Cucas and the Archive

My intervention into the debates around a queer ethics of desire draws on a series of performances and musical recordings that emerged at a historical moment and geographic site filled with political challenges and possibilities—that of San Francisco and the Mission District in the late 1990s and early 2000s. Specifically, I focus on the recordings of the short-lived "mariachi punk band" Las Cucas, centrally comprised of Latina performance artists and musicians Nao Bustamante, Marcia Ochoa, Cheryl Tesh, and Gigi Otálvaro-Hormillosa. The band's name is a tribute to Mexican composer Cuco Sánchez, whose songs they origi-nally covered, though they soon expanded their repertoire to include a mix of traditional and popular Latin American songs. Each song they covered became "punkified," yet remained recognizable to anyone that knew the originals. Indeed, although they reference the mariachi band to give a shorthand for their sound, Las Cucas' choice of genres acknowledges their ability to translate the sounds of a transnational Latin American "sentimental education" to their queer and punk audi-ences, many of whom would certainly have been familiar with these

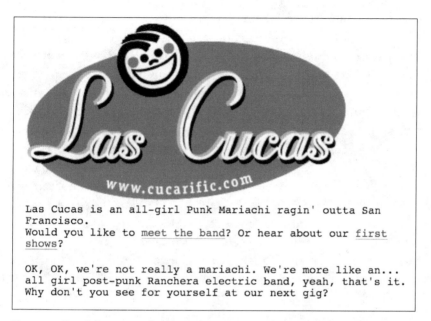

Figure 3.2. Detail from cucarific.com in the Internet Archive. Screenshot by author.

songs and sonic histories. I read the Latina queer punk scream that Las Cucas perform through the language of pain as that of the bolero—one of the genres that they covered—and delve into the possibilities that the excessive, melodramatic, and often self-annihilating longings of lesbian feminist desire afford. The drive to annihilation through sound is mirrored by Las Cucas' short life as a band. Although their recorded output comprises only five songs, their live repertoire included punk versions of classic Latin American songs like "Guantanamera" and punk standards like the Ramones' "I Want to Be Sedated." The recordings remain commercially unreleased, circulating through informal networks of friends and in the memories of those who attended their legendary performances. I came upon this archive serendipitously, when band member Marcia Ochoa shared their few recorded songs with me after a conversation about the understudied importance of lesbian punk in queer cultural formations in Latina/o America.

My own search for an archive of a band that existed all too briefly has meant listening to ephemeral (and often misremembered) accounts of the group's participants and their audience members to piece together a

history. The most helpful accounts come from the band's now-defunct website, cucarific.com. Although their page is no longer directly accessible online, I found traces of their updates through the Internet Archive's Wayback Machine. The site recounts many of their performances, capturing their excitement, tongue firmly in cheek: "Mea Culpa [Bustamante] whirled through the show in a white satin organza extravaganza, replete with flowing scarves. The rest of us wore seasonally-appropriate, post-Memorial Day white pants and baby blue & mint green shirts. Topped off by a sky blue cowboy hat & black feather boa, the effect was, er . . . hypnotic."[35] But even this invaluable resource cannot record every update to the site, leaving me to explore the band's short-lived career through fragments. For example, a series of polaroid photographs sent to me by Nao Bustamante show the artist singing (perhaps) next to Marcia Ochoa in one of their performances. In another photograph, Ochoa stands on the table next to Bustamante, acoustic guitar in her arms. Bustamante's hair is disheveled; she holds a beer bottle and moves around the table as each photograph catches a different point in her gyration. Neither Bustamante nor Ochoa remembers the specifics of the performance or the venue. But they can recount the affective thrill of performing, the sociality at their shows, the overall feeling of the moment. I witness the photographs as a fan removed by decades as I place myself in the audience for this show, conjuring my own knowledge of their sounds as it exists in their few recordings. (I've also been told by several sources of the existence of a video that captured one of their shows, but even though they have tried to help me locate it, its existence remains apocryphal.) And yet it is just such a messy, incomplete, and largely ephemeral punk ethos of the queer archive of a band that was too briefly on the scene that animates my reading. I listen to these ephemeral traces as a different, perhaps more intimate, version of the bootleg that I have returned to across this book. Indeed, through Las Cucas' recordings and photographs, and in my attempts to reconstruct this archive from the virtual detritus of their website, I have managed to create a personal history as a potential, scaled-down version of the bootleg that, through this chapter, I aim to bring a bit closer to the surface of new publics.

Las Cucas played their first show in San Francisco on April 27, 1999, at the (now defunct) York Theater, "en la Michón"—San Francisco's his-

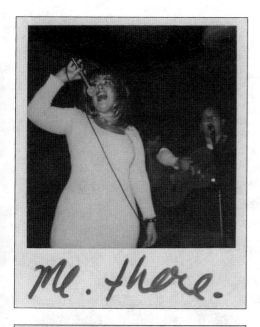

me. there.

Figures 3.3, 3.4, and 3.5. Nao Busta-
mante and Marcia Ochoa Unplugged.
Polaroids. Nao Bustamante Archive.
Courtesy of the artist.

torically Latina/o Mission District. They recorded a few songs, which now make up the still listenable traces of their work. The song selection included four covers—"Sabor a Mí"; "Súbete a Mi Moto," originally interpreted by the Puerto Rican boy band Menudo; "Gritenme Piedras del Campo," originally written and performed by Cuco Sánchez, the band's namesake; and "Tu, Solo Tu," originally written by Felipe Váldes Leal and made popular by Pedro Infante, and later returned to popularity by Selena in her posthumously released album, *Dreaming of You*—and "Muñequita," their one original song. It is hard not to delve into Las Cucas' archive without being thrust back into the vibrancy of queer life in San Francisco in the late 1990s and early 2000s. That the band came to exist at this moment in the history of queer and Latina/o San Francisco seems indicative of the changing demographics of the Mission at the time; it was a period of coexistence between Latina/o families that had resided in the area for decades and a new wave of largely white queer denizens who were abandoning the Castro in search of cheaper rents. The fact that their archive is filled with reminders of places in the Mission now lost to the forces of gentrification also seems fitting for my discussion of the bands' lesbian aesthetics and ethics of self-annihilation. What I identify as Las Cucas' exploration of the melodramatic, near-suicidal themes of Latina lesbian desire came out of a specific temporal and cultural milieu. The group's sound emerged at the intersection of the queer punk and the Latina melancholic that could perhaps uniquely flourish at this geographic and historical conjunction, while also defying the limitations and dictates of both traditions.

Nao Bustamante is an ideal artist to take us through the melodramatic, melancholic, and self-annihilative journey that I will discuss in the rest of this chapter. Her career is filled with moments of punk tears. José Esteban Muñoz discusses how Bustamante's performance and installation art engages with the depressive position occupied by many brown subjects. In his reading of her installation *Neapolitan*, Muñoz finds "a feeling of brownness that transmits and is structured through a depressive stance, a kind of feeling down."[36] Bustamante's performance art, while often comedic, rarely offers a pleasing, complimentary, or celebratory account of brown queer female sexuality. Laura Gutiérrez calls this Bustamante's "bad girl aesthetics"—a racialized and sexualized unsettling of avant-garde aesthetic norms. Bustamante's bad girl art and

performance trouble our notions of experimental praxis by situating the brown female body at the center of the gaze. Much of her work is saturated with melancholia. *Neapolitan*, for example, consists of a television playing a video of a close-up shot of Bustamante, in tears, while watching the Cuban film *Fresa y Chocolate*. In her performance piece *America the Beautiful*, Bustamante repeatedly fails at normative standards of white femininity as she wraps herself in increasingly grotesque layers of costuming, fabric, and even plastic wrapping tape. As Gutiérrez maintains, "Bustamante's racialized and gendered body-centered performances are important critical interventions (at times literally) in dominant and mass-mediated (Latino) American discourses regarding notions of femininity and the female body."[37] Most recently, Leticia Alvarado has taken on Bustamante to attend to the abject aesthetics of the artist's work, concluding that "Bustamante [. . .] offers us a mode of dissociation from neoliberal multiculturalism that allows, through the centering of affect, affiliation within the abject realm."[38] Bustamante's aesthetic practice then calls on its viewers to disidentify with dominant narratives of Latinidad, and especially the politics that have defined it after the neoliberal turn. I see the work of Bustamante—who since her artistic career began in the early '90s has had to create plenty of work in the context of an art scene (both Latina/o and queer) that is unsure what to do with her—as being in direct response to the Latino Boom. Las Cucas has been one of the most understudied projects in Bustamante's career in large part due to the inaccessibility of the recordings. I take Las Cucas both as a part of Bustamante's larger oeuvre and as a band in their own right. But it is Bustamante's vocal performance, which I see in relation to her work as a performance artist, that guides my leap into the dark recesses of the lover.

Tasting Abjection, or a Lesbian Lover's Discourse

The rest of this chapter approaches Las Cucas' lesbian punk fragmentation of the bolero through a series of cross-readings that explore the relationship between fragmented language and excessive desire. I read two theoretical French texts from the 1970s alongside two Latina/o American reflections on queer erotics: Monique Wittig's *The Lesbian Body* alongside tatiana de la tierra's bilingual text *Para las Duras: Una*

Fenomenología Lesbiana, and Roland Barthes's *A Lover's Discourse* with Rafael Castillo Zapata's *Fenomenología del Bolero*. In their insistence on the fragment as a mode of articulation for lesbian (dis)identity and the lover's protestation, these texts prove generative guides to understand Las Cucas' performance of "Sabor a Mí" by providing a sense of the discursive elements that pair queer desire and the lesbian punk.

Bustamante's vocal performance of "Sabor a Mí" indexes the possibilities of desire by speaking to the Other, an address in which utterances become central. Although each of the writers I mentioned above is deeply invested in the literary history of desire, for them, desire is manifested in the shift from the written to the sonorous. One may write to the lover, but the act of interjection, the moment in which one risks loss, is when the lover is addressed or when their name is uttered. "Sabor a Mí" takes the form of the utterance, and in doing so, turns us (the audience) into the subject of Bustamante's address. The song and its histories are thus the perfect vehicle to engage with the lover's address, as the lyrics invite the listener into a sensorial realm where desire, loneliness, and the ethics of queer desire are staged through Bustamante's voice.

The notion of desire as found in the bolero provides a worthy sonic companion to the move from the discursive legacies of the lover into the specific desires that Bustamante's voice brings into being. In an essay on famed Cuban singer Olga Guillot, José Quiroga refers to her specialty of performing "the bolero of despair and eros, the song that produces the erotic charge of steamy sex under a red lightbulb, or the one sung by the woman after the man has left her panting, and she hides a knife under the pillow on a creaking bed where the sheets are wet."[39] It should come as no surprise that La Guillot is one of the many artists who have covered "Sabor a Mí." Her version is accompanied by lush strings and performed in a trembling, quivering voice that is soaked with a defiant sense of longing. Quiroga describes her voice as "deep but not exuberant, all timbre and no inflection, embodied rather than ethereal."[40] La Guillot's "sentimental performance" brings together several listening publics in thrall to her voice, but Quiroga notes that straight women and queer men especially have found solace in her oeuvre. The power of the bolero lies in its ability to stretch outward, to touch the listener's body through the sonorous drive of strumming guitars and sultry vocals, to stage a clash of genders that spills over from the heterosexual orientation of the song's

lyrics. As Quiroga further argues, the soundscape of the bolero illustrates that "there is love and there is sexual abandon; there is love as tragedy; infidelities are legion; one may be married and have a lover; there may be a razor blade somewhere for the suicide or the murder."[41] These queer excesses dictate the gender politics of the bolero, transformed by many men and women into the sound that embodies their failed longings.

Yet if the bolero is deeply heterosexual in its origins, and in the 1990s we find a host of artists "who voice boleros [. . .] via the melancholic homosexual as a polemical figure of mourning and celebration,"[42] how might we tune into the sounds of lesbian longing that Las Cucas perform? The band answers this by producing a version of the song that adopts the aggressive noise of punk. In their cover, Las Cucas use the cacophonous properties of punk, and in particular the scream of Nao Bustamante's lead vocals, to place this song in particular—and perhaps also the bolero genre in general—within a lesbian performance and musical genealogy that unabashedly embraces the affective excesses of desire. A heterosexual reading of the song as performed by its many singers gives a much different view than Las Cucas' version of it. But its sentimental overtones remain across its many singers. For example, the 1970s rock band El Chicano's version, sung by the band's lead singer, Ersi Arvizu, highlights the trembling melancholy of the lyrics. Arvizu's voice carries what begins as a traditional rendering of the song, as the sounds of an organ push her singing into a soft rock croon that brings together multiple sonic traditions. Although Arvizu's tone is decidedly more restrained than Bustamante's wail, we can hear in it the pangs of an unfulfilled desire that continue to make the song one of the most popular compositions in the Latin American canon.

"Sabor a Mí" recalls in its older iterations a gentle romantic longing often found in the Latin American song tradition, what Venezuelan theorist Rafael Castillo Zapata describes as the genre's "symbolic plot of representing the amorous phenomenon, the bolero, as it manifests this figure, possesses the extraordinary capacity to serve as constant support to the Latin American lover when it's time to elaborate all of the adventures that characterize their experience."[43] Castillo Zapata, who in *Fenomenología del Bolero* attempts to rewrite Barthes's lover into the Latin American sonic imaginary, imagines the drive of any bolero to be an enunciation of the substance of love. But if the song as filtered by het-

erosexual longing gives a glimpse of the drunk lover stumbling through the words, Bustamante's voice places her dragging along the floor, hand extended, asking to not be left behind.

Las Cucas' recording begins with the electric guitar plunking out the recognizable first notes of the song. Even though this is punk, the strings play gently, followed by Bustamante's voice softly intoning the song's opening words: "Tanto tiempo disfrutamos de este amor." She elongates each of these opening words, leaning into them while the guitar strums and the rhythm of the bass and drums unfurls in the background. The only jarring sonic element in these early moments is the electric buzz of the guitar and the jangly, slightly "off" beating of the snare drum. The feeling of desire is expressed at a slow, melancholic pace. As the first verse comes to an end, however, Bustamante's voice begins to quiver, cracking in her intonation of "sabor a mí." The song takes a turn with the drawn-out "mí" as the instrumentation shifts to the aggressive tone of punk rock. Within barely a second of this last word, Bustamante releases a dramatic and exuberant "oi, oi, oi." Here the song gains an excessively melodramatic quality unrealized by the many other singers who have performed it. Bustamante's moan is harsh. In it we hear not just longing, but sexual lust and the tragedy of a lover's abandonment. Yet this is only the beginning of the heights of excess the performance will reach. While the backup vocalists sing the chorus ("no pretendo"), Bustamante follows them ("ser tu dueño") with a desperate, high-pitched, and defiantly sexual scream. The razor blade is not under the bed or the pillow, but lunging out from her throat. She reaches the last words of the chorus ("soy tan pobre, que otra cosa puedo dar?") with the final "dar" elongated into the shape of a mournful cry.

In Bustamante's voice, the sonic thrust of the song takes on the melancholic tone of the verses, which attempt to balance the languorous pace of the bolero against the punk explosion of the chorus. The connecting tissue between the final "dar" of the chorus and the "pasaran" of the following verse is a choked-off sigh. We have shifted back from the punk scream to the bolero's tender exhale. Her beckoning toward eternity is sweet—a flirtatious promise of that flavor of the lips. But once again, as she ends the verse, the earlier deep "oi"s become tortured "ay"s. The contrast between the first bridge and this one is telling; whereas the "oi" of the first transition betrayed a deep pain, this "ay" entangles

pain with orgasmic resonance. The second verse abandons the first's flirtatiousness; hope for the beloved's return is replaced by resignation. The eternities in each are now vastly different: the sweetness of the first turned into an unbearable forever.

Key to my argument is the explicit potentiality of the lesbian body. In *The Lesbian Body*, Monique Wittig practices both the possibility of cataloguing the very idea of lesbian soma, as well as its dissolution within it. The text is generated through the singular and addressed to an unnamed other, the subject of unruly desire, the direction of another woman. Wittig writes in a series of fragments:

> I discover that your skin can be lifted layer by layer, I pull, it lifts off, it coils above your knees, I pull starting at the labia, it slides the length of the belly, fine to extreme transparency, I pull starting at the loins, the skin uncovers the round muscles and trapezii of the back, it peels off up to the nape of the neck, I arrive under your hair, m/y fingers traverse its thickness, I touch your skull, I grasp it with all m/y fingers, [. . .] I hold all of you silent immobilized every cry blocked in your throat your last thoughts behind your eyes caught in m/y hands, the delight is no purer than the depths of m/y heart m/y dearest one.[44]

Although ostensibly a novel, Wittig's pursuit is hardly narrative. Instead, she accumulates moments of physical encounters to create anti-masculinist language. For Wittig, the fragmented and chaotic disarticulation of lesbian desire from narrative drive shapes her linguistic play to this violent and always erotic encounter.

This form is echoed in *Para las Duras: Una Fenomenología Lesbiana*, by the late Colombian-born, Miami-raised, Los Angeles–based poet tatiana de la tierra. This bilingual text likewise turns to the body in a series of poems. I find her in concert with Wittig in "A Lesbian, by Parts" as de la tierra writes, "the hands: representing pleasure, they should invite with softness and shine. the style and décor of the nails depends on intimate desires; lesbians unite through the finger nails."[45] Like Wittig, de la tierra nullifies the separation between physical interior and exterior. To invoke an encounter between lesbians is to eradicate identity itself. It's a surrender, a dissolution, and, ultimately, an ethics that I hear in the tremble of Bustamante's voice.

Bustamante's intonation of "sabor a mí" captures this mode of corporeal, disjunctive, and interruptive performance. The leftover taste of the departed lover that the singer carries comes from both sets of lips, an incorporation that connects bodies, orifices, and organs. Importantly, this departs from the discourse of the racialized body and ingestion, an important literature that nonetheless tends to imagine race as the site of consumption. In lesbian sex, as Wittig argues and Bustamante's performance affirms, there is no ingestion but rather a dissolve in which the political histories of the body merge in an erotic, sonic embrace.

Bustamante's growls draw from the brown queer legacies of singers like Chavela Vargas and Alice Bag in her vocal gesture toward the self-dissolving force of erotic abandonment. Tears of loneliness soak Bustamante's increasingly desperate snarl, as the lover moves further away in each repetition of the chorus. In *Listening in Detail*, Alexandra Vazquez follows the grunts of mambo musician Pérez Prado (another of the song's major interpreters), and finds that "these sounds do not abide by protocols of bourgeois comportment. They betray potential overindulgence or an inability to self-control."[46] Part of this power is in the grunt's ability to shift, its inability to remain static and thus legible. "Sabor a Mí" is told in this recording through the growls, grunts, and screams as the increasing overindulgence in Bustamante's voice transforms the meaning of the song into a register of brown lesbian desire.

Sound studies has been particularly interested in investigating the meaning and uses of the voice across various registers. As Licia Fiol-Matta reminds us, "voice is a cultural artifact, a product of culture."[47] In his introduction of a section of the *Sound Studies Reader* dedicated to voice, Jonathan Sterne affirms that "voices are among the most personalized and most naturalized forms of subjective self-expression; speakers and auditors routinely treat them as the stuff of consciousness."[48] However, he suggests, referring to the work of Mladen Dolar, that "it is, in some sense, what is left over before or after language."[49] Bustamante loads her vocal performance with the aesthetic prowess of a singer and the strategic artificiality of a performer. She is able to move across registers not only in this song but also in the rest of the numbers she sings. This is perhaps what Barthes refers to as the "grain of the voice," or "the very precise space (genre) of *the encounter between a language and a voice*."[50] He argues that "the 'grain' will, of course, be only the appar-

ently abstract side, the impossible account of an individual thrill that I constantly experience in listening to singing."[51] Indeed, the thrill of Bustamante's singing produces a relational field that makes the listener aware of her body as it takes on the kind of lesbian physicality that Wittig and de la tierra attempt to describe. Barthes writes, "something is there, manifest and stubborn (one hears only *that*), beyond (or before) the meaning of the words, their form (the litany), the melisma, and even the style of execution: something which is directly the cantor's body, brought to your ears in one and the same movement from deep down in the cavities, the muscles, the membranes, the cartilages, and from deep down in [. . .] language, as though a single skin lined the inner flesh of the performer and the music he sings."[52] He concludes, "The 'grain' is that: the materiality of the body speaking its mother tongue; perhaps the letter, almost certainly *significance*."[53]

The grain of Bustamante's voice allows me to hear her performance as an example of what Licia Fiol-Matta has called "the thinking voice." According to Fiol-Matta, "the thinking voice is an event that can be apprehended through but is not restricted to music performance. It exceeds notation, musicianship, and fandom, although it partakes of them all. No artist owns the thinking voice; it cannot be marshaled at will or silenced when inconvenient. Its aim is not to dazzle or enthrall, although it may do so."[54] Instead, the thinking voice "orients" the listener toward a shared sense of the world by foregoing normative expectations of mastery associated with women's vocal performance. Fiol-Matta hears the thinking voice as offering a corrective to male notions of dissolution in music. Reading the long career arc of the great Puerto Rican singer Lucecita Benítez, Fiol-Matta suggests that "dissolution as a male fear is prevalent in male singer-songwriter [. . .] repertoire," but Lucecita's singing "raised this and other ballads above the banality permanently hovering at their edges [. . .]. Her recoding of melancholy and melodrama suggests an imbuing of thought into pop song, the existence of a yearning for or orientation to thought."[55] Bustamante's deployment of the thinking voice similarly invites Las Cucas' listeners to encounter ways of thinking that are produced through yet exceed the space of the song. In particular, she takes the melancholy longings of Carrillo's original composition and imbues them with a longer history of love (and lovers) gone awry, with the thinking voice's entanglement with "nothingness" as an ethical and political challenge.

Bustamante's scream shifts with each repetition of the chorus, accumulating the affective force of the earlier verses. The first chorus retains its composure, with every word building toward the moment of complete abandonment. Bustamante is now the abandoned lover, and each word takes longer to sing, her breathing increasingly restless. Toward the end of the song, her desperate performance absorbs more words: the lyrics "soy tan pobre, que otra cosa puedo dar?" stretch and hover on the edge of unintelligibility. The third and final chorus begins from that emotive incoherence. Each of the lines is delivered as a desperate scream—the lover's last stand. Yet as Bustamante's voice chokes further, she is not alone. The backup vocals of her bandmates swoop in to sustain her through the desperate moans. The abandoned lover may be consigned to solitude, but the sonorous accompaniment of these vocals work to hold Bustamante in the embrace of brown lesbian collectivity forged from a sense of sorrow, pain, and rage.

Listening to Barthes and Bustamante, Together

As I listen in detail to Las Cucas' cover of "Sabor a Mí" I cannot help but hear echoes of Roland Barthes's articulation of the figure of the lover in *A Lover's Discourse*. The remainder of this chapter follows the sonic resonances between the two figures that meet in the span of the song: the Chicana punk and the lover. Barthes's book is a fragmentary address to the beloved from the abandoned lover, rendered in a series of short chapters that mine the affective archive of the desolate speaker. In the opening pages, Barthes signals that "the lover's discourse is today *of an extreme solitude.*"[56] This solitude necessarily renders the language of the lover as one disavowed by the dominant culture: this language "is completely forsaken by the surrounding languages: ignored, disparaged, or derided."[57] But Barthes follows this assertion with an important distinction: "Once a discourse is thus driven by its own momentum into the backwater of the 'unreal,' exiled from all gregarity, it has no recourse but to become the site [. . .] of an *affirmation.*"[58] In Barthes's notion of affirmation, I find a way of describing the queer ethical practice that punk affords the bolero in Las Cucas' performance of desire. In other, more putatively heterosexual versions of "Sabor a Mí," the *tristesse* of the song leaves the lover

abandoned next to a bottle of mezcal. Bustamante's scream detaches the song from this scene of desolate betrayal. Instead, the brown lesbian punk singer destroys the bar, crawls on the street, and begs her beloved to stay until she has gone mad.

A key concept throughout *A Lover's Discourse* is the notion of becoming engulfed. In the first fragment, Barthes writes, "Either woe or well-being, sometimes I have a craving *to be engulfed*."[59] Las Cucas' cover of "Sabor a Mí" ends precisely on this note. Bustamante's final "sabor a mí" is delivered in a resigned sigh—one that has been building upon the suicidal tendencies of the bolero. To become engulfed, Barthes reminds us, is to break away from the burden of the "I." While it certainly is "I" who realizes and expresses these desires, love itself "from happiness, this time, the same outburst of annihilation sweeps through me. This is how it happens sometimes, misery or joy engulfs me, without any particular tumult ensuing: nor any pathos: I am dissolved, not dismembered; I fall, I flow, I melt."[60] I am drawn to how Barthes's notion of engulfment, equally murderous and suicidal, is woven throughout Wittig's and de la tierra's and Castillo Zapata's literary evocations of erotic desire, and how it is in turn sonically appropriated by Las Cucas.

But must the brown lesbian be doomed to failure, erotic frustration, and self-dissolving desolation? Indeed, why must the Latina lesbian bear the labor of pain? Haven't lesbian characters been fated to die enough? Yet to survive, to be happy, to love and let go are forms of queer orthodoxy that participate in erasing the scars of love. As Barthes suggests, "By releasing his tears without constraint, [the amorous subject] follows the orders of the amorous body, which is a body in liquid expansion, a bathed body: to weep together, to flow together."[61] The invitation that the song extends toward its audience to weep and moan and scream alongside Bustamante offers a performance of brown lesbian desire that offers a queer ethics that celebrates neither nonrelationality nor queer sexual perversity for its own sake. Perversity here lies in the too-muchness of love, a too-muchness that Latina/o queers are perhaps all too familiar with. Indeed, tears beg for a response, not only from the lover who has departed, but from us, the audience.

I propose Barthes and Bustamante as partners in tears. Not the tears that one may hide at first, afraid of being seen, but which eventually burst, becoming the kind of tears that one chokes on. Bustamante and

Barthes choke on their tears. They choke on their queerness. This queerness is exemplified not only by their aberrant sexual desires, but by their inability to enter the promised futurity of proper queer—and, in the case of Bustamante, brown—subjecthood. They each occupy a too-muchness that queerness rejects; they love too much, in the wrong ways; they fail at the normative comportments of desire. Bustamante's queer Latinidad will not be joyful, but will instead be too extravagant, too steeped in failure, begging for dissolution.

The ecstasy of unrealized desire is precisely the emergence that renders Bustamante's scream productive against nihilist calls toward the nonrelational. Suicide surfaces as fantasy, which, as Juana María Rodríguez observes, allows us "to make queer racialized female sexuality if not visible, then imaginable, as a site of polymorphous perversity, a place of dangerous possibilities."[62] Allow me to remain with Rodríguez for a minute, who takes up Judith Butler's assertion in *Undoing Gender* that "[f]antasy is what allows us to imagine ourselves and others otherwise; it establishes the possible in excess of the real; it points elsewhere, and when it is embodied, it brings the elsewhere home."[63] But Rodríguez insists that, in the scene of Latina lesbian abjection, "[t]aking the critical promise of fantasy seriously, however, requires another kind of meaning making that journeys beyond rationality. Very often, fantasy takes us to places filled with dread and indignity, to hidden corners of our psyche peopled by our own demons, fueled by the private terrors of collective horrors."[64] But the collective horrors that Rodríguez invokes can also exist in the realm of the deeply personal, the dread of who someone can become in the event of a breakup. Indeed, Rodríguez invokes fantasy as that which allows us to experience pleasure in moments that may appear to foreclose it. She writes, "this is the type of sexual fantasy that we dare not confess, the type of sexual fantasy that marks us as improper sexual subjects of feminist politics."[65] I extend her reading to see fantasy as a guide to Bustamante's performance (and vice versa) to illuminate the pangs of desolate love in each of their scenes of failed erotic connection—a pang with no resolution. This is a fantasy that queer theory often fails to confess—one that Barthes, Witting, de la tierra, and Castillo Zapata help me read. It's the fantasy of dissolution found in the event of the lesbian breakup, as the singer fails to compose herself in the name

of a queer futurity and instead lingers in the fantasy of what was, what could be, and what will never be.

So what is a desolate lover to do? Where is the ethical ground that brown lesbian desire generates in this performance? Neither Wittig, Barthes, nor Bustamante would be so easily consoled if the lover were to come back. On the contrary, the lover's absence and their presence both form the source of pain. In our current political moment, in which queer politics have stagnated into the opposing poles of pro- and anti-marriage debates, and Latina/o political imaginaries on both sides of the border are consumed with the trope of familial belonging, is there room for the queer desolate lover?

I argue in the affirmative by turning to a reading of the butch playfulness of another Las Cucas song, "Súbete a Mi Moto," first performed by the Puerto Rican boy band Menudo in 1981. The song topped the charts in all of Latin America upon its release, and is still widely known and loved throughout Latina/o America. Las Cucas turn this pop ditty into another punk anthem of lesbian desire. Marcia Ochoa sings lead vocals in this song, lending it a butch tonality decidedly different from the boyish flirtatiousness of Menudo's original. (Of course, it also helps that the motorcycle that the song conjures has been one of modern lesbian culture's most persistent icons.) Yet all of the boyish flirtatiousness is not completely devoid of romance.

In Las Cucas' performance of the song, the chorus "súbete a mi moto / ella guardara el secreto de dos / de los dos" doubles as a promise in Ochoa's voice, cleverly hinting at their secret. Her singing reveals motorcycles as a site of queer erotic longing. In the original 1980s music video, the Menudo members ride fancy, colorful road bikes. When one hears Ochoa, one hears something more seductive in the revving of the motorcycle. Although the original music video sees the girl won over, the lyrics never say so. It's an expression of desire that, as far as we know, goes unanswered. Las Cucas' punk reworking of this unanswered desire turns it into a celebration of promise, gesturing toward the possibility of ecstasy of which Barthes writes. Las Cucas' sonic performance of brown dyke desire allows us to dwell in the most painful stages of love, offering a powerful instance of negation that refuses the normative scripts of belonging and identity demanded by the exigencies of queer and brown identity formations. The Chicana lesbian punk thus becomes a figure

that opens up the space for others to embrace ways of being and desiring that may at first appear foreclosed by the bounds of normative Chicano political and cultural discourses.

Las Cucas emerged at a time when Latina and queer existence became increasingly tied to state inclusion via the promise of belonging. But if we read this lesbian punk as an excess to the bourgeois comportment of citizenship, what emerges is a rejection of the normativity of the state's investment in enforcing the demands of proper inclusion. Queer desire, in Bustamante's voice, is messy, extreme, inconclusive, and it cannot conform to the expectations of normative politics. This sonic negation offers an alternative political imaginary that depends on our ability to live in the pain of difference and the unexpected pleasures it might afford. To embrace this pain is also the beginning of an ethical relation to a world that often aims to order the most potentially unruly boundaries of desire, especially when this desire seems to push subjectivity itself to the edge of comprehension. It is precisely at this edge, at the ends of subjectivity and subjecthood, where we find the possibility of reaching out to an/other, reaching out toward an embrace. This is because, ultimately, the pain of queer love is not eternal but the site of a beginning that refuses to be appropriated. However intense that pain, we still find in it, as listeners, a space of sharing, a way for us, in our tears, to flow together once more.

4

Truly Disappointed

Morrissey, Latina/os, and the Joys of Shared Melancholia

On May 26, 2012, at the Bob Hope Theater in Stockton, the British rock star Morrissey made what would be his only appearance in Northern California that year. In video footage from the concert, we see Morrissey perform new songs and older hits with his typical flair for showmanship to a clearly receptive and excited audience. At some point during the concert, Morrissey hands the microphone to a young woman in the audience. While she doesn't have an accent per se, her voice carries within it traces of Latinidad—in its cadence, its pronunciation, its very timbre. Her speech is almost too formal, too melodramatic for the moment—a sometimes calculated formality that many Latina/os adopt to assert seriousness, education, and maturity. She begins by acknowledging Morrissey's birthday—only a couple of days away—as "the beginning of your fifty-third year on this miserable planet." Morrissey kneels on stage above her. His expression is humble, if studied. But the girl is sincere. She thanks him for "exposing your exquisite heart" and for "giving hope to so many people who just can't find their place in this world." The rest of the crowd clearly shares her sentiments, cheering loudly after everything she says. Her reference to "this miserable world" is not terribly out of place: this is Stockton after all, a city named by *Forbes* magazine in 2011 as "the most miserable" in the United States.[1] Indeed, studies have ranked Stockton as the most illiterate city in America, as well as one of the two most obese. So when the girl speaks of misery, of those who don't belong, the grain of her voice expresses it— she *knows* it, she *feels* it, and she *lives* in it.

The fact that Morrissey—or "Moz," as he is affectionately known to fans—performed in Stockton is not particularly remarkable in itself, given his status as a world-touring musician. But it does feel significant that during this short North American tour his only three stops were the

California cities of Stockton, Bakersfield, and San Diego, each of which is racially marked. In Stockton, Latina/os make up over 40 percent of the population.[2] Bakersfield is not far behind in this demographic dominance of Latina/os, nor, for that matter, is San Diego, especially with its proximity to Tijuana, another home of many a Morrissey fan. It should be noted that Stockton and Bakersfield are not cities often visited by popular touring musicians; the much more likely places are Los Angeles and San Francisco, with other stops in California here and there. Morrissey, however, had by this time *cancelled* multiple dates nearby in San Francisco and Oakland, even though they dominate the cultural geography of Northern California. So why does it matter that Morrissey played Stockton, Bakersfield, and San Diego? Why does it matter that the "most miserable city in America," populated mostly by Latina/os, for one night welcomed an artist whose public persona has made him known as one of the most "miserable" singers in pop music? How do social, geographic, psychic, and musical misery connect at this junction?

For someone with only a cursory knowledge of Morrissey's music, these questions and the young woman's enthusiasm might seem confusing. How could a fey British singer whose most prominent cultural touchstones are derived from figures like Oscar Wilde and kitchen-sink British films from the 1960s speak to the everyday feelings of being Latina in Stockton? For anyone with knowledge of Morrissey's oeuvre, though, the moment might seem perfectly reasonable. One could point, for example, to "Reel Around the Fountain," the opening track of the Smiths' eponymous debut in 1984. The song is filled with references to Fellini's *La Dolce Vita* as well as Shelagh Delaney's 1958 play *A Taste of Honey*, one of Morrissey's most invoked influences. But one needn't know the references to find solace in the ballad's pace coupled with the soft tone of Morrissey's voice as he delivers the lyric, "Fifteen minutes with you / Oh, I wouldn't say no / Oh, people see no worth in you / Oh, but I do." The song famously illustrates the singer's romantic failures, captured in the lines, "I dreamt about you last night /And I fell out of bed twice / You can pin and mount me like a butterfly / But 'take me to the haven of your bed' / Was something that you never said / Two lumps, please / You're the bee's knees / But so am I." The song's meanings are multiple: On one hand, we can hear the kind of hopeful longing familiar to any queer adolescent facing the pain of rejection—in this case most

likely at the hands of countless straight boys. But we can also hear the promise Morrissey sings to the fans gathered here—fans who occupy that worthlessness against their will—that at least one person out there recognizes their worth.

This final chapter uses Morrissey fandom to closely analyze underexplored affects in the canon of Latina/o studies: the feeling of worthlessness, of living in locales that seem worthless to the outside world, of appearing like a politically worthless subject. In many ways, this is the chapter that most concretely examines the reject as an ethical figure that faces feelings of worthlessness by embracing their affective undertones. In short, I explore Morrissey's Latina/o fan base as one bound by the affective excesses of despair—excesses that exceed the minoritarian subject's relationship to both a dominant white public sphere and the Latina/o and Chicana/o communities that have continuously cast Latina/o Morrissey listeners as "bad subjects." Both mainstream and Latina/o media have held up this Morrissey listener in quizzical fascination, often veering into accusations about their neglecting the proper political stakes of Latinidad. In this context, Latina/o Morrissey fans are imagined as stuck in a youthful moment of teenage angst, listening to sad music in order to cling to the time before the responsibilities of adulthood and family force them to grow up. To turn to worthlessness, depression, despair, and other such feelings is to reject the call to a fully human racial subjecthood and proper citizenship, and to instead linger in the affective pull of, as the title of another Morrissey song puts it, spending the day in bed.

Mainstream interest in the Latina/o Morrissey fan has produced a sizeable cottage industry of documentaries, photo books, magazine articles, news stories, and editorial reflections that focus on the corporeal stylization of these listeners. But this chapter does not engage with Moz's music per se; instead, I explore the affective soundscape of Morrissey fandom through the visual—and especially the silent—mediums of photography and drawing. I delve into the melancholic overtones of one such photographic project, William E. Jones's photography book and documentary film *Is It Really So Strange?*, to grasp the kinds of relationalities that listening together produces. I then turn to the work of artist Shizu Saldamando to explore the relational affect I argue these subtle and depressive forms of listening allow, namely friendship. In-

deed, friendship is the bond that allows rejects to find each other and create forms of solidarity that exceed the limits of national and cultural belonging. As I explore later in the chapter, friendship is defined by one's ability to form what I understand as a deeply ethical relation to an/other outside the bounds of family, nation, or ethnicity. Friendship sustains the reject by showing that other forms of recognition and intimacy are possible.

To write about Latina/o Morrissey fans is to focus on an artist who seems to draw the most attention in this cultural context, but these fans listen to much more than Morrissey. Their subcultural soundscape is also made up of many other British acts from that period, like Siouxsie and the Banshees, The Cure, Depeche Mode, Joy Division, and others who arose from an '80s music scene that favored dark imaginaries in their lyrics and sound. Most of the writing on the Latina/o Morrissey fan has focused on the question of what these brown listeners find in an artist that stands at such racial, geographic, and temporal distance. I will inevitably nod to some of these questions and answers throughout the chapter, but the reasons *why* Latina/os listen to depressive '80s British sounds only interests me to a minor extent. I am more invested in examining the relationalities produced by a listening practice shared by those who consistently experience a state of rejection or social and cultural alienation. I follow Richard T. Rodríguez's work on the intimacies between British musicians and Latina/o publics in *A Kiss across the Ocean* and his attempt to "reveal deep connections between working-class, racialized, queer, and historically marginalized individuals and communities from the trajectory of popular music."[3] These shared practices extend far beyond the confines of Morrissey's discography or a singular racial group, creating what Rodríguez identifies as "a multifaceted intimacy that flies in the perplexed faces of those writers and tedious articles intent on cracking the code to how Latinos/as could possibly listen to music that exceeds their reductionist designation of the cultural parameters of taste."[4]

So what forms of subjecthood might be opened when we listen to depression, melancholia, and the sonic boundaries of unbelonging? Rather than locate the reasons why Latina/os listen to Morrissey in terms of cultural affinity, I ask what this listening practice tells us about the complex ways in which Latinidad is experienced, felt, understood, and lived. The

answers I propose exceed the conventional vocabulary through which we understand Latinidad. Typically, Latinidad is discussed through notions of citizenship and assimilation, ultimately arguing for the enfoldment of the Latina/o subject into the nation-state; I instead turn toward how melancholia, depression, self-expression, and friendship render an alternative account of Latina/o life based on a rejection of these norms—or, rather, by embracing the possibility of being a reject of the nation-state. To be sure, this is not the first piece of writing dedicated to Latina/o Morrissey fans, either in mainstream journalism or academic writing. However, as I explore in this chapter, I have found many of the prior accounts and their attempts to explain the root causes for this fandom insufficient. This project began precisely when I realized that the modes of expression of this subculture extended beyond this particular fandom and American borders. I certainly did not expect the scale of the cultural fascination that the phenomenon continues to attract, and yet I am still convinced that most takes, including the smartest ones, remain steadfast in their conviction that the Latina/o fan and the British singer can be reconciled at the level of cultural comparison. By contrast, I care little about *why* Latina/os love Morrissey and instead focus on the affective dissonances certain kinds of sounds allow Latina/o listeners to access. Even as more and more studies (and the fan base itself) attempt to frame the love for Morrissey as an act of cultural reclamation, here I insist on what it means to reject a kind of subjecthood defined through one's racial/ethnic positioning.

The reject is a particularly resonant figure in this case study. To embrace being figured as a reject is an ethical act that aims to refuse the terms that define who gets to belong and how. In addition, to understand and present oneself as a reject is to recognize the ways in which Latina/o subjects are invited to earn belonging in spite of economic and racial limitations imposed by the mainstream. As mentioned previously, Latina/os exist within spaces defined by racial, economic, and cultural exclusion. But as Morrissey has become an increasingly polarizing figure who continues to make scandalous and inappropriate statements, more and more Latina/os and Chicana/os have sought to castigate and question the political commitments of his listeners in these communities.[5] Latina/o Morrissey fans can never belong, but like other figures throughout this book, they do not *want* to belong. They understand

that their allegiance to being "rejects" renders them outsiders to both mainstream and local cultures, which seek politically legible subject-hood. Morrissey's Latina/o following upends many dominant models of thinking Latinidad, in particular the insistence on tethering race to the nation. As Karen Tongson and others have pointed out, the reason why US Latina/os may be so drawn to Morrissey is due in part to his music's overt class consciousness and its awareness of the dimensions of working-class life so often missing in American cultural production and political discourse. Indeed, unlike American popular culture, which continuously espouses a mythos of striving toward upward mobility instead of class allegiance, British popular music has a long history of articulating defiantly working-class experiences, providing a discursive and aesthetic field in which class is ever present.[6] Examining the appeal of this musical tradition for Latina/os lets us disentangle this cultural practice from the limiting US/Latin America binary so often privileged in critical discussions of Latina/o performance, allowing us to see how minoritarian subjects subvert and complicate what Tavia Nyong'o has identified as the American telos of racial integration and multicultural American harmony.[7] As I will explore further, Latina/os' relationship to British rock music from the '80s opens up new avenues for think-ing critically about the complexities of national belonging, location, and temporality. In listening to Morrissey, Latina/os are able to access cul-tural modes that operate beyond the foreign-land/homeland dyad.

In *Ends of Assimilation*, John Alba Cutler argues that one of the ways to understand the history of Chicana/o literature (and by extension, cul-ture) is in the context of assimilation sociology and the results of the paradigms produced by this entanglement. He writes, "assimilation has been an elephant in the room in Chicana/o literary studies, a largely un-acknowledged presence we must constantly maneuver around."[8] Assimi-lation, the measuring stick that determines the line between foreigner and citizen, has been the primary paradigm by which we achieve the goal of multiculturalism. But as Cutler maintains, "assimilation is never merely about becoming American but becoming an American man or woman, and in Chicana/o literature anxiety about that transformation arises in relation to ideas about what it means to be (or *have been*) an authentic Mexican man or woman."[9] The "politically aware" subject has then chosen anti-assimilation. Anti-assimilationist discourse proposes

that one must remain that authentic Mexican man or woman to retain cultural autonomy, free from the demands of national incorporation and the looming threat of whiteness, which appear here as inevitable subjection—or, as Ruben Salazar famously defined the Chicano, "a Mexican-American with a non-Anglo image of himself."[10] Cutler shows that the terms of this discourse are far more complex, that "Chicana/o literary works wrestle with assimilation in terms that disrupt and exceed the nation form."[11]

While I am attentive in this chapter to Cutler's argument, I show that the Latina/o Morrissey fan offers a different articulation of Latinidad that disrupts and decidedly eschews assimilation altogether. This subject instead participates in a web of interactions in which the assimilation/anti-assimilation binary offers insufficient explanatory meaning. We are faced with subjects who imagine the geographical worlds they inhabit in deeply local terms: Stockton, the Inland Empire, Manchester, and Mexico City are all linked by their affective and sonic proximities, made legible when listening to Morrissey and other '80s British rock. We thus find a notion of transnational Latinidad that includes, and is rooted in, the melancholic contours of difference, rejection, and empire. It's an affective glossary rarely offered by the political demands of citizenship, and one that ultimately proposes modes of relationality foreclosed by predominant understandings of Latinidad.

The aural articulation of Morrissey's imagined proximity to Latinidad does not necessarily bear the recognizable traces of politics that Chicana/o and Latina/o movements have provided in relationship to the specter of assimilation. But as Marissa K. López argues in her analysis of the enmity between emos and punks in Mexico City and beyond, "even if the emos are not self-consciously political, their musical and stylistic communities can tell us something."[12] This "something" is what she calls "a transnational refraction of Chican@ engagements with punks and new wave."[13] What these subjects share is "alternately, Latin@ belonging and ostracization from broad national and global communities. Emo's stylistic flourishes afford a window onto how the body registers such geopolitical concerns."[14] I draw from López's astute and nuanced reading of the Latina/o emo for my argument, build on her insights about the emo's (dis)placement on a global scale, and add several further elements. Latina/o Morrissey fans understand that they have been dispos-

sessed by both nation and capital, but they fail to find a welcoming home in community or family. By refusing the imagined comforts of family as well as the safety of assimilation promised by neoliberalism, the Latina/o Morrissey fan chooses instead an aesthetic life of rejection, made accessible by the melancholy sounds of Morrissey.

On Morrissey

Although Morrissey is the central figure that grounds this chapter, he is primarily the vehicle that allows me to explore the understudied affective realms that his music allows his Latina/o listeners to access and express. I engage his figure and music only briefly, but he is a symbol that provides the articulation of negative affective states while remaining beside them. And even if his controversial statements test the loyalty of this fanbase, his fans have not stopped listening to him or attending his concerts. As Morrissey himself has written in his lyrics, he's a disappointing figure,[15] and anyone with such mythical status can't help but fall short of the contemporary expectations around the politics that famous artists should hold. But Morrissey has always been a disappointing figure, producing feelings of ambivalence in his native Britain since the beginning of his career. In the 1990s, his xenophobic statements to the press and use of the British flag to nod toward a return to a traditional, white England created a backlash with South Asian listeners in Britain who felt betrayed.[16] He's ostensibly homosexual but refuses to come out of the closet, presenting instead an asexual persona who always fails to achieve romantic closure. He is a vegetarian—something much derided by a meat-eating culture. His albums after the breakup of the Smiths have been of varying quality, producing a critical loop in which he is imagined either as finally finished or always on the brink of a comeback. He cancels shows at the last minute, leaving audiences frustrated and angry.

Born to an Irish family that relocated to Manchester, England, Steven Patrick Morrissey first came to prominence as the lead singer and lyricist of the Smiths, alongside guitarist Johnny Marr, bassist Andy Rourke, and drummer Mike Joyce. During their time together, they released four studio albums that transformed the sonic landscape of British rock music. The band has been credited with providing the

soundtrack to a British generation who experienced the brunt of Margaret Thatcher's neoliberal decimation of the English welfare system. The group's image was also decidedly antimonarchic, as evidenced by the title of their 1986 album, *The Queen Is Dead*. They represented the masses of British young people who had been dispossessed as industrial towns fell into economic depressions, unions were eviscerated, and a way of life established in the aftermath of World War II became a distant memory. The Smiths' music and lyrics interpreted the structural feelings of economic dispossession through deeply personal and depressive lyrics, and in doing so turned the rise of a neoliberal economy inward. In other words, their music responded to forms of social rejection that shaped that generation and others. The music of the Smiths thus was able to articulate and embrace becoming a reject in a particularly devastating economic moment. Morrissey's lyrics are often seen through just the lens of depression, but they also come from a particular brand of British humor that expresses the dreariness of everyday life in "a humdrum town that has got you down."[17] The band's songs also identified an early dissatisfaction with ever-increasing low-wage service economies, as heard in one of the most emblematic phrases in their oeuvre, "I was looking for a job and then I found a job, and heaven knows I'm miserable now." In spite of the band's relatively small discography, the Smiths achieved near mythical status in the aftermath of their breakup, and the English music magazine *New Musical Express* (*NME*) has time and again listed the Smiths as the most influential British band of all time—above even the Beatles.

After the Smiths' breakup, Morrissey embarked on a solo career that has experienced varying degrees of popularity. His early solo albums, such as *Viva Hate* (1988), *Bona Drag* (1990), *Kill Uncle* (1991), and *Vauxhall and I* (1994), enjoyed success rivaling that of the Smiths' string of hit records. However, Morrissey entered a period of relative obscurity following these early solo triumphs, maintaining his status as a cult figure, but languishing without a record contract for a number of years. During this period, Morrissey's Latina/o fan base around Los Angeles began to flourish. Since then, while Moz has experienced ebbs and flows of popularity, his iconic status has been sustained in large part by his Latina/o following, which he has acknowledged in several of his recordings, including one of his later hits, "First of the Gang to Die," which tells the

story of Hector, a young Chicano in Los Angeles who becomes a legend after being gunned down amid gang violence.

Morrissey himself is a consummate performer, building his persona from the early days of the Smiths as a depressive queer aesthete committed in equal parts to Oscar Wilde's wit and James Dean's style. His voice is extravagantly melancholic, gifted with an operatic vibrato that makes each word resonate with sad overtones that rise above any accompanying music. His live performances feature him swaying across the stage with self-assured pomposity. In his early days he would carry a bouquet of flowers that would rock back and forth, his shirt midway or completely unbuttoned, his expression matching the deep feelings of his lyrics. Morrissey has cast himself as the ultimate loner, the recipient of endless romantic disappointment who must settle with sleeping alone every night, away from a world that is too much for his sensibilities.

At the center of Morrissey's mythos are his lyrics, both gloomy and humorous, the determining factor that draws listeners to the singer. As Michael Cobb affirms in *Single: Arguments for the Uncoupled*, "[Morrissey's] lyrics create a soundscape offering a luxurious melancholy, a delicious tristesse, that needs no specific content. Specifics might interrupt the easy transferability of the melodrama of the anxiety of self-pitying adolescence, or even the glib and clever snideness of postadolescence."[18] Although he is far from the only great writer of sad songs, the excessive melancholy of Morrissey's lyrics is arguably without equal in modern music. From "I was happy in the haze of a drunken hour, but heaven knows I'm miserable now" to "last night I dreamt that somebody loved me, no hope, no harm, just another false alarm" to "all your friends and your foes, would rather die than have to touch you," Morrissey sings of an extravagant sadness. In their theatrical overindulgence in sadness, his lyrics allow listeners to recognize a sense of alienation articulated by an external voice that is nonetheless felt as deeply personal. Indeed, one of the recurring moments in the story of any Morrissey fan is their first encounter with his words—the sense that he had somehow captured a feeling that had always been there and that now had been voiced by another who somehow felt the same way.

Any account of Morrissey would be incomplete if we failed to consider the already complex meanings attached to his Britishness. Nabeel Zuberi's excellent *Sounds English* traces how popular British music in the

1980s and 1990s became a sort of battleground for defining British identity at a time of great change, particularly Thatcherist economic reforms that blasted the tradition of the British working class into near extinction and the cementing of immigrant populations from East and South Asia, the Middle East, and the Caribbean. This resulted in waves of anti-immigrant sentiment—a story told explicitly in something like Siouxsie and the Banshees' "Hong Kong Garden." As Zuberi explains, Morrissey was a complex figure who was one of the first major artists to invoke an idealized image of working-class Britishness through the visual culture of the kitchen-sink drama paired with a constant queer referencing of his own tastes and life.[19] Part of what distinguished British music of the period was how much of it came not from London, but from places like Manchester, Sheffield, Crawley, and other industrial cities where livelihoods had been decimated throughout the 1970s and 1980s. The Smiths' sound and lyrics reflected this change in affective terms: the mood of postindustrial towns sinking into economic depression.

If, as Zuberi points out, Morrissey has always been an ambivalent figure when it comes to race, in recent years he has made increasingly explicit statements, including allusions to Chinese "subhumanity" (on account of their consumption of domestic animals) and xenophobic rants that aim to uphold "Europe as Europe." (He has also offered a defense of sexual harassers like Harvey Weinstein and Kevin Spacey.) Although Morrissey has time and again claimed that these were taken out of context, the racial undertones of his lyrics have always been present. His invocation of a "pure" British culture that enjoyed its prime in the 1950s and 1960s cannot but be tied to its working-class whiteness—a racially homogenous "paradise" that was interrupted not only by Thatcherite policies but also by South Asian immigrants who had once found affective refuge in his music.

Morrissey keeps disappointing his fans, and even if I do not want to make this chapter about him or his more troubling expressions, they have become increasingly necessary to address not only for me but for many of his Latina/o fans. I am not interested in defending him or his views; I believe the singer's persona and his aesthetic output must be kept separate. I find myself turning to Susan Sontag's obituary for the writer Paul Goodman to articulate my own views on this dilemma. Although Sontag greatly admired Goodman, considering him one of her

favorite writers, he treated her with cold indifference at best, misogynis-
tic rancor at worst. Sontag writes, "I was told by mutual friends that he
didn't really like women as people [. . .]. I resisted that hypothesis as long
as I could (it seemed to me cheap), then finally gave in."[20] And yet Son-
tag couldn't help but maintain her intellectual and aesthetic admiration
for Goodman, even as she avoided sharing space with him. She goes as
far as to say that "not only were Paul Goodman and I not friends, but I
disliked him."[21] And yet her admiring description of him could describe
my own (or any other fan's) admiration for Morrissey: "Paul Goodman's
voice touched everything he wrote about with intensity, interest, and
his own terribly appealing sureness and awkwardness. What he wrote
was a nervy mixture of syntactical stiffness and verbal felicity; he was
capable of writing sentences of a wonderful purity of style and vivacity
of language."[22] Sontag, in the end, does not need Paul Goodman the
person because she has Paul Goodman the writer. However, she knows
that "there is a terrible, mean American resentment toward a writer who
tries to do too many things,"[23] or, I would add, to a singer that means so
much to so many people. Toward the end of her short reflection, Sontag
explains, "his voice on the printed page is real to me as the voices of
few writers have ever been—familiar, endearing, exasperating. I suspect
there was a nobler human being in his books than in his life, something
that happens often in 'literature.'"[24] I invoke Sontag not simply to let
Morrissey off the hook from his ongoing problematic statements, but
as an important example of how fascination with and indebtedness to
a writer or artist may be separated from the person. Such retrospective
glances may seem easier to give to figures who have passed away, but I
am convinced by Sontag's stunning recuperation of Goodman that there
is a way to think beyond a person and instead focus on the kinds of
things that they have made accessible to us.

A Short History of the Latina/o Morrissey Fan

The backbone of the Latina/o Morrissey fan base began with a yearly
convention that gathered listeners to trade bootlegs, memorabilia, and
other merchandise dedicated to Moz. These events were soon accompa-
nied by live tribute bands, including the Sweet and Tender Hooligans.
Led by José Maldonado, the Hooligans attempted to recreate the feeling

Figure 4.1. William E. Jones, *Stage Side at the Smiths/Morrissey Convention*, 2003. Gelatin silver print. © William E. Jones. Courtesy of the artist and David Kordansky Gallery, Los Angeles and New York.

and experience of having been at a Smiths concert. But audience members at a Sweet and Tender Hooligans performance feel no irony or nostalgia; instead, these concerts provide an opportunity to experience a scene that predated these fans—a way of touching the past through a reenactment of the music. Yet we cannot forget that the audience in this case is made up of Latina/os sharing the same depressive mood that allows itself to be turned into ecstasy.

The Latina/o Morrissey fan appeared with full force in mainstream media in two articles published within months of each other—the first, an August 2002 article by Chuck Klosterman in the music magazine *Spin*; the second, a piece by Chicano writer Gustavo Arellano in the *OC Weekly* that October. In a collection of his essays, Klosterman recalls being given the assignment; when he asked the editors of the magazine what they wanted the angle to be, they replied, "I have no fucking idea. I'm not sure why we're even doing this story, to be totally honest. Just go there and find some freaks."[25] The article finds Klosterman at the sixth annual Smiths/Morrissey convention in Hollywood. He writes, "these

fans are not the glowering white semi-goths you'd expect to encounter; this scene looks like a 1958 sock hop in Mexico City. To argue that Morrissey's contemporary audience skews Hispanic would be inaccurate; Morrissey's contemporary audience *is* Hispanic, at least in L.A. Of the 1,400 people at this year's convention, at least 75 percent of the ticket buyers—virtually all under twenty—were Latino. For reasons that may never be completely understood, teenage Hispanics tend to be the only people who still care about Manchester's saddest sack."[26] The writer's incredulousness comes from the fact that, during this time, Morrissey had lost his recording contract, and he had been without a label for a few years. To many, he was simply a figure from the past who had descended into obscurity. Finding a thriving fan base thus came as a major surprise, especially given that these fans did not resemble the melancholic white Morrissey listener of his 1980s and early 1990s heyday.

Gustavo Arellano's "This Charming Man: Dispatches from the Latino-Morrissey Love-In" is much more generous toward this audience. Whereas Klosterman's piece holds Latina/os at a distance, Arellano recounts stories from his friends and family. He remembers, "At the concert, it's more of the same; the man wins me over, his words come to life and his acknowledgement of my culture is so beautiful. How could I *not* love Morrissey? Morrissey sings to the disaffected, and God knows alienation is part of the assimilation tradition—the equal and opposite reaction of the immigrants [*sic*] drive to blend in. We ache; Morrissey soothes."[27] Arellano importantly recognizes that, "[d]espite such a devoted fan base, media treatment of the Latino Morrissey phenomenon is universally condescending, if not outright racist." In his foreword to Melissa Mora Hidalgo's excellent *Mozlandia: Morrissey Fans in the Borderlands*, written over a decade after the publication of his *OC Weekly* piece, Arellano explains that "about every couple of months for the past decade, a new news outlet—whether radio, television, film, Internet, Snapchat, *something*—discovers that the mercurial Mancunian has a fanatical Mexican following."[28] He continues, "inevitably, those lazy journos fail. Their cardinal sin: treating the love fest as nothing more than a freak show, and thinking of themselves as a mix of Freud, Cortés, and Lester Bangs, leading to vacuous, precious prose."[29]

However, regardless of the context, fans still manage to express what exactly draws them to Morrissey. Klosterman quotes Gloria Antunez, a

middle-school teacher who brings Moz's lyrics into the classroom and explains that his background—his Irish emigrant family and how it was "kind of socially segregated from the rest of" England—is "very similar to the Latino experience here in Los Angeles. We see things within his songs that we can particularly relate to. He sings about loneliness. He sings about solitude. Those are things any minority group can relate to."[30] In the years since the publication of Klosterman's and Arellano's articles, the amount of space devoted across various media to explaining the relationship between Morrissey and Latina/os has been vast. For example, in Simon Goddard's *Mozipedia: The Encyclopedia of Morrissey and the Smiths*, an entry devoted to Latino fans explains, "Various magazine articles investigating Morrissey's 'Latino appeal' [. . .] have all arrived at the same demographic conclusions: Latinos, and especially Los Angeles Mexicans as an ethnic minority subject to prejudice and exclusion, immediately identify with his gospel of outsiderdom; their love of his music is conscious rebellion against the prevalent hip hop culture as a means of asserting their own identity; and, aesthetically, his rock and roll trappings of black quiff, sideburns and jeans sit very comfortably with the 'greaser' tradition endemic in Hispanic youth culture since the 50s."[31] Other explanations point to Morrissey's voice as reminiscent of Mexican crooners with extravagant stage presence like Pedro Infante and Juan Gabriel, and still others have suggested that the melodramatic nature of his lyrics recalls a certain telenovela culture.

However, most cultural explanations fail to grasp how the Latina/o subculture around the British "Pope of Mope" came to be. A more convincing account has been given by various writers in what I call the "KROQ thesis." The legendary Los Angeles radio station was responsible for providing airplay to some of the great alternative rock bands of the 1980s and 1990s. The station could be heard across the greater Los Angeles area and its DJs would keep the Smiths and Morrissey on constant airplay. Perhaps Morrissey's biggest welcome to Los Angeles was a legendary performance at the Hollywood Bowl in August 1992, which sold out "in twenty-three minutes, breaking a longstanding record held by the Beatles."[32] Although this story has been usually rendered in relationship to Los Angeles and its own mythos, and thus we are unable to ascertain just how many early Latina/o Morrissey fans would have been present at the performance, we can speculate that, given how collective gatherings

of Latina/o Morrissey fans had become popular in Los Angeles by the late '90s, their presence would likely have been sizable even then.

In *Mozlandia*, Melissa Mora Hidalgo delves into multiple expressions of Latina/o Morrissey fandom, from sing-along karaoke nights in Boyle Heights to José Maldonado's weekly radio program, *Breakfast with the Smiths*. The characters and scenes in Hidalgo's writing are immediately recognizable to anyone who has ever been a part of this scene. Other names and faces reoccur throughout narratives of Latina/o fans. For Hidalgo, fandom's "potential for enacting resistance and creating new spaces of belonging in places where we are told, too often that we do not belong" *is* the point of Latinidad's nearness to Morrissey.[33] She turns to Gloria Anzaldúa's notion of the borderlands to understand the social and cultural connections forged among Morrissey's listeners. Rather than linger in the morbid fascination with Latina/o depressive states, Hidalgo prefers to see the Latina/o Morrissey fan as an active agent who reframes Anzaldúa's famous conception of the border as an open wound. It should come as no surprise that Hidalgo and I are interested in differing accounts of Morrissey's meaning to his brown listeners. Whereas she is interested in the spaces of belonging that fandom creates, I am invested in prodding the depressive affective states that Morrissey's music allows. However, I am also convinced by her larger argument and the examples she shows of the kind of capacious life-worlds that Morrissey fandom has created across a range of brown publics, in Los Angeles and beyond.

In a brief discussion of the Sweet and Tender Hooligans' shows in her book *How Soon Is Now?* (titled after the Smiths' song of the same name), literary scholar Carolyn Dinshaw exclaims that "Smiths fans know that desire can—and sometimes must—create its own time."[34] Dinshaw continues, "How to describe the *now* of a show [. . .] where audience members hug lead singer José Maldonado as they would Morrissey? It's not that they actually believe the Hooligans are the 'real thing,' but rhythm guitarist Jeff Stodel speaks of 'this sort of ritual thing' wherein 'people will come up and people will do the same things they would do to Morrissey at a live Morrissey performance.'"[35] Dinshaw's description of the affective temporalities opened by a Sweet and Tender Hooligans show results in a far more interesting engagement with Morrissey's Latina/o fan base than the endless glut of cultural explanations that attempt to construct a sense of racial proximity. Through her analysis of "How Soon

Is Now?" Dinshaw teases out the complicated temporalities involved in listening to Morrissey's melancholia. As Dinshaw writes, "For the voice in this song this situation is unbearably wearisome, each moment more hopeless than the last, opening onto a future that is nothing but one newly empty *now* after another. The word *soon* only makes things worse, shifty and resistant as it is to fix a definite time."[36] Dinshaw neglects to mention the ethnic/racial specificities of the audience at a Sweet and Tender Hooligans show, but her analysis is relevant to my reading. By attending the show, Latina/o fans are able to open up and, potentially, to enter a temporal mode different from their own.

But perhaps the most convincing explanation of the sonic affinities between Morrissey and Latina/os has been offered by Karen Tongson. She points to British cultural critic Simon Frith's explanation of "suburbia as an operative sign in the formation of British popular music and musical subcultures,"[37] or the fact that major musicians from this era emerged far away from a thriving London. Tongson writes, "the mainstream popularity of British pop in the United States [. . .] forged a soundscape that underscored the imperial legacies—some obvious, others more remote, both historically and cartographically—embedded in the Southern California landscape."[38] She analyzes the performances of the East Los Angeles–based performance group Butchlalis de Panochtitlan (BdP), who frequently used Morrissey songs in their performances. Tongson finds that "the sonic styles and expired fashions that adhere to certain bodies cannot be extracted from the spatial negotiations that transpire simultaneously on a micro-scale—between patrons within a specific setting—and the macro-scales of development: from contemporary struggles over civic redevelopment, to historical, colonial conflicts and fantasies."[39]

Allow me to remain with Tongson's careful consideration of Morrissey's Latina/o fan base. She also discusses the kinds of cultural explanations that have been given to make sense of this phenomenon and critiques how "it presupposes a racially coherent, authentic, and self-aware subject that always has 'home' or diasporic point of cultural origin as an affective coordinate."[40] Tongson quotes Raquel Gutiérrez (one of the lead performers in BdP) and her assertion that "Morrissey functions as a reference point because he invokes with his own brooding suburban outsiderhood a version of Southern California spiritually significant to

a spectrum of queer Latinas and Latinos."[41] Most importantly, Tongson explores how "Latino fans [. . .] transpose Morrissey into their own imaginaries, rather than conforming to the assumptions disseminated through his fan culture's critical reception in the mainstream media. In other words, the BdP are not Moz's loyal subjects; instead, the BdP demonstrate through their performances that Morrissey potentially functions as an objective correlative for the sentiments of displacement and incongruity—both spatial and sexual—that might be shared by Latinos throughout Southern California's suburbs."[42]

I draw from Tongson's careful reading of Latina/o Morrissey fandom because she captures temporal/geographic relations that go beyond the cultural explanations given by endless outlets. I am especially convinced by the ambivalences she uncovers in positing how "these encounters are perhaps out of time as well as out of place, both vexed and resplendent."[43] I move beyond the suburban locales of Los Angeles and England that Tongson writes about by considering how the fan phenomenon in this chapter has by now exceeded the confines of these two places. Indeed, "Morrissey nights" are attended by ever-faithful Latina/os in places like Chicago's Pilsen neighborhood, and Morrissey's following has consistently grown in Mexico and other countries in Latin America. As Morrissey himself points out in his autobiography, he has been welcomed by audiences throughout Mexico, where he has sold out places like the enormous Palacio de los Deportes in Mexico City in record time, and, as he chronicles, at a show in Puebla, an enthusiastic audience managed to outsing him as he performed some of his greatest hits.[44] I still find Tongson's analysis convincing even when stretched outward from Southern California and England, and we might conceptualize as Mexico as the suburban/geographic other of the United States. Even if the racial dynamics of Mexico and Latin America are decidedly different, the national-economic relation between the United States and the rest of these countries maintains major elements of this relation.

Shared Listening, Shared Rejection

I move from the spatio-historical and toward an aesthetic notion of self-creation in the pits of melancholy to understand the modes of being that Morrissey's music facilitates. I turn to French philosopher Jean-Luc

Nancy's notion of listening to articulate my own approach. Nancy posits aurality and the sonorous as essential to activating the potential of inter-subjectivity. He wonders, "What secret is at stake when one truly *listens*, that is, when one tries to capture or surprise the sonority rather than the message?"[45] To listen, contends Nancy, is to open oneself to the other beyond the bounds of identity, "on the edge of meaning."[46] To occupy this edge makes it possible for listeners to embrace being rejects. Nancy specifically points to sound as "tendentially methexic (that is, having to do with participation, sharing, or contagion)."[47] For him, hearing, out of all the senses, has the capacity to expand our relationship to the social world without resorting to representational models of being. This is not to say that listening is thus opposed to other forms of knowing, but that it can function as an enhancement that operates beyond visual and even linguistic registers.

How may one speak of these senses? Of how one listens? Or indeed, of *why* one listens? The Norwegian writer Stig Sæterbakken described the process of listening to sad music, of seeking out melancholy:

Maybe there is an excess of something black in the music that we can call melancholic, a dark element, which [can be] labeled "sad," and which, just as it comes into contact with us, brings us face to face with an enor-mous chasm, an alluring abyss, where that should have been, which if it were there, would have made us whole, would have satisfied us totally and completely, and given us peace, but which, because it is not there, keeps us longing for something alive. And maybe that is what sad music calls forth in us, just as it brings us to the edge of our inner abyss, a longing to remain standing there, unfulfilled, in this longing, which is a longing for another music than the one we actually hear, a music that resembles it, but which is not identical to it, and which is a music we desperately want to hear, but which at the same time is available only through the other that we listen to right now, that which can only be distinguished as a possibility, so to say, in the music we listen to, which is not the music we are longing for, but which resembles it, a similarity that is a delightful satisfaction and at the same time a frustrating absence of satisfaction.[48]

Sæterbakken refers to his own listening practices, and in particular his love of Estonian composer Arvo Pärt. Sæterbakken's description allows

me to approximate some of the affective language utilized by Morrissey followers, and what listening to this melancholic music affords us. In short, Sæterbakken proposes that, in listening to sad music, we approach our own internal abyss, created at the hands of the Other. He proposes that listening to sad music is an ethical position, one that I argue is central to brownness, to Latinidad. Sæterbakken continues:

> we are never fully and completely ourselves. Because our lacks, our weaknesses, and our fears make up an essential dimension within us. Because our wounds are meant not only for healing, but also the opposite, to be kept open, as a part of our receptivity to that which is around us and within us. And because there is also relief in this, not to be healed, not to be cured, melancholia satisfies us by preventing us from reaching satisfaction, it calms us by keeping our anxiety alive, it gives us peace by prolonging the state of emergency, the state of emergency that answers to the name Humankind.[49]

Race as a state of emergency, belonging as an abyss. Or perhaps, the abyss of belonging as a state of emergency, the languorous tristesse of Morrissey's music as abeyance. This abyss of belonging is constructed by two apparently contradictory but quite complementary developments. The first is exemplified by a *New York Times* article by Nate Cohn from May 2014 with the title, "More Hispanics Declaring Themselves White." There is a hopeful crisis in the article, which uses census data to conclude that "[t]here is mounting evidence that Hispanics are succeeding in American society at a pace similar to that of prior waves of European immigrants."[50] The responses were swift and forceful. Cohn was misinterpreting demographic data, many claimed, at the same time ignoring the specificities of class, or even the meaning of whiteness. In another piece, Cohn added that indeed these specificities did matter, but in both directions: "Many analyses of census data shows that Hispanics who call themselves white have higher levels of educational attainment, income and civil engagement than those who identify as some other race."[51]

But another form of belonging comes at a time in which Latina/os in the United States are being diagnosed with clinical depression in unprecedented numbers. In tandem with this psychiatric trend, new studies, patient guides, and even a full volume devoted to depression in Latina/o

communities have hit the clinical marketplace. In their introduction to *Depression in Latinos*—a comprehensive survey of clinical diagnosis and treatment—the editors write, "Depression has silently accompanied every immigrant in his/her travel to another land, choosing to make its presence known when circumstances overwhelmed the capacity of the individual to cope and adapt to the stressors enveloping them."[52] While this chapter does not offer an analysis of psychiatric trends, it's worth pointing out that many of the studies featured in *Depression in Latinos* begin from the supposition that depression may be the result of political, economic, and cultural inequality. While most examples of this literature advocate for otherwise unproblematized medicalized treatment regimens, they highlight cultural and ethnic difference as a potential cause for depression. Ultimately, these guides stop short of critiquing the systems responsible for these inequalities themselves. By contrast, my discussion proceeds from the supposition that depression, beyond its clinical dimensions, functions as an essential part of the culture of Latinidad in the US and can itself be understood as an affective position taken up in response to an antagonistic relationship to national narratives of ethnic and racial norms.

Latina/o studies has produced work that is particularly receptive to this melancholic turn. In *Dead Subjects: Toward a Politics of Loss in Latino Studies*, Antonio Viego suggests that ethnic studies in general and Latina/o studies in particular can learn from the notion of the split subject developed in the work Jacques Lacan. For Lacan, all subjects are "split"—marked by an irreparable loss occasioned by our entry into language. Viego attempts to counter the dominance of ego psychology in the United States after World War II, a discourse that shaped the way Latina/o and other racially marked subjects have been medically and culturally understood since the postwar period. I want to return to his argument, quoted in the last chapter, that "we fail to see how the repeated themes of wholeness, completeness, and transparency with respect to ethnic-racialized subjectivity are what provides racist discourse with precisely the notion of subjectivity that it needs in order to function most effectively."[53] In other words, the problem with ego psychology in the United States is that it relies on distinct notions of wholeness in which the subject—and specifically the racialized subject—is imagined as an insufficient self that must be completed through integration into

the dominant norms of the nation. For Viego, ego psychology's desire for psychic wholeness is predicated upon the white subject who has, at least in theory, already attained it. That is why he argues that instead we might turn to Lacan's conception of the subject. As Viego writes, "Lacan understands the inscription of the subject in language as constituting a loss, a loss of hypothesized fullness prior to the impact of language that he will refer to as belonging to the order of the Real."[54] In this Lacanian reading of the Latina/o subject, the idea of fullness becomes secondary to another project, a project in which subjectivity itself is structured by a racially marked inability to enter language or the language of wholeness and instead, a mode of subjectivity "alive to the effects of language on the human organism."[55] Viego seeks to politicize this process and to find a different way of conceiving the psychic life of Latina/os.

Viego highlights the pachuco, one of Chicano culture's most persistent and iconic figures. A product of 1950s Chicano culture, especially around Los Angeles, and sartorially represented by the zoot suit, the pachuco has been an enduring figure of study, criticism, and imagination. For Viego, pachucos, in their unruliness, may be regarded as a subject of Chicano anti-identitarian politics. The pachuco bears kinship to Morrissey's Latina/o listeners. These publics, in their attention to sartorial, cultural, and listening practices, also figure as anti-identitarian Latina/o subjects par excellence. While the pachucos are now celebrated figures in the construction of a Chicano past, they were figured as threats to an order of respectability at one point. Pachucos defy language even as language tries to apprehend them, to render them knowable. Similarly, Morrissey's lyrics position Latina/o fans just outside of the realm of language.

Viego's work thus encourages us to begin to think about how Latina/os might emerge as melancholic individuals and how the lexicon of race might be embedded within the language of loss. Such a shift also allows us to turn the discussion from the clinical into the realm of cultural production and aesthetic practice. The goal of this chapter, however, is not to convince the reader of the myriad forms that loss, melancholia, and depression can take under the psychic weight of racial difference. The point, rather, is to investigate how lingering—and even wallowing—in negative affects like depression and misery can be potentially performative actions, can bring something into the world and allow us to rethink

the complexities of Latina/o and other racialized subjectivities. In particular, the affective realm of the sonic provides such an entrance into this encounter because, even when narrative, its properties rely on affective strategies *just outside* of language. I want to think seriously about the negative adjectives and feelings used to describe the actual, physical locales where Latina/o subjects may find themselves. In other words, I understand melancholia and depression not simply as psychic states, but also as spatial markers that apply not only to Stockton, but to many other cities, neighborhoods, barrios, and communities in the United States and beyond. From the west side of Chicago to towns along the southern US border, the spatial life of these places matters when one thinks of the continuing economic disadvantages that Latina/os experience and their psychic repercussions. Listening to Morrissey, I argue, allows Latina/os to come in contact with and externalize the negative affects that define the cultural and geographic spaces they inhabit. Rather than refusing them, Morrissey's music offers them a vessel within which they can dwell and even celebrate these "negative," "bad," and sometimes "ugly" feelings and moods.

But Is It Really So Strange?

Is It Really So Strange? began as a photographic project by Los Angeles–based artist William E. Jones. Trained as a filmmaker, Jones extended his book of photographs into a feature-length documentary, released in 2004. Jones recalls stumbling upon an ad for a Smiths/Morrissey night in Los Angeles in 2001, during one of the singer's periods of obscurity. Like other original fans of the Smiths, Jones thought of Morrissey as a nostalgic figure from his youth. But Jones would encounter a thriving subculture where such nostalgia was absent. He recounts being taken aback by a crowd of Latina/os who appeared to be mostly in their twenties, and thus significantly removed from Morrissey's original heyday. This encounter moved him to start documenting the scene, stretching to several locations, from various clubs in Los Angeles to Porky's Place, a popular rock music bar in Tijuana.

My analysis of *Is It Really So Strange?* encompasses both its photographic and documentary incarnations. First, I focus on a few of the photographs in the series, contextualizing them alongside moments in

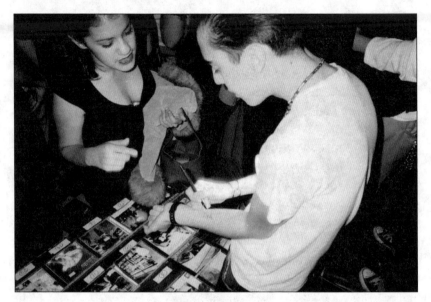

Figure 4.2. William E. Jones, *At the Bootleg Table, Fais do-do, Los Angeles*, 2003. Gelatin silver print. © William E. Jones. Courtesy of the artist and David Kordansky Gallery, Los Angeles and New York.

the documentary. I then turn to the speaking subjects in the film in an attempt to provide a reading of their performative relationship to Morrissey. I negotiate these readings through my own relationship to Morrissey more generally and Jones's project specifically. I am aware of the criticisms of appropriation that have dogged photography and documentary from their very beginnings. What does it mean that Jones, a gay white artist, decided to document this scene? Is this another example of something like Jennie Livingston's (or Robert Flaherty's) gaze? While I do not mean to discount such well-worn criticisms, Jones's projects remain among the most important to have captured the many economic, cultural, and affective components of Latina/o Morrissey fandom. In what follows, I chase the aural puncta I find across the photographs and documentary, as I attempt to translate what the aural elements of *Is It Really So Strange?* capture in moments hidden from plain view.

Jones's book is organized chronologically from a Smiths/Morrissey convention in April 2002 through a New Year's Eve celebration in December 2003. He includes portraits, candid shots during Morrissey/

Smiths nights at various locales, stills from the film, and photographs from another project, *Golden State*, devoted to capturing abandoned locales across Los Angeles and the Inland Empire. Making several appearances throughout the book is the aforementioned Smiths/Morrissey cover band Sweet and Tender Hooligans, fronted by José Maldonado, one of the most prominent faces of the phenomenon. The book allows us to get a sense of the collective intimacy of the scene, while paying careful attention to the sense of melancholia that is essential to the listeners. For example, Chris S., whom I will be returning to in this chapter, appears twice in the series. First in his bedroom, with a blank, sad expression, surrounded by posters of Morrissey and James Dean, holding a pillow almost as if to protect his large body from the multiplicity of gazes that will be directed at him. Sixty pages and almost a year later he reappears at a Sweet and Tender Hooligans show in El Paso, Texas. This time he is at the right of the frame, staring off, tongue sticking out. He's flanked by two girls, identified as Vero and Mary, both with cameras. Vero's camera is pointed at Jones, a return of the gaze that also signals a certain familiarity and trust with the photographer who has, after all, traveled

Figure 4.3. William E. Jones, *José Loses His Shirt, El Paso*, 2003. Gelatin silver print. © William E. Jones. Courtesy of the artist and David Kordansky Gallery, Los Angeles and New York.

Figure 4.4. William E. Jones, *Chris S. in Los Angeles*, 2003. Gelatin silver print. ©
William E. Jones. Courtesy of the artist and David Kordansky Gallery, Los Angeles and
New York.

to Texas from Los Angeles with Chris S. and Mary. But this contrast in the photographs also reveals the proximity between one's bedroom and the club. Morrissey's music makes them equally a place of escape from a hostile world outside.

Jones's camera often zeroes in on the hands and arms of the participants, adorned with tattoos dedicated to album titles, song lyrics, cover art, and even the impression left by Morrissey's signature on somebody's skin. These tattoos function as performative traces, as the intimacy of listening is translated and recorded through a physical pledge of allegiance. I want to remain for a moment on one such image: *Brigette and Joel Show Their New Tattoos*. The photograph shows two forearms, outstretched to display tattoos of Morrissey's signature on their wrists. The image is both melodramatic and melancholic, steeped in the sensorial markings of teenage despair. It conjures the visual iconicity of teenage suicide and the all too familiar sight of brown wrists stretched out to be handcuffed. These are the subtleties and excesses of Latina/o adoration, the negotiation between the racial realities of Latinidad and that which lies beyond its limits.

We find out in the documentary that these wrists belong to a young couple (Brigette and Joel) who recount a story of waiting for Morrissey outside his home in Los Angeles. They had parked their car in the driveway, blocking his exit and thus forcing him to interact with them. The singer approached them patiently, and they introduced him to their three-year-old son, who upon seeing the singer exclaimed, "Mommy, it's Morrissey! Look mommy, it's Morrissey!" Brigette recalls Morrissey's somewhat shocked expression at being recognized by such a young child, and his hesitation at being asked to sign the couple's wrists. The visibility of the singer's name on their wrists produces a shared affect between this encounter and the many other tattoos on other bodies. The name becomes a proud marking, a recognition of the weight of racial difference and the words and sounds that sanction Latina/os to wallow in racial melancholia as a sort of teenage angst. As many Latina/o teenagers know, a tattoo can be a mark of disobedience against one's culture and especially one's parents. But this isn't about the cultural or familial allegiance so often ascribed to Latina/o subjects; this is about creating an affective network of melancholia that reaches out to other wrists and other bodies.

Figure 4.5. William E. Jones, *Brigette and Joel Show Their New Tattoos*, 2003. Gelatin silver print. © William E. Jones. Courtesy of the artist and David Kordansky Gallery, Los Angeles and New York.

Figure 4.6. Still from William E. Jones, *Is It Really So Strange?*, 2004. © William E. Jones. Courtesy of the artist and David Kordansky Gallery, Los Angeles and New York.

The photographs of audiences singing and dancing further allow us into the melancholic's slippery negotiation between the abject loneliness of the music and the joyful relationality, even if rooted in depression, enabled by these sounds. For Latina/o viewers, the overabundance of brown bodies in the frame recalls other moments just like these, surrounded by other fans just like us on nights just like this. Lyrics to the songs in Morrissey's extensive oeuvre float into consciousness, sometimes by the titles given, sometimes just from memory: perhaps lyrics from "How Soon Is Now?" in which the speaker yearns for a moment of recognition that results in going home alone and crying oneself to sleep; or the lyrics to "Ask," which warn us that "shyness is nice / and shyness can stop you / from doing all the things in life you'd like to." Morrissey's doom and gloom is transformed from the sonic aches of a Mancunian pop star to the taxonomies of racial difference that graft themselves to these listening subjects. These images ultimately suggest that the loneliness of minoritarian feeling need not be felt alone.

In her book on the power of black-and-white images and their relationship to memory, Carol Mavor refers to photography's ability to produce in

Figure 4.7. William E. Jones, "Ask", 2004. Gelatin silver print. © William E. Jones. Courtesy of the artist and David Kordansky Gallery, Los Angeles and New York.

its viewers a "bruising passion." Expanding on the exquisite melancholy of Roland Barthes's *Camera Lucida*, Mavor writes that "[w]hen race meets the photograph, desire (punctum) resides in the shadows."[56] Race thus appears in the photograph as its punctum, what Barthes described as the photograph's "sting, speck, cut, little hole."[57] In other words, race exceeds the bounds of the photographs by alluding to racialized histories that we may otherwise wish to ignore. In Jones's depictions, Latinidad emerges both through its silences and as the punctum that exceeds the studium (manifest elements)—a greaser haircut, a tattoo, crooked teeth, pinup-girl lipstick, and many other small yet bruising details. But the bruise itself is not neutral. Mavor's analysis departs from the simple observation that a bruise is made up of the two colors of melancholia—black and blue—of which she says, "black is not the opposite of blue: it is its lining. Both are sad colors."[58] To allow ourselves to be marked by these snapshots, by paying attention to the wounds they may inflict in us, also invites an opening to other relational possibilities for feeling Latinidad.

The documentary version of *Is It Really So Strange?* becomes a melancholic companion to the photographs. Structured as a series of meditations from Jones as well as the interviewees, the film mulls over several aspects of the Latina/o Morrissey subculture. Jones asks fans about their first time listening to Morrissey, the times they have actually met him, their own sense of being racial subjects in the landscape of Southern California, and their thoughts about Morrissey as an artist and as a person. Toward the end, Jones reflects upon the short time that this group of fans have been Morrissey's primary audience. As Morrissey re-expanded his fame beyond his Latina/o fan base by the mid-2000s, the autonomy of the Los Angeles scene began to erode. Jones concludes the film by wondering if Morrissey's return to mainstream celebrity marked the end of a golden era unmarred by the marketing demands of the music industry. While I agree to some extent with Jones's musings in relation to the specific subculture that surfaced around Southern California, I do want to suggest that this subculture is emblematic of psychic structures of listening that make Morrissey an essential—though certainly not the only—means of accessing these affects.

Many of the Latina/o interviewees in the documentary are at once forthcoming and ambivalent about their participation. Several of them uncomfortably admit to having previously been featured in magazine

Figure 4.8. Still from William E. Jones, *Is It Really So Strange?*, 2004. © William E. Jones. Courtesy of the artist and David Kordansky Gallery, Los Angeles and New York.

articles and other news stories about the Latina/o Morrissey phenomenon. Jones, like Tongson, makes clear that in mapping out the territory of Southern California, these subjects inhabit the margins of the metropolitan area, encompassing the precariously defined Inland Empire, Orange County, and other less culturally recognizable areas. They are not a part of the glamorous Los Angeles that occupies so much of the California mythos, but rather the outskirts, the regions that have been overlooked by the forces of economic development that have reshaped the city over the past several decades. The population in the areas the documentary covers is predominantly Latina/o, and their economic situation mirrors the aforementioned circumstances in Stockton and other impoverished areas of California. Among the interviewees England emerges as a geographic elsewhere that in their imaginations is able to capture their affective realities. Inez, a young Latina with crooked teeth, pink hair, and generous amounts of makeup, puts it thusly: "I hate the sun, and that's all that LA is, the sunshine all the time." In this utter-

Figure 4.9. Still from William E. Jones, *Is It Really So Strange?*, 2004. © William E. Jones. Courtesy of the artist and David Kordansky Gallery, Los Angeles and New York.

ance, she resists the prevailing mythology of Los Angeles and Southern California. The sun she wishes to escape is not only the physical sun, but the normative affect demanded of racialized subjects.

Unlike prevailing representations of Latina/os and Latin Americans in US media as effusive, happy, and loud, the speakers here are reserved, soft-voiced, shy. Yet their expressions of fandom are passionate, articulated from an insecurity gained from living in cultures that so often silence them. Many of them seem uncomfortable in front of a camera, but Jones's questions put them at ease. He films most of the participants in their own homes, often in their own bedrooms. The walls of the younger interviewees' rooms are adorned with seemingly endless posters of Morrissey and the Smiths. I often return to the aforementioned Chris S., heavyset, shy, and slightly cynical. He is ambivalent about outsider interest in Latina/o Morrissey fans, given the constant framing of this following as Mexican. (He is Peruvian.) But when asked what the fans have in common, Chris responds, "It's the teenage angst we all have, and

Morrissey just sweats that all out of his body and his music [. . .] and we get drawn to that." That he refers to "we" and not "I" reveals a point of relation across and beyond national origin. Even if he has stated his dissatisfaction with being so easily identified as "Mexican," he recognizes his place in the same racial matrix. In another telling moment, Chris says, "Of course the Morrissey scene has to be more dramatic because we're labeled as the horrific children." What I find striking about this admission is the affect of his expression, his downward gaze and shyness before the camera as he situates Latina/os as outcasts in US culture. Morrissey's Latina/o fans become united under the sign of "horrific children" and "teenage angst," images that arguably resemble the social position of marginalized Latina/os in the Los Angeles area and beyond. They are the horrific children of an ever-developing area that overlooks the ways in which Latino/a residents and newly arrived immigrants struggle to find their place, despite the integrationist ideology of the city's Latina/o political establishment. But Morrissey's voice and music unites them and makes it possible for them to exteriorize their alienation.

Drawing, Listening, Friendship

Is It Really So Strange?—as both book and documentary—is helpful in illustrating the complicated and complex accounts that Latina/o Morrissey fans give of themselves and their allegiance to the singer, but I move now to another visual medium, drawing, to explore the kinds of relationalities it then enables. Shizu Saldamando (b. 1982, San Francisco) is the daughter of a Chicano father originally from Arizona and a Japanese mother whose family was placed in the Japanese internment camps during World War II. She was raised in the San Francisco Bay Area and completed her undergraduate art degree at UCLA, continuing on to receive her MFA from CalArts. Her work bridges a variety of social worlds that she has been a part of, and to which Morrissey, the Smiths, and other British acts from the '80s have been central. Her drawings capture a variety of moments, from nights at Latina/o gay clubs to scenes of hanging out with friends in backyards to carefully rendered portraits of friends and fellow listeners. In her introduction to Saldamando's catalogue for an exhibition at the Vincent Price Art Museum in Los Angeles in 2013, Raquel Gutiérrez writes, "Shizu presents a visual record that explores the nocturnal meanderings of

youthful discrepancy—the social experiments gone sublimely awry. That is probably why you, the silent receiver of Shizu's images, bob your head: there is music there, of course, and recognition."[59] Gutiérrez's introduction to these images goes beyond customary academic distance from an object, coming instead from a place of friendship—the relational ethics of two Morrissey listeners. She refers to Saldamando by her first name, Shizu, allowing gestures of friendship to determine the tone of her essay, thus giving us intimate access to the worlds depicted in these drawings. Gutiérrez, of course, is no stranger to staging the relationship between Latinidad, Morrissey, and queerness. As you will recall, Gutiérrez was the protagonist of Karen Tongson's careful and caring analysis of the Butchlalis de Panochtitlan mentioned previously in this chapter, so we are delving into the relational bond of friendships with others who listen along with us. Saldamando's work traces these relations through a variety of techniques, materials, and surfaces that bring her subjects into relational recognition. The music that Gutiérrez writes of is never too far off, in the background of the clubs, from a boom box at a friend's backyard, or from a car stereo. Gutiérrez continues:

> Let's bring it back to the state of fandom, of being fanatical, of being the number one fan. The set of feelings that come with gushing, twitching, and stalking the object of our admiration and affections. Have you ever seen early Morrissey live performance videos where fans bumrush the stage as though they were seeking absolution? Seeing the people in Shizu's work makes one cognizant of how we make good, rabid fans, especially since, as adolescents, we tend to offset our outsider feelings of robust alienation with quiet desperate longing.[60]

The first work of Saldamando's I encountered was a ballpoint pen drawing of Morrissey on a handkerchief. The image is part of *The Holy Cuatro* (2005), which depicts, as its title suggests, the four holy figures of '80s British pop for Latina/os: Morrissey, Robert Smith of The Cure, Dave Gahan of Depeche Mode, and Siouxsie Sioux of Siouxsie and the Banshees. The images immortalize and canonize four figures essential to Latina/o fandom, yet within a seemingly quotidian medium. In person the handkerchiefs are quite large, and in the years since their original presentation they have developed creases that highlight Saldamando's

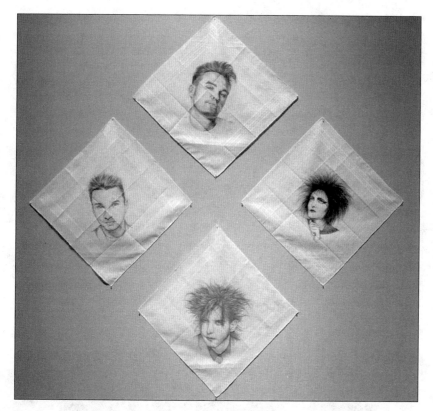

Figure 4.10. Shizu Saldamando, *The Holy Cuatro (Moz, Siouxsie, Robert Smith, Dave Gahan)*, 2005. Ballpoint pen on handkerchief. Courtesy of the artist.

careful use of the pen. There is a particular intimacy that drawing creates between the artist and her subjects. I can't help but think of the high school reject, sitting in the back of the class, making endless doodles of artists like this to find respite, even if temporarily, from the doldrums of daily life. The act of such drawing allows one to reject the stuckness of the present and to escape into a world on the page, exercising the desire to draw oneself out of *this* moment and into another.

Jean-Luc Nancy, in *The Pleasure in Drawing*, ruminates on how drawing constitutes the beginning of form, a basic possibility of aesthetic practice: "there is the singularity of the opening—the formation, impetus, or gesture—of form, which is to say, exactly what must not have already been given in a form in order to form itself. Drawing [*dessin*] is not a given,

Figure 4.11. Shizu Saldamando, *Sandy and Siouxsie*, 2007. Colored pencil, collage, glitter on paper. Courtesy of the artist.

available, formed form. On the contrary, it is the gift, invention, uprising [*surgissement*], or birth of form."[61] In the original French, Nancy plays the word *dessin* in close approximation to Heidegger's *dassein*, or coming into being, and throughout the book, drawing stands partly for the possibility of bringing being itself into form. In Saldamando's work, this possibility of being, and being with others, is brought into contact by form itself. But Nancy also understands the connective tissue between drawing's idleness and the possibility of becoming. I suggest here an idle Latinidad, which in its very shape remains queer and brown, unproductive in the best of ways. For Nancy, the line of drawing is involved in "showing the infinity of becoming visible [. . .]. Just as all lines in all drawings include the same infinity of points, so together they all respond with the same, endlessly modulated gesture, opening to infinitude."[62] This is precisely the methexic quality of drawing. In surrendering to its pleasures, one opens up unto an infinitude of forms. Listening and drawing: neither comes before the other; they are co-produced through their own practices.

The faces and names of *The Holy Cuatro* make other appearances in Saldamando's work as well. *Sandy and Siouxsie* (2007) depicts a woman holding a cigarette and staring into the distance. Siouxsie's face is tattooed on her arm, with the name from the band's logo underneath and multiple red and gray stars occupying the space above. She wears a Bauhaus T-shirt—another '80s British band. The technique of colored pencil, collage, and glitter on paper distinguishes each element of the figure. Saldamando's work is full of texture. Once again, Siouxsie songs parade through the mind, connecting Sandy to the other drawn figures. As Gutiérrez aptly describes,

> Shizu's project relies on magnifying her subjects by way of creating a negative space around the individual(s). More information can be gleaned from the absence of spatialized context than the environment they occupy. Shizu creates an oblique portraiture that is about the people who surpass their contexts, inviting the viewer to activate their own queries and conjecture onto the subjects—maybe mutual friends—in the work.[63]

While each retains its own formal elements, the soundtrack of Morrissey and others join them, allowing the viewer to recognize herself and her social worlds through these images.

Figure 4.12. Shizu Saldamando, *Embrace Series*, 2009. Exhibition view. Ballpoint pen on bedsheet. Courtesy of the artist.

Some of Saldamando's most striking pieces belong to her *Embrace Series* (2009). Using a ballpoint pen to draw on bedsheets, the series depicts various subjects in moments of intimate embrace across spatial and temporal contexts. Gutiérrez points out that the bedsheets in these pieces return the viewer to the adolescent bedroom, where a "first foray into fandom takes place in private—by pushing play on the CD deck, the iPod, or even the turntable. For many of us, this experience began in the bedroom with a Kenwood system and headphones handed down to us by older siblings."[64] Gutiérrez's description here encapsulates the Morrissey listener, and thus the promise of what I identify as idleness. The recurring images of Morrissey's Latina/o fan base in Saldamando, Jones, and perhaps in their many depictions across media, are punctuated by a form of idleness created in moments like the hangout, or, as in the *Embrace Series*, between the lying in bed and the hanging out. I differentiate idleness from boredom, although the two can surely be closely related, but the former points us toward nonproductivity, the feeling of not wanting to do anything. Depression's dangers, lest we forget, are often signaled by what might to the outside world appear as an excessive idleness. And although certainly technically prodigious in Saldamando's hands, drawing and doodling are two of our most common companions

in moments of idleness, of retreating into the self in a public space, of finding a moment that seeks nothing but itself. Saldamando's drawings invite us to wallow in depression as an enactment of idleness. Indeed, many of her drawings use a ballpoint pen, one of doodling's most consistent tools.

I read the *Embrace Series* as an invitation into the act of idling. The use of bedsheets, which Gutiérrez locates within a larger history of "the bed" in contemporary art, also points to an act of idling. *Morrissey Night, Underground LA* (2009) uses a flower-patterned sheet. Drawn on it are two figures, a lesbian couple perhaps. A long-haired femme with Morrissey's name tattooed on her forearm looks at her nails, holding a butch lover in an embrace. We are not sure if the butch partner is staring off into the distance, or is perhaps about to whisper something, but in the embrace and the pattern of the sheets they become united, their whole bodies grafted onto the pattern, the flowers becoming their own shared tattoos, both becoming engulfed by the pattern and arising from

Figure 4.13. Shizu Saldamando, *Embrace Series, Morrissey Night, Underground LA* (detail), 2009. Ballpoint pen on bedsheet. Courtesy of the artist.

Figure 4.14. Shizu Saldamando, *Embrace Series, Ripples, Long Beach* (detail), 2009. Ballpoint pen on bedsheet. Courtesy of the artist.

it. Saldamando never gives us the names of the couple in embrace, simply where they were. This serves to retain the intimacy of the embrace, maintaining our exteriority to it, while at the same time inviting our placement onto it via our memories of our own embraces. *Embrace Series, Ripples, Long Beach* (2009) shows two Latino gay boys embracing at the Long Beach gay club. There is no context for the embrace; it could be on the dancefloor, a broken stumble, in the midst of a kiss. The rose patterns on the found bedsheet again mark their bodies, uniting drawing and canvas. If the sheet is for its viewers a queer appeal to memory, they are called to enshrine minor memories.

The end of *The Pleasure in Drawing* seems particularly apt here. In his final lines Nancy writes, "In all its forms, in all its allures and ways—graphic, sonorous, dancing, or others—drawing designates this design without a project, plan, or intention. Its pleasure opens onto this infinitude."[65] Saldamando's drawings are a way to approach Morrissey and Latinidad, one settled on a relational plane rooted in melancho-

lia, in idleness, in affects that negate the normative promise of cultural inclusion.

But as I have maintained throughout this chapter, perhaps Morrissey's Latina/o fan base no longer *needs* Morrissey to remain operational. The worlds that he made recognizable were perhaps ready to come into existence and (mis)recognition through fandom but also independent from him. In *To Return*, a 2018 exhibit at the Charlie James Gallery in Los Angeles's Chinatown, Saldamando's recent work shows us how the world enabled by Morrissey fandom exceeds him and the temporal relation that he emerged out of. These drawings, rendered on a variety of surfaces with multiple techniques, continue to chronicle her carefully rendered portraits of friends and the subcultures they form. We are given names and nicknames: *Vikki and Audrey, Chicas Rockeras*; *La Maya*; *Rafa, El Unico*; and *La Sandra*. They are captured in stillness and in action. For example, *La Sandra* (2018) shows the titular woman applying her femme visage, combing her bangs while holding a compact mirror while at a bar or club. On the lower right corner of the paper we see a pink-and-purple efflorescence emanating from the table next to a canned object. The effect is subtle but it points to a potential outburst of color and glitter that mirrors the pink comb La Sandra uses. These images are not quite "lifelike," but in their carefully defined rendering they pull the eye toward subtle specificities, such as the folds in her striped shirt and the focused glance that dictates the process of femme self-transformation. *Claudia and Mari* (2018), a graphite portrait on wood panel, shows two Chicana butches sitting next to each other. Once again Saldamando is attentive to the smallest of details, such as the careful parting of a butch haircut, the way a pair of sunken eyes are visible past rectangular glasses, and the carefully outlined tattoos on one of their arms. The wooden surface is essential as well to the way the two butches appear into the space. They are not simply placed upon the surface, but in the lower right corner they blend and disappear (or perhaps, emerge) from the wood itself. They aren't so much drawn on the wood as they are materially essential to each other, the grain of the wood acting just like the floral patterns on the bedsheets did in the *Embrace Series*.

Saldamando has recently expanded her work in portraiture to depict other elements of the scenes and backgrounds of her subjects. She has also developed a series of drawings of lunchboxes lent to her by friends.

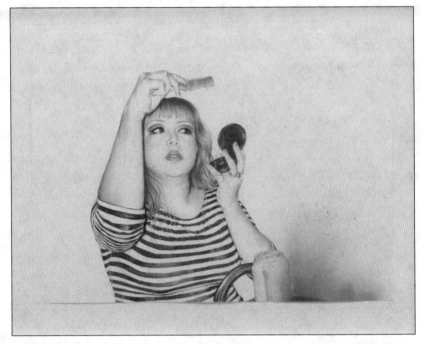

Figure 4.15. Shizu Saldamando, *La Sandra*, 2014. Colored pencil, glitter, spray paint on paper. Courtesy of the artist.

These lunchboxes are teenage school relics, decorated by their owners in ways that render the original images on them unrecognizable. Most of them seem to be metallic, and they are adorned with stickers of favorite bands. Once again using wood as her surface, *Rudy's Lunchbox* (2017) is decorated with Bikini Kill, Bauhaus, and other band stickers. There are many things this lunchbox could tell us about Rudy, yet Saldamando chooses to withhold details that would make this object entirely knowable. On the left corner of the lunchbox we see only a portion of a sticker, with "DO YOU / HELP / AC" visible. While it is unclear what exactly this sticker discloses, the lunchbox may tell us a world about Rudy. The reference to Bikini Kill, the legendary riot grrrl band founded by Kathleen Hanna in Olympia, Washington, during the early 1990s, moves beyond the context of '80s British rock and instead gives us the sounds of an angry feminist band who once began a record by exclaiming, "We're Bikini Kill / We Want Revolution Grrl Style Now!" and who

included defiantly feminist lyrics that would have been at home in the ears of someone like Alma, our punk guide in chapter 3. *"Sunshine's Lunchbox"* shows us a lunchbox from the side, covered with stickers from the late '70s/early '80s New Jersey punk band The Misfits along with their skull logo, and another sticker from The Cure, displaying Robert Smith's recognizable face. The box's handle appears to be tiger-striped, but once again Saldamando conceals certain details. She is not attempting to show us the lunchbox itself, but rather a suspension in time. We may not know who Rudy and Sunshine *are*, but we can picture them in some Los Angeles middle school, coming into aesthetic and musical awareness, choosing to step out of the confines of the lunchbox's evocation of childhood and into a form of subjecthood that evinces a drive toward unbelonging. These lunchboxes were carried by the weirdos who listened to sad, angry, and aggressive sounds that once upon a time perhaps showed that these teenagers were ready to reject the social, ethnic, and cultural worlds they had been born into. But I also want to suggest that these lunchboxes show us that those carrying them were *not* alone, that they were already in those years a part of social worlds that offered survival. In other words, I want to propose that just because one

Figure 4.16. Shizu Saldamando, *Claudia and Mari*, 2018. Graphite on wood panel. Courtesy of the artist.

Figure 4.17. Shizu Saldamando, *Rudy's Lunchbox*, 2017. Graphite, spray paint on wood panel. Courtesy of the artist.

may choose unbelonging, to reject social strictures, that doesn't mean that one is alone in doing so.

The recurring sense of sociality that Saldamando portrays—and one I argue extends through the Latina/o Morrissey scene—is the intimacy of friendship. I use the term in multiple modalities: a politics, an ethics, a theory. The conceptualization of friendship invoked perhaps most often in queer theory draws on Michel Foucault's "Friendship as a Way of Life"—that friendship rests on the kinds of erotic connections that gay men are able to forge among each other.[66] Indeed, the account of friendship that queer theory has thus far provided insists on the collapse between the friend and the lover, and the expansive possibilities of such a relation. But I want to finish this chapter, and this book, by appealing to other kinds of friendship that don't require the promise of erotic consummation to be sustained and sustaining for those committed to them. Friendship as an essential component of human experience has at times proven difficult for critical theory, queer theory, ethnic studies, and Latina/o studies to grasp. At the same time, as Gregory Jusdanis shows in *A Tremendous Thing*, "friendship has become the metaphor of

the Internet age," recurring as the mode of relation that sustains the ano-
nymity of online sociality; and it is quite easy—and even common—to
take it for granted.[67] As Jusdanis reminds us, "friendship, then, engages
us with people outside of our house, in relationships not underwrit-
ten by law, religion, or the state, in attachments formed through love,
pleasure, and possibility."[68] This makes friendship one of our most es-
sential and yet fragile relations, for "friendship can't count on the legal,
religious, and social infrastructure that family can. Nor is it motivated
by the endgame of sexual fulfillment and reproduction, like marriage.
Finally, it does not rest on professional alliances. Even though you may
become friends with your boss or your teacher, the inequality is likely
to strain, if not hobble the relationship."[69] As much as friendship might
sustain us, it is still free from responsibilities dictated by contracts, law,
or family obligations.

Giorgio Agamben, in a short piece on friendship, turns to Aristo-
tle to argue that friendship is what might afford existence itself a sense
of pleasantness. He writes, "The friend is not another I, but an other-
ness immanent in self-ness, a becoming other of the self. At the point
at which I perceive my existence as pleasant, my perception is traversed
by a concurrent perception that dislocates it and deports it towards the
friend, towards the other self. Friendship is this de-subjectivization at
the very heart of the most intimate perception of self."[70] So friendship
arises as the possibility of understanding the self in relationship to an-
other who is explicitly separate, a relationship that for me arises in the
sharing of a cigarette, a piece of gossip, or a dance floor. It is the moment
of being without aim, without nation, without family: simply existing
in itself, perhaps the feeling of "pleasantness" itself. Friendship is the
bond that rejects can share in solidarity against the rest of the world, or,
to paraphrase another of the Smiths' most famous songs, "rejects of the
world, unite and take over." This is what Jones and Saldamando capture
in their projects: a scene founded on love for an artist but maintained by
the bonds of friendship.

Sadness and Friendship

So what does listening to Morrissey offer his Latina/o audience? I do
not want to advocate for a simple correlation that posits that listening

to Morrissey automatically grants access to an intersubjective realm of alternative racial feeling. Rather, understanding Latinidad from the starting point of depression and loss, idleness and melancholia, allows us to construct racial imaginaries that resist the teleological lines of assimilation or resistance. Jones's photographs and Saldamando's drawings point us away not only from the nation, but also its traditional site of resistance in Latina/o politics: the family. The Latina/o Morrissey fan points us instead toward relational modes—in this case, friendship—that surpass the normative demands of belonging. We are left with the expansive possibility of unbelonging, together, as a community that wallows, and grows.

One New Year's Eve, I found myself dancing at Marrakech, a gay bar in Mexico City that plays a diverse mix of music from current pop hits to cumbia to '80s Mexican divas. The club was packed with bodies that sweated and danced until time lost meaning. Suddenly, the Smiths' "There Is a Light That Never Goes Out" took over the sound system, and the place erupted. We jumped, danced, and loudly sang along, "and if a ten-ton truck / kills the both of us / to die by your side / well the pleasure, the privilege is mine." The ecstasy of the song united the bodies in the club, a shared affect decipherable between those of us who were there singing along, but the moment stretches beyond this club, and this night, to lonely queer Latina/os singing in their teenage bedrooms, to a girl crossing the border hoping to make a new life, to other countless yet indefinite memories of driving alongside a friend in a car thinking that if the end struck, if it were all to end right now, even for this fleeting moment, the pleasure, and the privilege, was *ours*.

Coda

How Soon Was Now?

In May 2015 the Mexican rock band Mexrrissey took the stage at the Brooklyn Academy of Music. This so-called "supergroup," made up of some of the leading musicians in the contemporary Mexican rock scene, performs covers of the Smiths and Morrissey, but unlike the Sweet and Tender Hooligans, who aim to recreate the songs as faithfully as possible, Mexrrissey translates them into Spanish, arranging them with more "traditional" Mexican sounds. In many ways, their show, filled with playful images that "Mexicanize" Morrissey's image as well as his sounds, also worked to translate the singer's Latina/o following to this curious and mostly white audience. Indeed, John Schaefer, the night's host and the world music DJ on a local NPR station, spoke to the band before the start of their set, repeating the same befuddled set of questions about Mexican and Latina/o audiences' love of Morrissey as if a definitive answer would finally be uttered. Mexrrissey finally took the stage, and at first there was something thrilling in the novelty of hearing these familiar songs reinterpreted in the sonic vein of *rock en español*. But after a few songs I became increasingly uncomfortable. Camilo Lara, the band's vocalist and ostensible leader, chastised the audience at BAM for remaining in their seats. Although I am usually a firm believer that a rock show is best experienced standing up to meet the force of the music, Lara's beckoning to us felt different. He informed us that Mexicans love to dance, and that since tonight we were all Mexican Morrissey fans, then we should do as true Mexicans do and stand up to dance. But this invocation of Mexicanidad rang hollow. As one of the Morrissey fans Mexrrissey is in the business of translating, my own love of Morrissey has never summoned this famous Mexican cheer, and in fact, as I have shown, part of what draws so many of us to this music is precisely because it makes the *opposite* possible: a rejection of such a

call for authenticity. As the concert continued, the band's sonic transla-
tions become increasingly jarring, as the musicians attempted to build
a joyful bridge between Morrissey and Latinidad that held the negative
affect of the lyrics and music at bay. Ceci Bastida, the group's leading
female vocalist, sang her numbers in the style of Mexican rock-pop,
with a sweetness that became grating, making Morrissey's depressive
lyrics less and less recognizable with each verse. The translations also
"corrected" Morrissey's sexual confusion, inverting the gender in her
songs, effectively turning them into heterosexual ballads instead of the
bedroom musings of a depressed and lonely queer on the verge of tears.
The band members continued to encourage the audience to embrace
what they would recognize as Mexican affective extravagance, rousing
an increasing number of people from their seats. But my companions
for this evening remarked that I looked almost comically uncomfort-
able. And I was. By the time the concert reached its halfway point I was
noticeably cringing, being hailed against my will by the band as some-
one who should possess an intrinsic desire to dance as "real" Mexicans
do, even if I would prefer not to. Even tonight, I am an unbelonging
subject stuck listening to an object that wants to belong.

There were also other details that signaled a distance between Latina/o
Morrissey listeners and Mexrrissey's performance of this fandom. For
one, the band clearly claimed Mexico as their geographic and aesthetic
home. The wayward Latina/os that first turned their love of Morrissey
into an underground scene in the complex landscape of Southern Cali-
fornia, extending into Tijuana and Northern California—growing in
their ranks to become a cultural phenomenon—were entirely missing
from this night. There was no weeping to Mexrrissey, only a celebration
that championed the kind of cultural hybridity and belonging that my
case studies in this book have rejected. This was not entirely acciden-
tal. Prior to their trip to Brooklyn, Mexrrissey toured across England as
part of a celebration in which Mexico declared 2015 the year of England
and vice versa. The major political event of this mutual celebration took
place in March 2015, when Mexican president Enrique Peña Nieto con-
ducted the first visit from a Mexican head of state to England in over
twenty years, culminating in a state dinner hosted by Queen Elizabeth.
The visit was not without incident, however. About seventy demonstra-
tors showed up at 10 Downing Street to protest the disappearance of

forty-three Mexican students in Ayotzinapa, a crime that Peña Nieto refused to fully investigate, in large part because of the government's own involvement in the atrocity. Mexrrissey's shows across England neglected to make mention of such an event or even to hint at a critical stance against the Mexican state. Their goal was to serve as cultural ambassadors, not political agitators. There are other symbolic ironies immediately recognizable to any fan, such as the fact that the Smiths and Morrissey's earliest sounds and lyrics were forged in opposition to the emergent neoliberal economic tide of Thatcherist England, and lest we forget Morrissey's expressions of working-class antimonarchic sentiment that longed for a Britain in which "The Queen Is Dead"— literally and symbolically. But in 2015, Mexrrissey would not export or bring to life such political sentiments. The band's "Latinization" of dissonant sound emptied their potential to reject the norms of belonging, and instead celebrated a criminal president and a still reigning queen. In the years since, the band has continued to tour across England, the United States, and Latin America, each time Mexicanizing their image and sound a little more. As one of their most recent tours promised, the band would up the ante of cultural recognition by donning mariachi outfits, pushing their Mexican overtones to the extreme.

If an embrace of pessimism has been a recurring theme in this book, I cannot help but end on a pessimistic note. I finish with Mexrrissey because as I awkwardly stood at the band's beckoning, it became clear to me that the forms of rejection exemplified in my chapters had now been consumed by a new sonic landscape that reappropriated their negative affects in the service of the neoliberal models of cultural and ethnic belonging they had once opposed. I admit that perhaps I shouldn't have been so surprised by this realization. After all, one of the most effectively powerful tools of neoliberalism and late capital is an apparently unstoppable ability to fold bursts of opposition into the logic of the market, what Mark Fisher has called "capitalist realism."[1] And indeed, if the sonic negations offered by the dissonance between "white sounds" and "brown bodies" for a moment provided refuge for those outside of the political and cultural mainstream, that night at BAM showed me that such a moment was now gone. A newer generation that had come of age in neoliberalism's promises of economic—and thus cultural—belonging now claimed these dissonant sounds in the spirit of national and ethnic

celebration, welcomed by a market that knew how to embrace them. The negative gestures that had provided subjects living on the margins a sound that rejected the normative stakes of national and ethnic belonging have now become fashionable. No longer confined to the underground, these subcultures now claimed recognition. There have been a few positive developments as dissonant sounds became increasingly harmonious with the cultures that had once turned away from them. Artists like Alice Bag and others who populated these sonic undercommons have been recuperated to show the importance of Latina/os and Mexicans to musical genealogies that had once excluded them. Younger generations, especially in the United States, have access to much more comprehensive sonic archives, and although perhaps still strange, these listeners were no longer subject to the same level of accusation of cultural and ethnic betrayal. Yet my own memories of these subcultures and the time that I spent in them leave me with the certainty that we have lost something in exchange, not the least of which is the desire to unbelong. We no longer want to be rejects. Now we want to be embraced by the mainstream cultures that we had turned our backs to.

But the truth is that no moment or aesthetic of opposition lasts forever. Even if the weight of neoliberalism has crushed the potential alternative of unbelonging that these dissonant sounds once held out, we can still glance back to what they offered us. In the opening to *Disidentifications*, José Esteban Muñoz admits that the disidentificatory practices he favors are "*not always* an appropriate strategy of resistance or survival for all minority subjects. At times, resistance needs to be pronounced and direct."[2] I wrote the majority of this book during the years that Donald Trump gained massive popular support by stoking paranoid fears of Latina/o invasion from the South, so I am ultimately aware that the minor modes of resistance offered by dissonant sounds perhaps became inadequate in such a brutal political moment. Still, I remain convinced that sometime again—maybe not now, but in the not-too-distant future—we will need to reject promises of belonging that while appealing to inclusiveness thrive by excluding certain subjects. I hope that *Unbelonging* has invited readers into the potential joys of welcoming exclusion, of becoming rejects of systems of inequality that hide their violence under a veil of benevolence. I am also certain that these modes of unbelonging, of turning away from inclusion, will become necessary once

more, as the ongoing onslaught of political crises beget more and more categories of marginal subjects. Thus, as the numbers of those who must survive at the edges of dispossession continue to grow, we may seek to join them rather than escape their ranks by claiming a right to belong. I remain hopeful then that the artists and the aesthetics of dissonant sounds might still show us how to champion inauthenticity, an ethics of unbelonging, together.

ACKNOWLEDGMENTS

A book rooted in the forms of listening that shape collectivity could not have been written without the community of listeners that helped me shape it. Even as it has changed over the years, this project will always carry the generosity of the dissertation committee that first encouraged me to take risks to discover it. Juana Maria Rodríguez is the most kind and caring mentor I could have been lucky to encounter. Her continuing support and friendship have sustained me over the years and I am forever grateful for her allowing me to be folded into her capacious and loving sense of Latinidad. Brandi Wilkins Catanese modeled a truly ethical way to be in the academy from our very first encounters, even during the highest of highs and lowest of lows. Her voice is never too far off as I navigate this world. Abigail De Kosnik taught me more survival methods than I can count, and I am certain that without her wisdom and guidance my trajectory would have never been as rewarding and sane. Mel Chen showed me the importance of patience and of encountering the world with a deep sense of open generosity. I can safely say that I always do my best to carry the lessons of their mentorship into my own, what I can only hope is a small tribute to their support over the years. Deb Vargas agreed to be my mentor for the UC President's Postdoctoral Fellowship, and her essential guidance immediately after graduate school is carried in every page of this book. Her intellectual mentorship is only matched by the affectionate kindness of her friendship over the years.

I don't know what I must have done in a past life to deserve the presence of Hentyle Yapp in my world. From our earliest cohort days to the present, our conversations have sustained me in innumerable ways. This book owes its biggest gratitude to his many reads of and comments on each draft, and I owe much of my confidence in this project and profession to him. At Berkeley, I was also incredibly fortunate to arrive with a cohort that included Heather Rastovac, Omar Ricks, and Karin Shankar, all of them essential interlocutors at the time in which I needed

them the most. I must also thank the many professors who offered me various forms of mentorship during my graduate school years, especially Catherine Cole, Lyn Hejinian, Darieck Scott, and Shannon Jackson, who never hesitated to include me as one of their students.

I was so lucky to begin my journey into the academy at San Diego City College, where I found the most supportive faculty who encouraged me to pursue what seemed to be a distant dream as a community college student. I will forever be indebted to the mentorship of Roberta Alexander, Hector Martinez, Kelly Mayhew, Jim Miller, and Candace Waltz. This book exists because they believed in me.

I couldn't have asked for a more kind and intellectually exciting community during my time at the University of Maryland, College Park. Christina Handhardt was not only my faculty mentor, but also a wonderful friend who never hesitated to model the ethical stakes of life in and beyond the university. Nancy Raquel Mirabal took me into her world without hesitation and our conversations over dinners and walks gave me a home I will forever treasure. I miss having an office down the hall from Alexis Lothian, my almost birthday twin who I got to conspire with and who showed me the importance of patience and care in the work that we do. David Sartorious's collegiality and friendship were essential to finding my footing at Maryland, and I look forward to many more years of drinks and conversations. I also must acknowledge the wonderful colleagues at UMD and beyond in the DMV, including Elsa Barkley Brown, La Marr Jurelle Bruce, Perla Guerrero, Eva Hageman, Michelle Rowley, and La-Monda Horton-Stallings. I followed Manuel Cuellar, Caitlin Marshall, and April Sizemore-Barber from Berkeley to the DMV, and much of this book is the product of our conversations and work sessions over the years. I was also very fortunate to be embraced by the graduate community in the Harriet Tubman Department of Women, Gender, and Sexuality Studies, including Maria Cecilia Azar, Damien Hagen, Rahma Haji, Amira Lundy-Harris, Eva Peskin, Cara Snyder, and Taylor York. Chioma Agjbaraji was a dream undergraduate student and I am grateful for the friendship we have been able to forge over the years. I don't know that I would have been able to complete work on this manuscript during an essential moment without the work of my graduate research assistant, Anna Storti. Witnessing her own growth first as a graduate student and now as a faculty colleague has been one of the most rewarding parts of this career.

Although life in the academy can feel quite lonesome at times, I have encountered lasting friendships and conversations that will stretch far into the future. Joshua Javier Guzmán has spent countless hours on the other end of the line talking with me through endless ideas. His friendship animates some of the central arguments across these pages. Christina León reminds me to remain grounded with humor and sophistication when the world feels overwhelming. Summer Kim Lee is the best co-conspirator to share a love of the aesthetic with. My ongoing conversations with her continue to animate my thinking in ways that I will forever be truly thankful for. I am also greatly indebted to my friends outside of the academy who have become my family over the years. David Francisco Vidaurre is my partner in listening and the closest I have come to having a sibling. Geraldine Ah-Sue and Emi Kojima will forever be my truest family. Sepi Aghdaee, Cary Cody, Harris Kornstein, and Scott Reed continue to bring immeasurable joy and sanity into my life. Evan Knopf allows me to vent even the most petty annoyances. I can safely say I would not be here without Denise Gilbert. She has remained my most constant partner in life, and her love of so many of the sounds in this book gave me the earliest language to articulate the joys of unbelonging. Ari Brostoff, Dan Drake, Allison Hughes, and Peter Oleksik have made New York another home. Judy Aronson and Marc Hilton have welcomed me into their family without hesitation; for that I will be forever grateful. Ron Athey, Nao Bustamante, Xandra Ibarra, Pig Pen, and Julie Tolentino are the artists and friends who I always look to when I need to restore my faith in the aesthetic.

This book has received the most feedback over the years from friends and colleagues who I have spent my early career in conversation with, including Kemi Adeyemi, Kelly Chung, Jules Gill-Peterson, Ianna Hawkins Owen, Vivian Huang, Paige Johnson, Sarah Kessler, Kareem Khubchandani, Marci Kwon, Meredith Lee, Salar Mameni, Sunita Nigam, Lakshmi Padmanabhan, Leticia Robles-Moreno, Judy Rodriguez, Thea Sircar, Thea Quiray Tagle, and Alex Pittman. The work and career I have been lucky to build would have been impossible without the selfless mentorship and friendship of Latina/o scholars and thinkers who opened a path before me, including Ondine Chavoya, Lena Burgos-Lafuente, Marissa K. López, Kirstie Dorr, Macarena Gómez-Barris, Maylei Blackwell, Licia Fiol-Matta, Laura Gutiérrez, Raquel Gutiérrez, Karen Jaime, Ricardo Montez, Mar-

cia Ochoa, Ricardo Ortiz, Roy Perez, Ramón Rivera-Servera, Sandy Soto, Richard T. Rodriguez, Eliza Rodriguez y Gibson, Sandra Ruiz, Josie Saldaña, Alberto Varón, and Alexandra T. Vazquez. This book would not be here without the ongoing intellectual guidance and friendship of Patrick Anderson, Christine Bacareza Balance, Jayna Brown, Julian Bryan-Wilson, Jennifer Doyle, Erica Edwards, Elizabeth Freeman, Lucas Hilderbrand, Malik Gaines, Zakkiyah Iman Jackson, Sara Clarke Kaplan, Roshanak Kheshti, Homay King, Joshua Chambers-Letson, Heather Love, Mara Mills, Greg Mitchell, Amber Musser, Tavia Nyong'o, David Serlin, Karen Shimakawa, C. Riley Snorton, Eric Stanley, Zeb Tortorici, Jennifer Tyburczy, and Shane Vogel. Karen Tongson has nurtured this book and its ideas since its beginnings. She is my greatest model of how to approach this profession, and life even, with joy, diligence, and care. José Esteban Muñoz was an early believer in this project, and his influence informs every chapter in this book.

I arrived at Brown University and Providence to find the embrace of many communities. Leticia Alvarado and Christine Mok have made me feel at home in ways that escape articulation. They are the most wonderful co-conspirators I could ask for. Patricia Ybarra has been the most dedicated mentor and friend I could hope for at Brown and beyond. My colleagues and comrades here include Julia Jarcho, Lynne Joyrich, Ren Ellis Neyra, Dixa Ramirez, Ralph E. Rodriguez, Sydney Skybetter, and Sarah Thomas. Alexander Hardan and Amanda Macedo Macedo witnessed me get this book to completion; they are the most brilliant and caring graduate students one could ever ask to be in conversation with. Eric Zinner followed and supported this project since its earliest days and his ongoing editorial guidance and patience have reassured me time and again that this is indeed a book. Josh Rutner's exacting and generous editing helped shape this manuscript into its best possible version. I also want to thank my readers, whose rigorous feedback transformed this manuscript. Kirstie Dorr and Laura G. Gutiérrez revealed their identities at key moments during the toughest moments of revision, and a third anonymous reader pushed the ideas in this book to always be better. I hope they will see evidence of their careful and caring reviews across these pages.

I am also thankful for the support of a Subvention Award from College of Arts and Humanities at the University of Maryland. UMD also provided me with a summer fellowship at the National Humanities Center at

a crucial time. This project was supported by a Ford Foundation Postdoc-
toral Fellowship, which allowed me to have the time to complete major
revisions. The "Queer Hemispheres" working group at the UC Humanities
Research Institute gave me essential feedback during the earliest revisions.
I especially thank the members of that group: Kirstie Dorr, Christina
León, Marcia Ochoa, Justin Perez, Judith Rodriguez, Shelly Streeby, Jenni-
fer Tyburczy, and Deb Vargas for convincing me to reshape chapter 3. I am
deeply grateful for audiences and institutions which provided invaluable
feedback as I developed this project, including the English Department
Colloquium series at UC Riverside, the Department of Theater, Dance,
and Performance Studies at UMD, the F-Words Symposium at Boston
University, the Sounding Latinidades Symposium at Indiana University
Bloomington, the American Studies Colloquium at Princeton University,
and the Theater & Performance Colloquium at Harvard University. Por-
tions of chapter 2 previously appeared in the articles "Aimless Lives: Ama-
teur Aesthetics, Mexican Contemporary Art, and Sarah Minter's Alma
Punk," in a special issue of *Third Text* on "Amateurism," edited by Julia
Bryan-Wilson and Benjamin Piekut; and "Pirates and Punks: Bootlegs,
Archives, and Performance in Mexico City," in *Turning Archival: The Life
of the Historical in Queer Studies*, edited by Daniel Marshall and Zeb Tor-
torici. Their meticulous editorial comments greatly contributed to helping
me shape the arguments in this chapter.

This book is dedicated to my mother, Josefina Morales, and the mem-
ory of my father, Daniel Ramoz Martinez. They worked hard to give me
everything they never had, and they were endlessly patient and supportive
of me even when, or especially when, my direction in life seemed un-
certain. Even when we had very little, they made sure to fill my life with
books, music, and movies. I owe everything, including my love of the aes-
thetic, to them. Finally, this book would not exist without Leon Hilton and
the homes we have built together throughout the years, most recently with
our beloved Hugo. I am forever thankful to him for his patience, love, and
always giving me reason to look forward to all of the adventures we've yet
to have.

NOTES

INTRODUCTION

1 El Tianguis Cultural del Chopo, often referred to informally as El Mercado del Chopo, first began (in October 1980) inside the Museo Universitario del Chopo, but its success soon drove it from the museum to the streets, including Santa María la Ribera, Delegación Cuauhtémoc, Colonia San Rafael, and since 2006, next to the José Vasconcelos library, where the Buenavista train station once sat.

2 I use "rock" to refer to the larger, more mainstream category of rock music and still dominant in the market, whereas I use "rock and roll" to name a more temporally specific category of music that emerged in the 1950s and '60s. Although metal and punk derive from rock and roll and might be considered subgenres of rock music in general, I differentiate them here to mark that for listeners in these subcultures (and often as market categories) these three categories remain different in part due to subcultural affiliations. Thus, even when punk and metal can be classified as subcategories of rock, for their adherents these divisions define more strict divisions that show how listeners relate to these sounds.

3 The irony of course, is that far from being originally white, these sounds were originally part of Black sonic traditions, primarily in the United States, and have over the decades been pillaged and appropriated to the point of severing the racialized origins of these sounds.

4 In this case, "rock and roll" specifically names the genre that was originally introduced into Mexico in the 1960s in order to demarcate the temporal distinction in the arrival of these genres.

5 Alexander Nemerov, *Acting in the Night: Macbeth and the Places of the Civil War* (Berkeley: University of California Press, 2010), 3–4.

6 Jennifer Lynn Stoever, *The Sonic Color Line: Race and the Cultural Politics of Listening* (New York: NYU Press, 2016), 7.

7 Deborah R. Vargas, *Dissonant Divas in Chicana Music: The Limits of La Onda* (Minneapolis: University of Minnesota Press, 2012), xiv.

8 Ignacio Corona and Alejandro L. Madrid, eds., *Postnational Musical Identities: Cultural Production, Distribution, and Consumption in a Globalized Scenario* (Lanham, MD: Lexington Books, 2008), ix.

9 Ibid.

10 Ibid., 5.

11 Frances R. Aparicio and Cándida F. Jáquez, eds., *Musical Migrations: Transnationalism and Cultural Hybridity in Latin/o America, Volume 1* (New York: Palgrave Macmillan, 2003), 8.

12 Ibid.

13 Eric Zolov, *Refried Elvis: The Rise of the Mexican Counterculture* (Berkeley: University of California Press, 1999), 9.

14 For an in-depth exploration of this concept and its genealogies, see Néstor García Canclini, *Hybrid Cultures: Strategies for Entering and Leaving Modernity*, trans. Christopher L. Chiappari and Silvia L. López (Minneapolis: University of Minnesota Press, 1995).

15 See Leticia Alvarado, *Abject Performances: Aesthetic Strategies in Latino Cultural Production* (Durham, NC: Duke University Press, 2018); José Esteban Muñoz, *Disidentifications: Queers of Color and the Performance of Politics* (Minneapolis: University of Minnesota Press, 1999); Ramón Rivera-Servera, *Performing Queer Latinidad: Dance, Sexuality, Politics* (Ann Arbor: University of Michigan Press, 2012); and Juana María Rodríguez, *Queer Latinidad: Identity Practices, Discursive Spaces* (New York: NYU Press, 2003).

16 Alexandra T. Vazquez, *Listening in Detail: Performances of Cuban Music* (Durham, NC: Duke University Press, 2013), 9.

17 See Licia Fiol-Matta, *The Great Woman Singer: Gender and Voice in Puerto Rican Music* (Durham, NC: Duke University Press, 2017).

18 The political utility of aesthetic works has a longer history when considering Mexican and Chicana/o art. For an overview of this history, see Edward J. McCaughan, *Art and Social Movements: Cultural Politics in Mexico and Aztlán* (Durham, NC: Duke University Press, 2012).

19 Rubén Gallo, *New Tendencies in Mexican Art: The 1990s* (New York: Palgrave Macmillan, 2004), 7.

20 Ibid., 7–8.

21 Jennifer A. González, "Introduction," in *Chicano and Chicana Art: A Critical Anthology*, ed. Jennifer A. González, C. Ondine Chavoya, Chon Noriega, and Terezita Romo (Durham, NC: Duke University Press, 2019), 1.

22 Chon Noriega, "Definition and Debates: Introduction," in *Chicano and Chicana Art*, ed. González et al., 13.

23 Lawrence Weschler, *Everything That Rises: A Book of Convergences* (San Francisco: McSweeney's, 2006), 1.

24 Ibid.

25 See Ania Loomba, "Race and the Possibilities of Comparative Critique," *New Literary History* 40, no. 3 (2009); Lisa Lowe, *The Intimacies of Four Continents* (Durham, NC: Duke University Press, 2015); and María Josefina Saldaña-Portillo, *Indian Given: Racial Geographies across Mexico and the United States* (Durham, NC: Duke University Press, 2016).

26 Loomba, "Race and Possibilities," 501.

27 Saldaña-Portillo, *Indian Given*, 8.

28 Lowe, *Intimacies of Four Continents*, 18.

29 Sianne Ngai, *Ugly Feelings* (Cambridge, MA: Harvard University Press, 2005), 1.

30 Ibid., 6.

31 Ibid., 9.

32 Lauren Berlant, *Cruel Optimism* (Durham, NC: Duke University Press, 2011), 1.

33 See Ann Cvetkovich, *Depression: A Public Feeling* (Durham, NC: Duke University Press, 2012).

34 Alvarado, *Abject Performances*, 11.

35 Ibid., 15.

36 Franco "Bifo" Berardi, *Heroes: Mass Murder and Suicide* (London: Verso, 2015), 121–22.

37 Ibid., 22.

38 Ibid., 122.

39 Ibid., 122–23.

40 Ibid., 123.

41 Ibid., 124.

42 Ibid., 127–28.

43 Ibid., 128.

44 Christine Bacareza Balance, *Tropical Renditions: Making Musical Scenes in Filipino America* (Durham, NC: Duke University Press, 2016), 4.

45 Ibid., 5.

46 See Muñoz, *Disidentifications*.

47 Irving Goh, *The Reject: Community, Politics, and Religion after the Subject* (New York: Fordham University Press, 2014), 7.

48 Ibid.

49 Ibid.

50 Ibid., 10.

51 Prior to the signing of NAFTA, the United States and Canada had already negotiated a free trade agreement, and since Canada seemed to be at least a comparable economic force compared to its southern neighbor, public discourse at the time focused primarily on the treaty's effects on the relationship between the United States and Mexico.

52 Ann E. Kingsolver, *NAFTA Stories: Fears and Hopes in Mexico and the United States* (Boulder, CO: Lynne Rienner Publishers, 2001), 2.

53 Ibid., 4.

54 Although the actual text of the treaty was publicly unavailable at the time, the document can now be accessed at www.trade.gov/north-american-free-trade-agreement-nafta.

55 See Adrian Johns, *Piracy: The Intellectual Property Wards from Gutenberg to Gates* (Chicago: University of Chicago Press, 2009).

56 Deborah Paredez, *Selenidad: Selena, Latinos, and the Performance of Memory* (Durham, NC: Duke University Press, 2009), xii.

57 Although I see the aftermath of Selena's murder and the launch of *People en Español* as the defining cultural events that led to the Latino Boom, it is also worth mentioning that this moment of Latina/o cultural pride came in the aftermath of the passing of Proposition 187 in California, a law that specifically targeted an imagined swarm of undocumented immigrants, denying them access to education, healthcare, and other public goods without "proper" documentation. Proposition 187 came at a moment of increasing anti-immigrant sentiment—in part the result of anxieties about the effects of NAFTA on American laborers. However, in spite of the fact that the law was swiftly struck down by the courts before it could ever be implemented, its popularity with California voters reveals the kinds of vitriol directed at Latina/os more generally during this time.

58 At this time, the notion that Latina/os across the country were a discrete demographic group was still fairly new. Until the 1960s and '70s, there was no sense that Latina/os were a unified identity category in the United States. Its three major subgroups—Mexicans, Puerto Ricans, and Cubans—were seen as having almost nothing to do with each other in their histories, cultures, or (most importantly) political aims, until the civil rights movements of the 1960s. As scholars such as G. Cristina Mora and Cristina Beltrán have shown, the road toward defining a specific Hispanic—and later, Latina/o—population was the result of negotiations between activists, government agencies, and media entities seeking a shared meaning that could encompass different national and ethnic groups. See Cristina Beltrán, *The Trouble with Unity: Latino Politics and the Creation of Identity* (New York: Oxford University Press, 2010), and G. Cristina Mora, *Making Hispanics: How Activists, Bureaucrats, and Media Constructed a New America* (Chicago: University of Chicago Press, 2014).

59 Arlene Dávila, *Latinos, Inc.: The Marketing and Making of a People* (Berkeley: University of California Press, 2012), 4.

60 Ibid.

61 Ibid., 11.

62 Ibid.

63 See Ana María Ochoa Gautier, *Músicas locales in tiempos de globalización* (Buenos Aires: Grupo Editorial Norma, 2003).

64 Kirstie Dorr, *On Site, In Sound: Performance Geographies in América Latina* (Durham, NC: Duke University Press, 2018).

65 Willem van Schendel and Itty Abraham, "Introduction: The Making of Illicitness," in *Illicit Flows and Criminal Things: States, Borders, and the Other Side of Globalization*, ed. Willem van Schendel and Itty Abraham (Bloomington: Indiana University Press, 2005), 4.

66 Ibid., 6.

67 See, for example, Abigail De Kosnik, *Rogue Archives: Digital Cultural Memory and Media Fandom* (Cambridge, MA: MIT Press, 2016); Clinton Heylin, *Bootleg: The Secret History of the Other Recording Industry* (New York: St. Martin's Press, 1994); Peter Manuel, *Cassette Culture: Popular Music and Technology in North*

India (Chicago: University of Chicago Press, 1993); Lee Marshall, *Bootlegging: Romanticism and Copyright in the Music Industry* (London: Sage, 2005); Andrew C. Mertha, *The Politics of Piracy: Intellectual Property in Contemporary China* (Ithaca, NY: Cornell University Press, 2005).

68 Shujen Wang, *Framing Piracy: Globalization and Film Distribution in Greater China* (Lanham, MD: Rowman & Littlefield, 2003), 3.

69 See Jacques Derrida, *Archive Fever: A Freudian Impression*, trans. Eric Prenowitz (Chicago: University of Chicago Press, 1995).

70 Lucas Hilderbrand, *Inherent Vice: Bootleg Histories of Videotape and Copyright* (Durham, NC: Duke University Press, 2009), 5–6.

71 Ibid., 22.

72 Ibid., 23.

73 Laura U. Marks, "Archival Romances: Found, Compressed and Loved Again," *FKW: Zeitschrift für Geschlechterforschung und visuelle Kultur* 61 (February 2017): 30.

74 Ibid.

75 Ibid.

76 Ibid., 35.

77 Melissa Gauthier, "Fayuca Hormiga: The Cross-Border Trade of Used Clothing between the USA and Mexico," in *Borderlands: Comparing Border Security in North America and Europe*, ed. Emmanuel Brunet-Jailly (Ottawa: University of Ottawa Press, 2007), 98.

78 Ibid., 113.

79 Maurice Rafael Magaña, *Cartographies of Youth Resistance: Hip-Hop, Punk, and Urban Autonomy in Mexico* (Oakland: University of California Press, 2020), 13.

80 Daniel M. Goldstein, *Owners of the Sidewalk: Security and Survival in the Informal City* (Durham, NC: Duke University Press, 2016), 4.

81 Ibid., 18.

82 Ibid., 21.

83 Ibid.

84 Ibid., 75.

85 Sandra C. Mendiola García, *Street Democracy: Vendors, Violence, and Public Space in Late Twentieth-Century Mexico* (Lincoln: University of Nebraska Press, 2017), 11.

86 José Esteban Muñoz, "'Gimme Gimme This . . . Gimme Gimme That': Annihilation and Innovation in the Punk Rock Commons," *Social Text* 31, no. 3 (Fall 2013): 105.

CHAPTER 1. MELTING MODERNITIES

1 Nancy Raquel Mirabal, *Suspect Freedoms: The Racial and Sexual Politics of Cubanidad in New York, 1823–1957* (New York: NYU Press, 2017), 2.

2 Amber Musser, *Sensual Excess: Queer Femininity and Brown Jouissance* (New York: NYU Press, 2018), 43.

3 Ibid.

4 Ibid.

5 John Mraz, *Looking for Mexico: Modern Visual Culture and National Identity* (Durham, NC: Duke University Press, 2009), 2.

6 Ibid.

7 Ibid., 13.

8 Ibid., 59.

9 Ibid., 63.

10 For comprehensive surveys of the history of artists of this generation, see Alejandro Anreus, Robin Adele Greeley, and Leonard Folgarait, eds., *Mexican Muralism: A Critical History* (Berkeley: University of California Press, 2012), and Mary K. Coffey, *How a Revolutionary Art Became Official Culture: Murals, Museums, and the Mexican State* (Durham, NC: Duke University Press, 2012).

11 For more on the history of the relationship between institutional changes and aesthetics in Mexico from the 1970s through the 1990s, see Amy Sara Carroll, *REMEX: Toward an Art History of the NAFTA Era* (Austin: University of Texas, 2017).

12 See Daniel Montero, *El cubo de Rubik, arte mexicano en los años 90* (Ecatepec: Editorial RM, 2013).

13 Manuel Rocha Iturbide, "Música Experimental y Poesía Sonora en México," in *Ready Media: Hacia Una Arqueología de los Medios y la Invención en México*, ed. Karla Jasso and Daniel Garza Usabiaga (Mexico, D.F.: Laboratorio de Arte Alameda-Instituto Nacional de Bellas Artes, 2010), 384.

14 Ibid.

15 For a rich and useful history of sound in art, see Douglas Kahn, *Noise, Water, Meat: A History of Sound in the Arts* (Cambridge, MA: MIT Press, 2001).

16 Rubén Gallo, *Mexican Modernity: The Avant-Garde and the Technological Revolution* (Cambridge, MA: MIT Press, 2005), 123.

17 Ibid.

18 See Alejandro L. Madrid, *Sounds of the Modern Nation: Music, Culture, and Ideas in Post-revolutionary Mexico* (Philadelphia: Temple University Press, 2008).

19 For an account of these genealogies, see Iturbide, "Música Experimental y Poesía," and Israel Martínez, "Experimentación Sonora Contemporánea," in *Ready Media*, ed. Jasso and Garza Usabiaga.

20 See Manuel Rocha Iturbide, interview with Guillermo Santamarina, "Aaaaaaaaaaaaaaaaaaaaaaaa," in *Manuel Rocha Iturbide: El Eco Esta en Todas Partes*, ed. Guillermo Santamarina (Mexico City: Alias, 2013).

21 Marcela Armas, "Ocupación/Ocupation," 2007, www.marcelaarmas.net. Accessed November 10, 2020.

22 Ibid.

23 Marcela Armas, "Circuito Interior/Inner Circuit," 2008, www.marcelaarmas.net. Accessed November 10, 2020.

24 Ibid.

25 Carroll, *REMEX*, 47.

26 Luis M. Castañeda, *Spectacular Mexico: Design, Propaganda, and the 1968 Olympics* (Minneapolis: University of Minnesota Press, 2014), xv.

27 Mirabal, *Suspect Freedoms*, 10.

28 Trevor Schoonmaker, "The Record: Contemporary Art and Vinyl," in *The Record: Contemporary Art and Vinyl*, ed. Trevor Schoonmaker (Durham, NC: Duke University Press, 2010), 14.

29 María Josefina Saldaña-Portillo, *The Revolutionary Imagination in the Americas and the Age of Development* (Durham, NC: Duke University Press, 2003), 6.

30 Ibid., 6–7.

31 Ibid., 65.

32 Mirabal, *Suspect Freedoms*, 11.

33 Hayden White, *The Content of the Form: Narrative Discourse and Historical Representation* (Baltimore: Johns Hopkins University Press, 1990), 2.

34 Ibid., 3.

35 For an exemplary model of narrating the wayward stories of the minor subjects of history, see Saidiyah Hartman, *Wayward Lives, Beautiful Experiments: Intimate Histories of Riotous Black Girls, Troublesome Women, and Queer Radicals* (New York: W. W. Norton, 2019).

36 Elsa Barkley Brown, "Polyrhythms and Improvization: Lessons for Women's History," *History Workshop* 31 (Spring 1991): 85.

37 Ibid.

38 Ibid., 86.

39 Ibid., 87.

40 Lisa Lowe, *The Intimacies of Four Continents* (Durham, NC: Duke University Press, 2015), 2.

41 Ibid., 3.

42 Ibid., 99.

43 Gavin Weightman, *The Frozen Water Trade: A True Story* (New York: HarperCollins, 2012), 3.

44 Ibid., 14.

45 Ibid., 16.

46 Ibid., 19.

47 Ibid.

48 Ibid., 61.

49 See César J. Ayala, *American Sugar Kingdom: The Plantation Economy of the Spanish Caribbean, 1898–1934* (Chapel Hill: University of North Carolina Press, 1999); Stuart McCook, *States of Nature: Science, Agriculture, and Environment in the Spanish Caribbean, 1760–1940* (Austin: University of Texas Press, 2010); April Merleaux, *Sugar and Civilization: American Empire and the Cultural Politics of Sweetness* (Chapel Hill: University of North Carolina Press, 2015); Fernando Ortiz, *Cuban Counterpoint: Tobacco and Sugar* (Durham, NC: Duke University Press,

1995); Omise´eke Natasha Tinsley, *Thiefing Sugar: Eroticism between Women in Caribbean Literature* (Durham, NC: Duke University Press, 2010).

50 Gabriel García Márquez, *One Hundred Years of Solitude*, trans. Gregory Rabassa (New York: Harper & Row, 1970), 1.

51 Ibid.

52 Ibid., 18.

53 Ibid.

54 Ibid., 226.

55 Wall text, *Teoría de la Entropía*, Centro Cultural Tijuana, Tijuana, Mexico, 2013.

CHAPTER 2. AIMLESS LIVES

1 Cristina Ochoa, "Phantom Power," 2012, http://cristina-ochoa.com. Accessed October 3, 2016.

2 Ibid.

3 For more on the global history of punk and other closely related genres, see Kevin Dunn, *Global Punk: Resistance and Rebellion in Everyday Life* (New York: Bloomsbury Academic, 2016); Raymond A. Patton, *Punk Crisis: The Global Punk Rock Revolution* (New York: Oxford University Press, 2018).

4 Eric Zolov, *Refried Elvis: The Rise of the Mexican Counterculture* (Berkeley: University of California Press, 1999), 203.

5 Ibid., 204.

6 Ibid., 205.

7 Although this event has been less featured in Mexican cultural production, it was most recently portrayed by Alfonso Cuarón in his *Roma* (2018).

8 See Tere Estrada, *Sirenas al Ataque: Historia de las Rockeras Mexicanas* (Mexico City: Oceano, 2008), 136.

9 For an insightful overview of the importance and impact of *rock en español* on Latina/o communities in the United States, see Josh Kun, *Audiotopia: Music, Race, and America* (Durham, NC: Duke University Press, 2005).

10 Annick Prieur, *Mema's House, Mexico City: On Transvestites, Queens, and Machos* (Chicago: University of Chicago Press, 1998), 3.

11 Ibid.

12 Guillermo Osorno, *Tengo Que Morir Todas Las Noches: Una Crónica de los Ochenta, el Underground y la Cultura Gay* (Mexico City: Debate, 2014).

13 Prieur, *Mema's House*, 3.

14 Ibid., 4.

15 Magaña, *Cartographies of Youth Resistance*, 2.

16 Ibid.

17 Ibid., 21.

18 Markus-Michael Müller, *The Punitive City: Privatized Policing and Protection in Neoliberal Mexico* (London: Zed Books, 2016), 3, emphasis in original.

19 Ibid., 4.

20 Ibid., 6.

21 Ibid., 7.

22 Ibid., 19.

23 Ibid., 32.

24 Laura Martínez Hernández, *Música y Cultura Alternativa: Hacia un Perfil de la Cultural del Rock Mexicano de Finales del Siglo XX* (Puebla: Lupus Inquisitor, 2013), 50.

25 Ibid., 51, emphasis mine.

26 See Sayak Valencia, *Gore Capitalism*, trans. John Pluecker (Cambridge, MA: MIT Press, 2018).

27 Estrada, *Sirenas al Ataque*, 136.

28 See Tere Estrada, *Sirenas al Ataque: Historia de las Rockeras Mexicanas* (Mexico City: Oceano, 2008).

29 See Licia Fiol-Matta, *The Great Woman Singer: Gender and Voice in Puerto Rican Music* (Durham, NC: Duke University Press, 2017).

30 Michelle Habell-Pallán, *Loca Motion: The Travels of Chicana and Latina Popular Culture* (New York: NYU Press, 2005), 152–53.

31 Julia Palacios and Tere Estrada, "'A contra corriente: A History of Women Rockers in Mexico," in *Rockin' Las Américas: The Global Politics of Rock in Latin/o America*, ed. Deborah Pacini Hernandez, Héctor D. Fernández l'Hoeste, and Eric Zolov (Pittsburgh: University of Pittsburgh Press, 2004), 155–56.

32 José Manuel Valenzuela, *¡A La Brava Ese!: Cholos, Punks, Chavos Banda* (Tijuana: Colegio de la Frontera Norte, 1988), 203, translation mine.

33 See Stefano Harney and Fred Moten, *The Undercommons: Fugitive Planning & Black Study* (Chico, CA: Minor Compositions, 2013).

34 Gabreila Aceves Sepúlveda, *Women Made Visible: Feminist Art and Media in Post-1968 Mexico City* (Lincoln: University of Nebraska Press, 2019), 5.

35 Dorr, *On Site, In Sound*, 17.

36 Mariana David, "Necropsy: Writing the History of the Collective SEMEFO," in *SEMEFO 1990–1999: From the Morgue to the Museum*, ed. Mariana David (Mexico City: El Palacio Negro y Universidad Autónoma Metropolitana, 2011), 23.

37 Luis Javier García Roiz, "Symphonies of Putrefaction," in *SEMEFO 1990–1999*, ed. David, 41.

38 Naief Yehya, "The Sounds of SEMEFO," *Unomásuno* 9 (March 1996): 16. Reprinted in *SEMEFO 1990–1999*, ed. David, 243.

39 Ibid.

40 Estela Leñero, "La Teatralidad del Performance," *Unomásuno* (April 1990). Reprinted in *SEMEFO 1990–1999*, ed. David, 100, translation mine.

41 Amelia Jones, *Body Art/Performing the Subject* (Minneapolis: University of Minnesota Press, 1998), 3.

42 Ibid., 5.

43 Laura G. Gutiérrez, *Performing Mexicanidad: Vendidas y Cabareteras on the Transnational Stage* (Austin: University of Texas Press, 2010), 18.

44 Ibid., 19.

45 Marco Antonio Rueda, "SEMEFO: Performance Art Must Convey Unique Sensations," *El Universal* 28 (August 1990). Reprinted in *SEMEFO 1990–1999*, ed. David, 217.
46 Ibid.
47 Jairo Calixto Albarrán, "Forensic Medical Service," *Excélsior* (September 1990). Reprinted in *SEMEFO 1990–1999*, ed. David, 217.
48 Ibid., 218.
49 Jeremy Wallach, Harris M. Berger, and Paul D. Greene, "Affective Overdrive, Scene Dynamics, and Identity in the Global Metal Scene," in *Metal Rules the Globe: Heavy Metal Music around the World*, ed. Jeremy Wallach, Harris M. Berger, and Paul D. Greene (Durham, NC: Duke University Press, 2011), 3.
50 Ibid., 7.
51 Ibid., 13.
52 Quoted in Luis Javier García Roiz, "The Music of SEMEFO: Carlos López Interviewed," in *SEMEFO 1990–1999*, ed. David, 45.
53 The end credits of *¿Cómo Ves?* include Las Susys among the list of bands who contributed to the film. It appears that some of the girls from the band appear momentarily, offstage, in a police lineup following a raid.
54 See Sarah Minter, "A Bird's Eye View: Video in Mexico, Its Beginnings and Its Context," in *Sarah Minter: Rotating Eye, Images in Motion 1981–2015*, ed. Cuauhtémoc Medina, trans. Robin Myers (Mexico City: Editorial RM, 2015).
55 Ibid.
56 Although the book's title is never mentioned, it seems likely that they are referring to a translation of A. Alvarez's *The Savage God: A Study of Suicide*. A friend of Plath's, Alvarez wrote the book shortly after her suicide, focusing especially on the works and lives of suicidal poets.

CHAPTER 3. DYKE CHORDS

1 Roland Barthes, *El Discurso Amoroso: Seminario en la Escuela de Altos Estudios, 1974–1976; Seguido de Fragmentos de Un Discurso Amoroso (textos inéditos)* (Barcelona: Paidós, 2011), 258, translation mine.
2 Ibid., 258, translation mine.
3 Jimmy Alvarado, "Backyard Brats and Eastside Punks: A History of East LA's Punk Scene," *Aztlán: A Journal of Chicano Studies* 37, no. 2 (Fall 2012): 157.
4 Colin Gunckel and Pilar Tompkins, "Vexing: Female Voices from East LA Punk," curator's statement, Claremont Museum, 2008, https://clmoa.org. Accessed February 27, 2021.
5 Colin Gunckel, "*Vexing* Questions: Rethinking the History of East LA Punk," *Aztlán: A Journal of Chicano Studies* 37, no. 2 (Fall 2012): 129.
6 Gunckel and Tompkins, "Vexing."
7 Marci R. Mcmahon, "Self-Fashioning through Glamour and Punk in East Los Angeles: Patssi Valdez in Asco's *Instant Mural* and *A LA Mode*," *Aztlán: A Journal of Chicano Studies* 36, no. 2 (Fall 2011): 23.

8 Michelle Habell-Pallán, *Loca Motion: The Travels of Chicana and Latina Popular Culture* (New York: NYU Press, 2005), 149.

9 Ibid., 153.

10 Ibid., 156.

11 See Alice Bag, *Violence Girl: East L.A. Rage to Hollywood Stage, A Chicana Punk Story* (Port Townsend, WA: Feral House, 2011).

12 Among some of these scholars who have completed or are completing dissertations on the intersection of Latinas and punk are Sarah Dowman at the University of Maryland, Marlen Ríos-Hernández at the University of California, Riverside, and Susy Zepeda at the University of Arizona.

13 Deborah R. Vargas, *Dissonant Divas in Chicana Music: The Limits of La Onda* (Minneapolis: University of Minnesota Press, 2012), 217.

14 Licia Fiol-Matta, *The Great Woman Singer: Gender and Voice in Puerto Rican Music* (Durham, NC: Duke University Press, 2017), 5.

15 Arlene Dávila, *Latinos, Inc.: The Marketing and Making of a People* (Berkeley: University of California Press, 2012), 97.

16 Ibid., 217.

17 Richard T. Rodríguez, *Next of Kin: The Family in Chicano/a Cultural Politics* (Durham, NC: Duke University Press, 2009), 2.

18 Ibid.

19 Sandra K. Soto, *Reading Chican@ like a Queer: The De-Mastery of Desire* (Austin: University of Texas Press, 2010), 10.

20 Leila Cobo, "How Latin Went Mainstream, and Why It Will Continue to Happen in 2018," *Billboard*, January 26, 2018, www.billboard.com.

21 See Jennifer Lynn Stoever, *The Sonic Color Line: Race and the Cultural Politics of Listening* (New York: NYU Press, 2016).

22 Jon Alpert and Matthew O'Neill, *The Latin Explosion: A New America* (2015).

23 For an essential history of Chicana/o contributions to the rock scene in Los Angeles and surrounding areas, see David Reyes and Tom Waldman, *Land of a Thousand Dances: Chicano Rock 'n' Roll from Southern California* (Albuquerque: University of New Mexico Press, 2009).

24 Antonio Viego, *Dead Subjects: Toward a Politics of Loss in Latino Studies* (Durham, NC: Duke University Press, 2007), 4.

25 Ibid., 231.

26 Ibid., 241.

27 Teresa de Lauretis, *The Practice of Love: Lesbian Sexuality and Perverse Desire* (Bloomington: Indiana University Press, 1994), 198.

28 Lynne Huffer, *Are the Lips a Grave?: A Queer Feminist on the Ethics of Sex* (New York: Columbia University Press, 2013), 33.

29 Ibid., 43.

30 Mari Ruti, *The Ethics of Opting Out: Queer Theory's Defiant Subjects* (New York: Columbia University Press, 2017), 2.

31 Ibid., 172.

32 Ibid., 181.

33 Tavia Nyong'o, "Punk'd Theory," *Social Text* 23, nos. 3–4 (84–85) (Fall–Winter 2005): 20.

34 José Esteban Muñoz, "'Gimme Gimme This . . . Gimme Gimme That': Annihilation and Innovation in the Punk Rock Commons," *Social Text* 31, no. 3 (2013): 97.

35 Las Cucas, 2000, www.cucarific.com, via Internet Archive, https://web.archive.org/web/20001024025843/http://cucarific.com.

36 José Esteban Muñoz, "Feeling Brown, Feeling Down: Latina Affect, the Performativity of Race, and the Depressive Position," *Signs: Journal of Women in Culture and Society* 31, no. 31 (2006): 676.

37 Laura G. Gutiérrez, *Performing Mexicanidad: Vendidas y Cabareteras on the Transnational Stage* (Austin: University of Texas Press, 2010), 141.

38 Leticia Alvarado, *Abject Performances: Aesthetic Strategies in Latino Cultural Production* (Durham, NC: Duke University Press, 2018), 129.

39 José Quiroga, *Tropics of Desire: Interventions from Queer Latino America* (New York: NYU Press, 2000), 145.

40 Ibid., 146.

41 Ibid., 149.

42 Ibid.

43 Rafael Castillo Zapata, *Fenomenología del Bolero* (Caracas: Monte Avila, 1990), 23, translation mine.

44 Monique Wittig, *The Lesbian Body*, trans. David Le Vay (Boston: Beacon, 1986), 17.

45 tatiana de la tierra, *For the Hard Ones: A Lesbian Phenomenology* (San Diego: Calaca Press, 2002), 19.

46 Alexandra T. Vazquez, *Listening in Detail: Performances of Cuban Music* (New York: NYU Press, 2011), 134.

47 Fiol-Matta, *The Great Woman Singer*, 224.

48 Jonathan Sterne, "Voices," in *The Sound Studies Reader*, ed. Jonathan Sterne (London: Routledge, 2012), 491.

49 Ibid.

50 Roland Barthes, "The Grain of the Voice," in *The Sound Studies Reader*, ed. Jonathan Sterne (London: Routledge, 2012), 505.

51 Ibid.

52 Ibid.

53 Ibid., 506.

54 Fiol-Matta, *The Great Woman Singer*, 169.

55 Ibid., 191.

56 Roland Barthes, *A Lover's Discourse: Fragments*, trans. Richard Howard (New York: Hill & Wang, 1978), 1.

57 Ibid.

58 Ibid.

59 Ibid., 10.

60 Ibid.

61 Ibid., 180.

62 Juana María Rodríguez, *Sexual Futures, Queer Gestures, and Other Latina Longings* (New York: NYU Press, 2014), 26.

63 Judith Butler, *Undoing Gender* (New York: Routledge, 2004), 29.

64 Rodríguez, *Sexual Futures*, 26.

65 Ibid., 152.

CHAPTER 4. TRULY DISAPPOINTED

1 Kurt Badenhausen, "America's Most Miserable Cities." *Forbes*, February 2, 2012, www.forbes.com.

2 "Stockton (city), California," *State and County QuickFacts*, US Census Bureau, www.census.gov.

3 Richard T. Rodríguez, *A Kiss across the Ocean: Transatlantic Intimacies of British Post-Punk and US Latinidad* (Durham, NC: Duke University Press, 2021), 25.

4 Ibid., 5.

5 I do not mean to dismiss the often troubling, and xenophobic, statements that Morrissey has made over the years. In addition to Sinophobic and Islamophobic statements and other provocative statements about other artists, not to mention the meat industry, one of his most recent controversies included the artist wearing a pin in support of a British far-right party during a performance on *The Tonight Show Starring Jimmy Fallon*. And in recent years he has embraced and fostered his status as a controversial figure by railing against "cancel culture."

6 Certain genres, like country music, do attempt to portray a working-class aesthetic. However, most mainstream artists in these genres and their careers remain invested in a narrative of upward mobility and certainly do not share a sense of class consciousness in the way that class appears in British cultural production.

7 Tavia Nyong'o, *The Amalgamation Waltz: Race, Performance, and the Ruses of Memory* (Minneapolis: University of Minnesota Press, 2009).

8 John Alba Cutler, *Ends of Assimilation: The Formation of Chicano Literature* (New York: Oxford University Press, 2015), 10.

9 Ibid., 12.

10 Quoted in Jennifer A. González, "Introduction," in *Chicano and Chicana Art: A Critical Anthology*, ed. Jennifer A. González, C. Ondine Chavoya, Chon Noriega, and Terezita Romo (Durham, NC: Duke University Press, 2019), 1.

11 Ibid., 17.

12 Marissa K. López, "¿Soy emo, y qué?: Sad Kids, Punkera Dykes and the Latin@ Public Sphere," *Journal of American Studies* 46, no. 4 (2012): 898.

13 Ibid.

14 Ibid., 899.

15 Morrissey, "Disappointed." *Bona Drag*. Sire Records, 1990. CD.

16 During a 1992 concert, Morrissey draped himself in a Union Flag, which at the time was a far-right symbol deployed against South Asian immigrants in the UK. See Jude Rogers, "Cornershop's Tjinder Singh: 'My Dad Said, "They'll Not Always Want You Here." That Stuck,'" *Guardian*, March 1, 2020, www.theguardian.com.

17 Smiths, "William, It Was Really Nothing." *Hatful of Hollow*. Rough Trade Records, 1984. CD.

18 Michael Cobb, *Single: Arguments for the Uncoupled* (New York: NYU Press, 2012), 160.

19 See Nabeel Zuberi, *Sounds English: Transnational Popular Music* (Urbana: University of Illinois Press, 2001).

20 Susan Sontag, "On Paul Goodman," in *Susan Sontag: Later Essays*, ed. David Rieff (New York: Library of America, 2017), 6.

21 Ibid.

22 Ibid., 7.

23 Ibid.

24 Ibid., 9.

25 Quoted in Chuck Klosterman, "1400 Mexican Moz Fans Can't Be (Totally) Wrong," in *IV: A Decade of Curious People and Dangerous Ideas* (New York: Scribner, 2006), 47.

26 Chuck Klosterman, "Viva Morrissey!," in *IV: A Decade of Curious People*, 49.

27 Gustavo Arellano, "Their Charming Man: Dispatches from the Latino-Morrissey Love-In," *OC Weekly*, September 12, 2002.

28 Gustavo Arellano, "Foreword: We Never Knew Our Place," in Melissa Mora Hidalgo, *Mozlandia: Morrissey Fans in the Borderlands* (Manchester: Headpress, 2016), 1.

29 Ibid., 2.

30 Klosterman, "Viva Morrissey!," 50–51.

31 Simon Goddard, *Mozipedia: The Encyclopedia of Morrissey and the Smiths* (New York: Plume, 2010), 218.

32 Zuberi, *Sounds English*, 17.

33 Melissa Mora Hidalgo, *Mozlandia: Morrissey Fans in the Borderlands* (Manchester: Headpress, 2016), 14.

34 Carolyn Dinshaw, *How Soon Is Now?: Medieval Texts, Amateur Readers, and the Queerness of Time* (Durham, NC: Duke University Press, 2012), 4.

35 Ibid.

36 Ibid., 5.

37 Karen Tongson, *Relocations: Queer Suburban Imaginaries* (New York: NYU Press, 2011), 160.

38 Ibid., 161.

39 Ibid., 166.

40 Ibid., 169.

41 Ibid., 170.

42 Ibid., 171.

43 Ibid., 172.

44 See Morrissey, *Autobiography* (London: Penguin Classics, 2013), 450–57.

45 Jean-Luc Nancy, *Listening*, trans. Charlotte Mandell (New York: Fordham University Press, 2007), 5.

46 Ibid., 7.

47 Ibid., 10.

48 Stig Sæterbakken, "Why I Always Listen to Such Sad Music," *Music & Literature* 1 (2015).

49 Ibid., 3–4.

50 Nate Cohn, "More Hispanics Declaring Themselves White," *New York Times*, May 21, 2014, www.nytimes.com.

51 Nate Cohn, "Pinpointing Another Reason That More Hispanics Are Identifying as White," *New York Times*, June 2, 2014, www.nytimes.com.

52 Sergio Aguilar-Gaxiola and Thomas P. Gullota, *Depression in Latinos: Assessment, Treatment, and Prevention* (New York: Springer, 2008), xix.

53 Antonio Viego, *Dead Subjects: Toward a Politics of Loss in Latino Studies* (Durham, NC: Duke University Press, 2007), 4.

54 Ibid., 51.

55 Ibid., 59.

56 Carol Mavor, *Black and Blue: The Bruising Passion of Camera Lucida, La Jetée, Sans soleil, and Hiroshima mon amour* (Durham, NC: Duke University Press, 2012), 39.

57 Roland Barthes, *Camera Lucida: Reflections on Photography* (New York: Hill & Wang, 2010), 27.

58 Mavor, *Black and Blue*, 15.

59 Raquel Gutiérrez, "What Is Revealed When You Sleep," *When You Sleep: A Survey of Shizu Saldamando* (Monterey Park, CA: Vincent Price Art Museum), 11.

60 Ibid., 12–13.

61 Jean-Luc Nancy, *The Pleasure in Drawing*, trans. Philip Armstrong (New York: Fordham University Press, 2013), 3.

62 Ibid., 93.

63 Ibid., 11.

64 Ibid., 13.

65 Ibid., 105.

66 See Michel Foucault, "Friendship as a Way of Life," in *Ethics: Subjectivity and Truth (The Essential Works of Foucault, 1954–1984, Volume One)*, ed. Paul Rabinow, trans. Robert Hurley (New York: New Press, 1997), 135–40.

67 Gregory Jusdanis, *A Tremendous Thing: Friendship from the Iliad to the Internet* (Ithaca, NY: Cornell University Press, 2014), 1.

68 Ibid., 2.

69 Ibid., 3.

70 Giorgio Agamben, *What Is an Apparatus?*, trans. David Kishik and Stefan Peda-
tella (Stanford, CA: Stanford University Press, 2009), 34–35.

CODA

1 Mark Fisher, *Capitalist Realism: Is There No Alternative?* (London: Zero Books, 2009).
2 Muñoz, *Disidentifications*, 5.

INDEX

abandoned: bodies, 103; lover (in "Sabor a Mí"), 134–36, 138–40; spaces, 85, 90–92, 104–5, 167; website (of Las Cucas), 110, 127–28

Abaroa, Eduardo, *Obelisco Roto Portátil para Mercados Ambulantes*, 47–48

abjection, 18, 22, 131–38; feminist, 97. *See also* SEMEFO

abortion, as subplot in *Alma Punk*, 102. See also *Alma Punk* (Minter)

Abraham, Itty, on "criminal things," 32

Abreu, Iván, 10–11, 54; *M(R.P.M.)*, 29, 37–38, 40–46, 55–63, 65–71; *Similitude (National Anthems MX-US)*, 44. *See also* ice; *M(R.P.M.)* (Abreu)

access: and the archive, 38; and the bootleg, 29, 32–34, 84, 86, 103; and desire, 33, 84; promise of (with NAFTA), 103

Aceves Sepúlveda, Gabriela, on feminist activists and media artists, 89

affirmation, 18–19, 124, 138

Agamben, Giorgio, 117; on friendship, 187. *See also* friendship

agency, of "ant traders," 35; of Latina/o Morrissey fans, 158. *See also* informal economies

aggression, of punk/metal, 10, 38, 74, 85, 110, 117, 185. *See also* SEMEFO (band)

Albarrán, Jairo Calixto, on SEMEFO's *Imus Cárcer*, 94–97. *See also* SEMEFO (band)

alienation: and assimilation, 156; of Morrissey's fans, 152, 156, 174–75; of punks, 88; of young people, 1, 5, 174–76

Alma Punk (Minter), 37–38, 75, 89–90, 98–107, 185. *See also* Minter, Sarah

Alvarado, Jimmy, on East LA punk, 112

Alvarado, Leticia, 11; on Latino abject performances, 18, 131. *See also* abjection; Bustamante, Nao

Alÿs, Francis, *Paradox of Praxis 1 (Sometimes Making Something Leads to Nothing)*, 70. *See also* ice

Angulo, Arturo, 90. *See also* SEMEFO (band)

Anzaldúa, Gloria, on the borderlands, 158. *See also* borders

Aparicio, Frances, on rock music and hybridity, 8–9. *See also* hybridity

appropriation: of abandoned spaces, 85, 90–92, 104–5; cultural, 29–30; and *rock en español*, 9

archive, the: and access, 38; alternatives to, 75–76; and Las Cucas, 126–31; as ephemeral, 125, 127–28; as insufficient/limited/absent, 12, 28, 75, 85–89, 98–99, 101, 114–15, 131; and memory, 127–28, 130; and piracy, 31, 33–34; structuring of, 115, 122

Arellano, Gustavo, and the Latina/o Morrissey fan, 155–56. *See also* fandom; Morrissey

Armas, Marcela, 50, 52–54; *Circuito Interior*, 53–54; *Ocupación*, 52–53

Armendariz, Alicia. *See* Bag, Alice (Alicia Armendariz)

Arnaz, Desi, 120

arte sonoro. *See* sound art

Fonsi, Luis, "Despacito," 120
Foucault, Michel, 1, 124; on friendship,
186. *See also* friendship
friendship, 39, 102, 176, 186–88; and dis-
like (concurrently), 154; and the reject,
145–47, 187; and sadness, 187–88. *See
also* relationality
Frith, Simon, on suburbia and British
popular music, 159. *See also* suburbia

Gabriel, Juan, 157
Gahan, Dave, 176–77, 179. *See also* De-
peche Mode
Galán, Julio, 13
Gallo, Rubén: on Mexican art (and poli-
tics), 13; on the radio and Mexico, 51
García Márquez, Gabriel, *One Hundred
Years of Solitude* and ice, 63–64, 70. *See
also* ice
García Roiz, Luis Javier, 97; on SEMEFO,
91. *See also* SEMEFO (band)
Gauthier, Melissa, on the *fayuca hor-
miga* (ant trade), 35. *See also* informal
economies
gender: and advertising, 118; and assimi-
lation, 148–49; and bolero, 133; and
history, 57–60; and labor exploitation,
80; and memory, 57; and metal/punk,
38, 73–74, 85–142; and nationalism,
117–19; and rock, 10; and sound art,
52–53
Girl in a Coma, 116
Goh, Irving, on the reject, 21–22. *See also*
reject, the
Goldstein, Daniel, on informal commerce,
35–36. *See also* informal economies
González, Jennifer A., on Latina/o art in
the '60s and '70s, 13–14
Goodman, Paul, Sontag on, 153–54
Goodrich, S. G., *A Pictorial Geography of
the World*, 62–63. *See also* ice
grain: of the voice, 136–37, 143; of the
wood, 183, 185

Greene, Paul D., on metal as mode of
resistance, 97. *See also* metal
Grupo Proceso Pentágono, 47
Guerrilla Girls, 89
Guillot, Olga, bolero of, 132–33. *See also*
bolero; desire
Gun Club, The, 122
Gunckel, Colin, on gender and East LA
punk, 112–13
Gurba, Myriam *Dahlia Season*, 116
Gutiérrez, Laura G., 11; on Bustamante's
"bad girl aesthetics," 130–31; on "un-
settling" in 1990s Mexican feminist
artists, 94
Gutiérrez, Raquel: on Morrissey, 159–60,
176; on Saldamando's work, 175–76,
179, 181. *See also* Butchlalis de Panoch-
titlan; fandom; Morrissey; Saldaman-
do, Shizu

Habell-Pallán, Michelle, 9; on Chicana
punk, 113–14; on gender limitations of
punk archives, 86
Hanna, Kathleen, 184
hardcore, 75, 91
Harney, Stefano, 89
Hernández, Ana, 101. *See also* **Alma Punk**
(Minter)
Hernández, Ester, "La Ofrenda," 119
Hernandez, Gilbert, *Love & Rockets*, 115
Hernandez, Jamie, *Love & Rockets*, 115
Hernández, Julián, *La Diosa del Asfalto*,
98
Herrera, Melquiades, 49
Hidalgo, Melissa Mora, *Mozlandia: Mor-
rissey Fans in the Borderlands*, 156, 158.
See also fandom; Morrissey
Hilderbrand, Lucas, 31; on bootlegs, 33–
34. *See also* bootlegs
hippies, 77, 84. *See also* Avándaro rock
festival
Holly, Buddy, 122
Huffer, Lynne, on lips as grave, 124–25

Nancy, Jean-Luc: on drawing, 177–79, 182; on listening, 160–61. *See also* listening
Nemerov, Alexander, 4
Neo-Mexicanism, 13, 47–48
Neza. *See* Ciudad Nezahualcóyotl
Ngai, Sianne, on ugly feelings, 16–17. *See also* ugly feelings
No-Grupo, 47, 49, 89
Noriega, Chon, on Chicana/o art(ists), 14
North American Free Trade Agreement. *See* NAFTA
nostalgia: absence of, 165; and repetition, 56; resistance to, 12. *See also* memory
Novo, Salvador, 51
Nuñez, Dulce María, 13
Nyong'o, Tavia, 148; on the intersection of punk and queer, 125–26

Ochoa, Cristina, *Phantom Power*, 72–73
Ochoa, Marcia, 110, 126–29, 141. *See also* Cucas, Las
Ochoa Gautier, Ana María: on piracy and Latin American local music culture, 28. *See also* piracy
Oliveros, Pauline, and the term "sound art," 50. *See also* sound art
Olympics, Summer (1968), 43, 54, 60, 67
Onda, La, 6–7, 76–78
One Hundred Years of Solitude (García Márquez), and ice, 63–64, 70. *See also* ice
Osorno, Guillermo, on queer life and class, 81
Otálvaro-Hormillosa, Gigi, 110, 126. *See also* Cucas, Las

pachucos, 164
Pacini Hernandez, Deborah, 9
Palacios, Julia, 86
Para las Duras: Una Fenomenología Lesbiana (de la tierra), 131–32, 135, 137, 139–40

Paredez, Deborah, on "Selenidad," 26. *See also* Latino Boom; Selena; self-identification
Peña Nieto, Enrique, 190–91
People en Español, 26, 204n57. *See also* Latino Boom; Selena
performance venues, alternative, 1, 5, 75, 85, 89–93, 104–5. *See also* abandoned: spaces
photography, and Mexican war/revolution, 46–47; and race, 171–72
piracy, 25, 28–29, 31–33; and the archive, 31, 32–33, 76; and resistance, 32. *See also* bootlegs
Plath, Sylvia, as invoked in *Alma Punk*, 102–3, 210n56. *See also* *Alma Punk* (Minter); suicide
police: as "the plague of the world," 106; violence/harassment, 74, 84, 98, 103–4. *See also* state violence
politics: and art/music, 13–14, 37, 44, 49, 51–52, 65–71, 74, 76, 79–80, 89; and the dissolution of self, 124; lack of (in Mexrrissey), 190–91; rejection of, 126
pollution, air/noise, 81. *See also* Ciudad Nezahualcóyotl
Polvo de Gallina Negra, 47, 89
Prado, Pérez, grunts of, 136
Prieur, Annick, on Neza, 81–83. *See also* Ciudad Nezahualcóyotl
progress narratives, letting go of/rejecting, 45, 48, 54–60, 65–66. *See also* temporality
psychoanalysis, 123–25, 163–64
punctum, 172; aural, 166. *See also* Barthes, Roland; photography
punk, 10–11, 13, 17, 28, 37, 82, 84; birth of, 113–14; Chicana lesbian, 38, 109–42; and class, 10, 85; and/in cultural production, 110–11, 115–17; and gender, 38, 74–75, 85–90, 98–142; and national/ethnic betrayal, 3–5; and Nazi sympathizers, 115; and temporality, 125–26

Ruti, Mari, on negativity and queer theory, 125. *See also* queer theory

"Sabor a Mí," 130, 132–40
Sæterbakken, Stig, on listening to sad music, 161–62. *See also* listening; melancholia
Salazar, Ruben, on the Chicano, 149
Saldamando, Shizu, 39, 145, 175–88; *Claudia and Mari*, 183, 185; *Embrace Series*, 180–83; *The Holy Cuatro*, 176–77, 179; and politics, 15; *Rudy's Lunchbox*, 184–86; *La Sandra*, 183–84; *Sandy and Siouxsie*, 178–79; *Sunshine's Lunchbox*, 185; withholding of, 184–85. *See also* Morrissey
Saldaña-Portillo, María Josefina: on research methodology, 15; on revolution and modernization in Latin America, 56–57, 59
Salinas de Gortari, Carlos, 13
Sama, Hari, *Esto no es Berlín*, 98
Sánchez, Cuco, 126; "Gritenme Piedras del Campo," 130. *See also* Cucas, Las
Sangronas y el Cabrón, Las, 116
Santa Cecilia, La: "El Hielo (ICE)," 70. *See also* ice
Santamarina, Guillermo, 49–52
Schaefer, John, 189
Schendel, Willem van, on "criminal things," 32
scream, the, 116–17; Chicana lesbian punk, 110, 123, 126–27, 133–40. *See also* Bustamante, Nao
Secta Suicida Siglo 20, 86
Selena: *Dreaming of You*, 130; and the Latino Boom, 26, 204n57. *See also* Latino Boom
self-annihilation, 22, 127, 130. *See also* suicide
self-destruction, 29, 43, 67–68, 109. *See also* Abreu, Iván: *M(R.P.M.)*

self-identification, 20, 26–27, 55. *See also* identity
self-representation, 78
SEMEFO (federal agency), 90. *See also* death
SEMEFO (band), 38, 75, 90–98; *Imus Cárcer*, 94–97; *Viento Negro*, 92–94, 97
sentimental: education, 126; performance, 132–33
Shakira, 26, 121. *See also* Latin craze; Latino Boom
shyness, 171, 174–75
Siqueiros, David Alfaro, 52
Siouxsie and the Banshees, 176; and Latina/o listeners, 39, 146
Siouxsie Sioux, 176–79. *See also* Siouxsie and the Banshees
Smith, Robert, 176–77, 179, 185. *See also* Cure, The
Smiths, the, 29, 140–59, 175; "Ask," 171; "How Soon Is Now?," 158–59, 171; *The Queen is Dead*, 151; "The Queen is Dead," 191; "Reel Around the Fountain," 144; "Shoplifters of the World Unite," 187; "There Is a Light That Never Goes Out," 188. *See also* Morrissey
Sontag, Susan, on Paul Goodman, 153–54
Soto, Sandra K., on Chicana subjectivity and sexual framework, 118
sound art: Mexican, 46–54, 75; Festival Internacional de Arte Sonoro, 49–50; as term, 50
Spartacus (club), 82. *See also* Ciudad Nezahualcóyotl
Spheeris, Penelope, *The Decline of Western Civilization*, 114–15
Stains, 115
Stallings, L. H., 125
state violence, 78–79, 83–84; El Halconazo (the Corpus Christi Massacre), 78; Tlatelolco massacre (1968), 67, 78. *See also* police

ABOUT THE AUTHOR

Iván A. Ramos is Assistant Professor in the Department of Theater Arts and Performance Studies at Brown University. He received his PhD in Performance Studies with a Designated Emphasis in Women, Gender, and Sexuality Studies from UC Berkeley. Iván is originally from Tijuana, Mexico.

His work has been supported by fellowships from the University of California Humanities Research Institute, the National Humanities Center, and the Ford Foundation. In addition, his writing has appeared in the *Oxford Encyclopedia of Latina/o Literature, Third Text, Women & Performance, ASAP/Journal,* and *Great North American Stage Directors, Volume 8,* among other places. He was also a contributor to the award-winning catalog for the exhibition *Axis Mundo: Queer Networks in Chicano L.A.,* sponsored by the Getty Foundation. He has an article in the forthcoming *Turning Archival* anthology. He currently sits on the editorial board for the journal *Afterimage.*